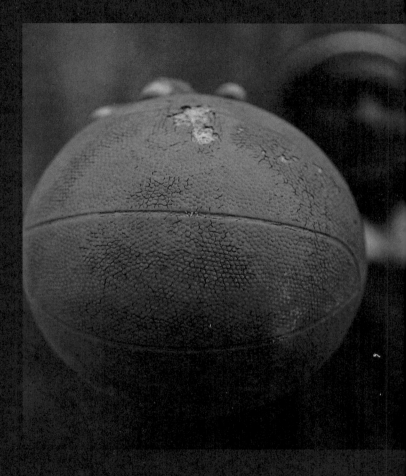

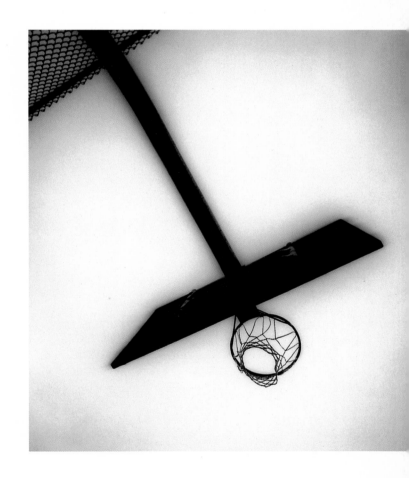

SOUL OF

Images & Voices of Street Basketball

THE GAME

Photography by John Huet
Poetry Compilation and Text by Jimmy Smith
Design and Art Direction by John C Jay

Melcher Media/Workman Publishing
New York

The best things you see in pro ball today were invented 25 years ago in the schoolyards of Harlem. And that's still where it's done best.

All the best moves of tomorrow are being invented today by some unknown kid in Philly, Chicago, Atlanta or you name it. Razzle and dazzle, creation and devastation—these are what the street brings to the game. When a player does a sandlot move in a pro game situation, you know he's for real, not the other way around. It's on the street that players earn their places in the hearts of the people. Where Earl Monroe became Black Jesus. Where Joe Hammond became the Destroyer.

I've seen the game played on playgrounds in ways I'll never forget. In ways that took my mind somewhere it had never been before. On the playground, legends are born, and you'll never forget what you see a legend do because you will never see anybody repeat it in quite the same way.

A finger roll by Connie Hawkins after he floats in from the foul line?

How about Jackie Jackson, New York's greatest leaper? This man had incredible springs. His hang time was unbelievable—don't check your watch, check your beeper. Imagine yourself trying to score points when you're laying up against a human astronaut. How're you not going

to get your shot blocked? I remember first seeing him play at 129th Street and Seventh Avenue. I was a high school freshman, watching through the fence. He was playing on his Brooklyn team with Connie Hawkins against Wilt Chamberlain, the 7-foot-1 Big Dipper, whom many consider the best big man ever to play the game. Wilt was shooting hooks that day. And Jackie would go up with him and block them. Not just block them, but catch them in midair. Jackie cuffed the ball under his arm and took it away. The impact and intensity from the crowd—you wouldn't believe it.

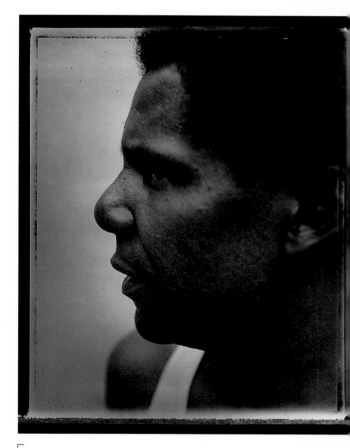

Playground legend Pee Wee Kirkland.

After the game was over, the crowd wouldn't leave. People started shouting, "Take it off the top, Jackie! Take it off the top!" I had no idea what they were talking about. Somebody brought out a ladder and put a 50-cent piece on top of the backboard. And Jackie jumped into the air and took the coin down. It shocked me. Here was a man who would spend 13 years with the Harlem Globetrotters and never play a minute in the NBA. I was amazed.

I guess that's what being a legend is: creating an indelible, lifelong impression in the minds of the crowd, like Jackie did to me. Excelling

as a professional basketball player, even being in the Hall of Fame, don't make you a street legend. The difference is that a guy on the street will not be considered a legend unless he has something about his game that's phenomenal. If he's a scorer, that means he cannot be stopped. If he's a jump shooter, he has to shoot 90 percent under pressure. If he can trick people, then that means he gotta have a bag of tricks, like St. Nick. If he's a rebounder, then he can't win and have thin skin. He gotta be tough.

When you see a guy playing in the NBA, everybody knows it's sort of restricted. A guy may come down the court, put the ball behind his back and pass, and everybody goes crazy. That's not acceptable in street basketball. When a guy come down the court, he has to go behind his back twice, flip it through his legs and throw a blind pass for an alley-oop yoke. Then the crowd is in an uproar.

In my day, the Rucker Pro Tournament in Harlem was the proving ground. I played at Rucker against teams with two or three NBA players. I played against some of the all-time greats, Wilt, Pearl, Julius. The pros played in the NBA for salary; they played in Rucker to prove they were for real. You could talk about it all year long, but it didn't mean anything until you had done it at Rucker. The streets were crowded for five blocks. People would watch from the highway overpass; people would hang from trees. Some would use binoculars to watch from the projects.

In the fourth quarter, when we was putting that showtime down so heavy, the crowd would be sitting in the stands trying to avoid going to the bathroom. Addicts be sittin' there, forget they had habits. When the game was over, people didn't know where they parked their cars. And the most amazing thing was, there were no police. There were never any problems, because people had too much respect for the game.

That's the legacy of the playground, where heart, hustle and pride rule the day. For some it's a place of refuge. For others, a place of challenge. For all, a place of hope. To the sports world, basketball is a multimillion-dollar business. To the kid on the street, it means a lot more. It's his or her identity. It's his or her reputation and, in too many cases, the final determination of his or her future.

The game of basketball is more loved today than ever. Courtside seats cost thousands of dollars. We have all-defensive teams, the top 50 players ever; every kind of statistic is kept, every outstanding accomplishment recorded. Except one: where the game came from, the playground. The real school of skillz, where every crossover, head fake, three-sixty and reverse crossover is practiced. Where talents are first noticed and success first achieved. It's the arena of goodwill, where the game is played from the heart and the love is there from the start.

—Pee Wee Kirkland
 NYC point guard

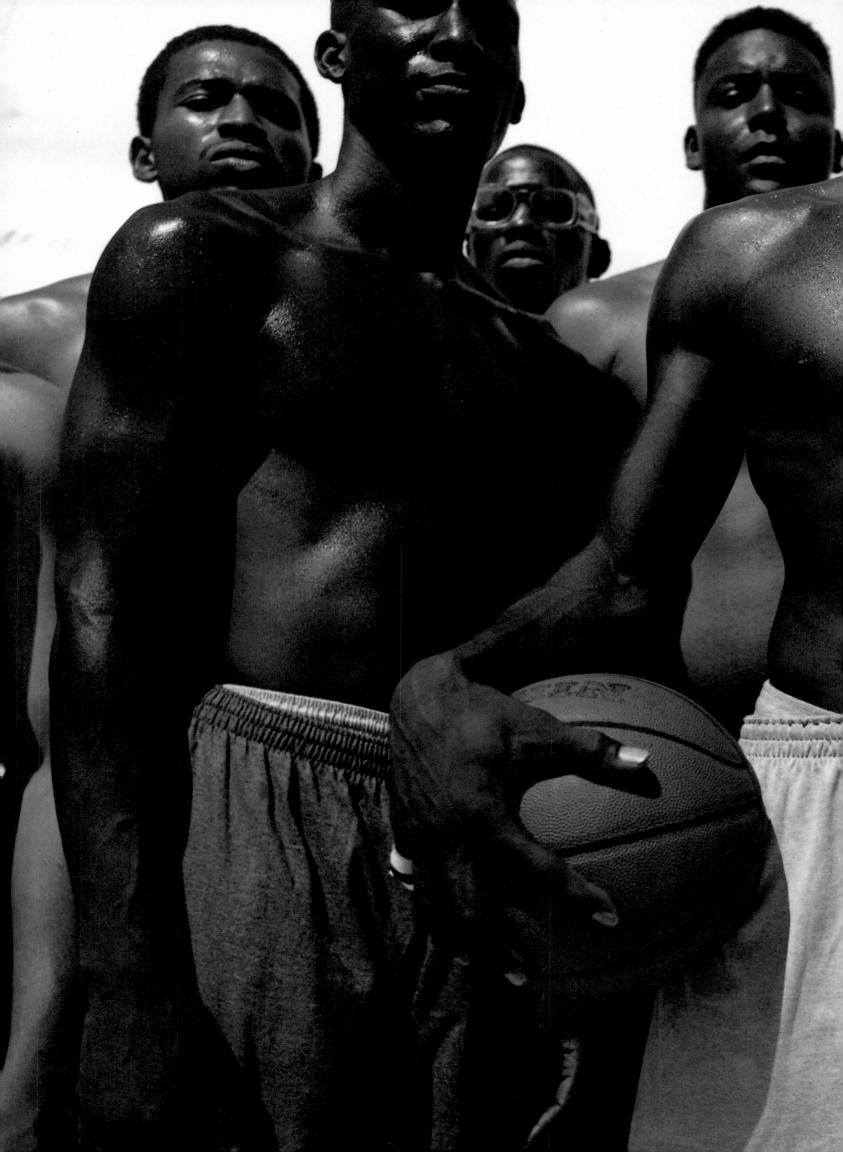

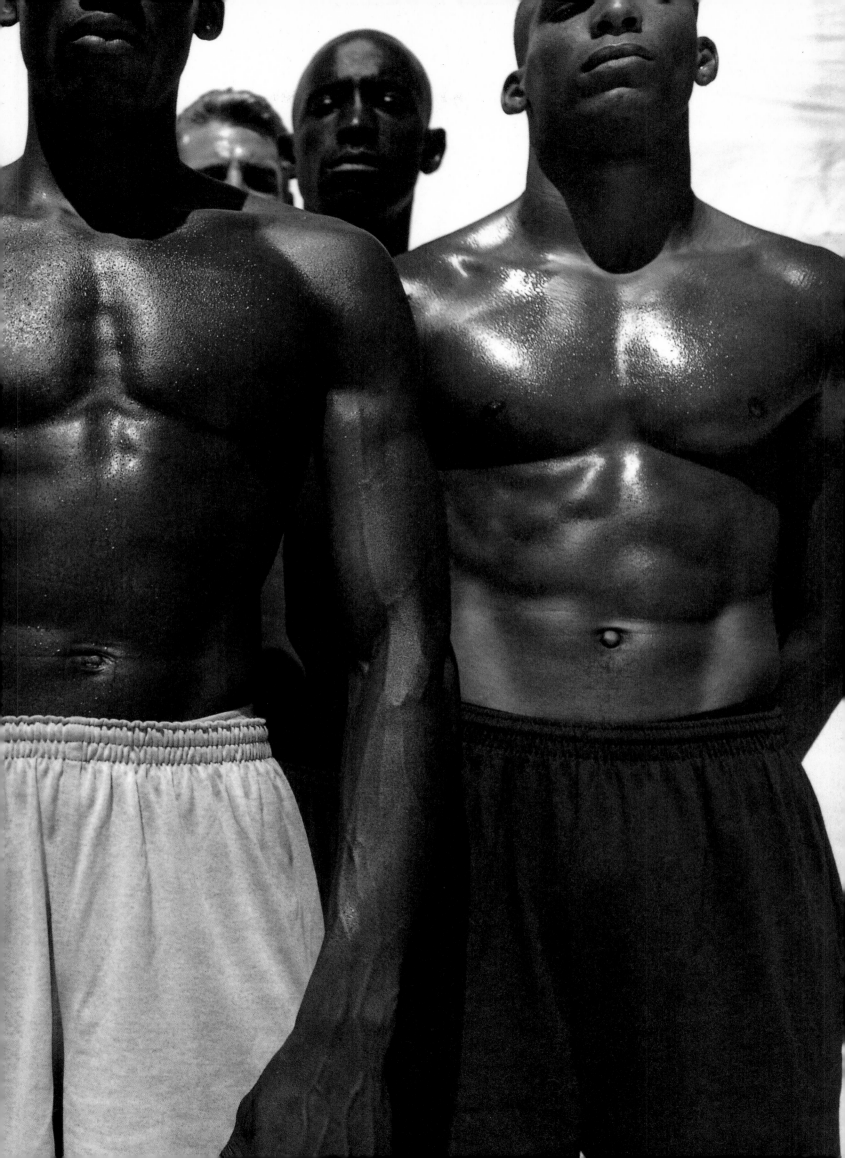

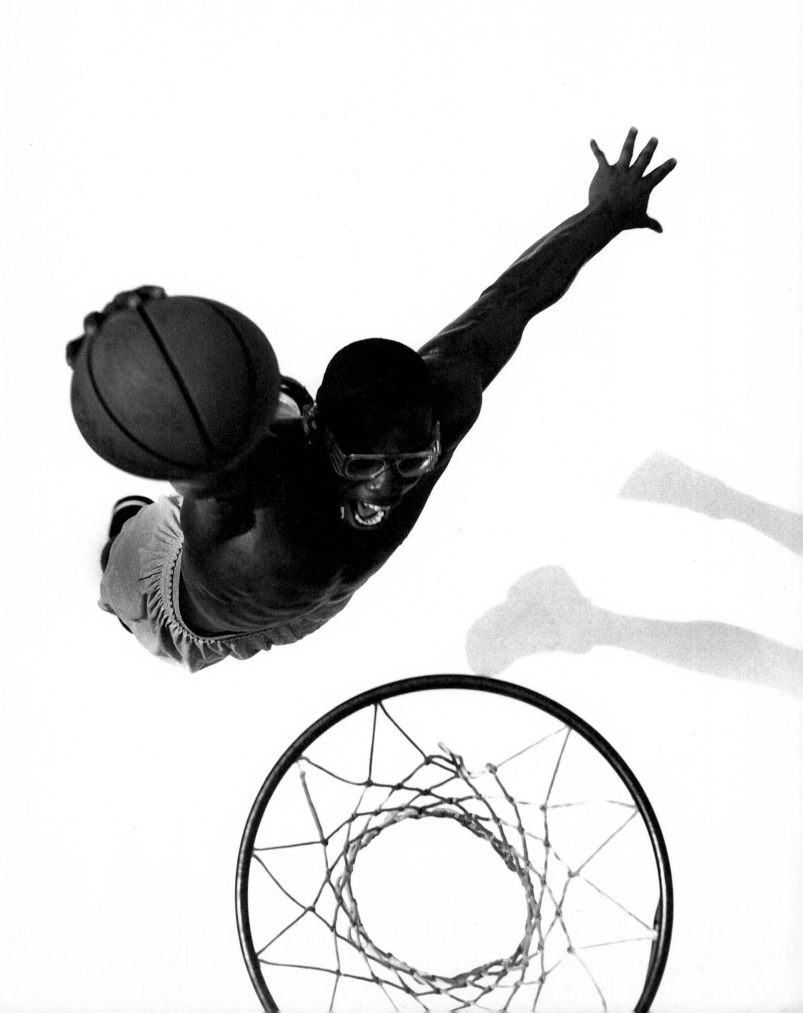

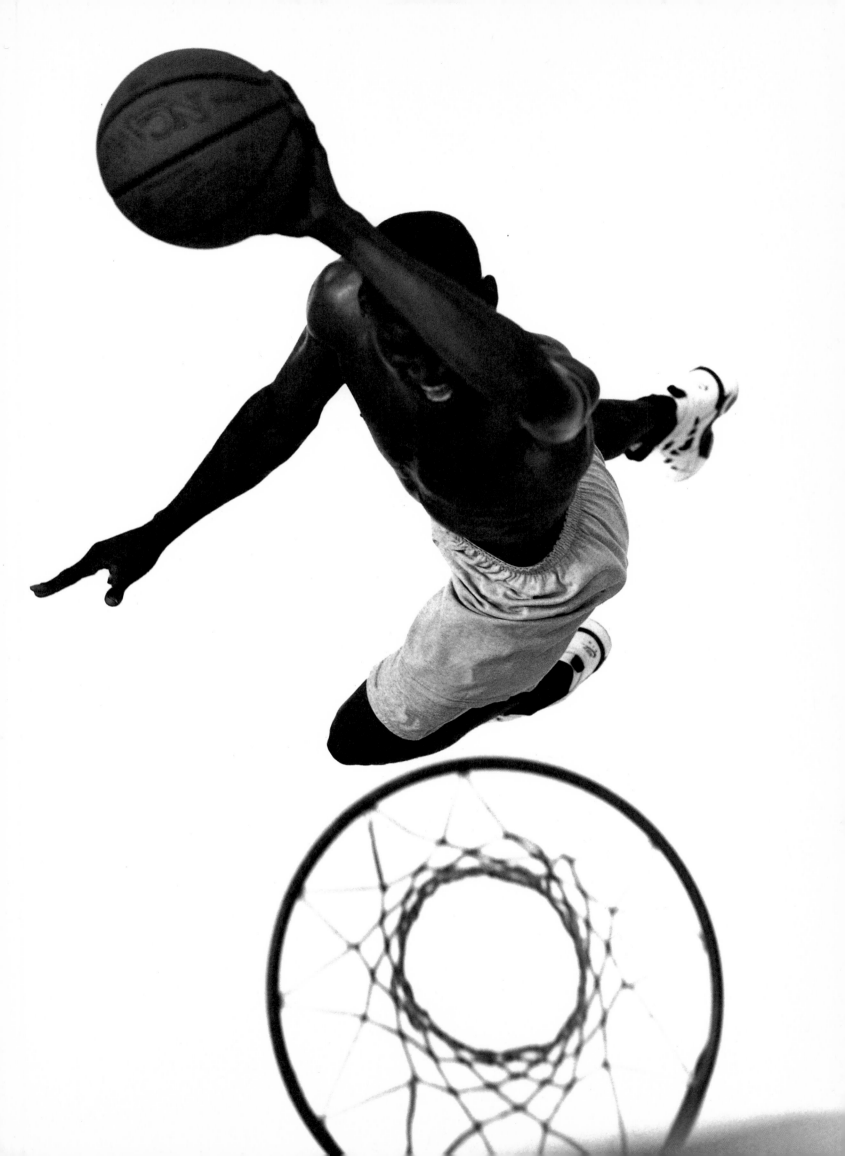

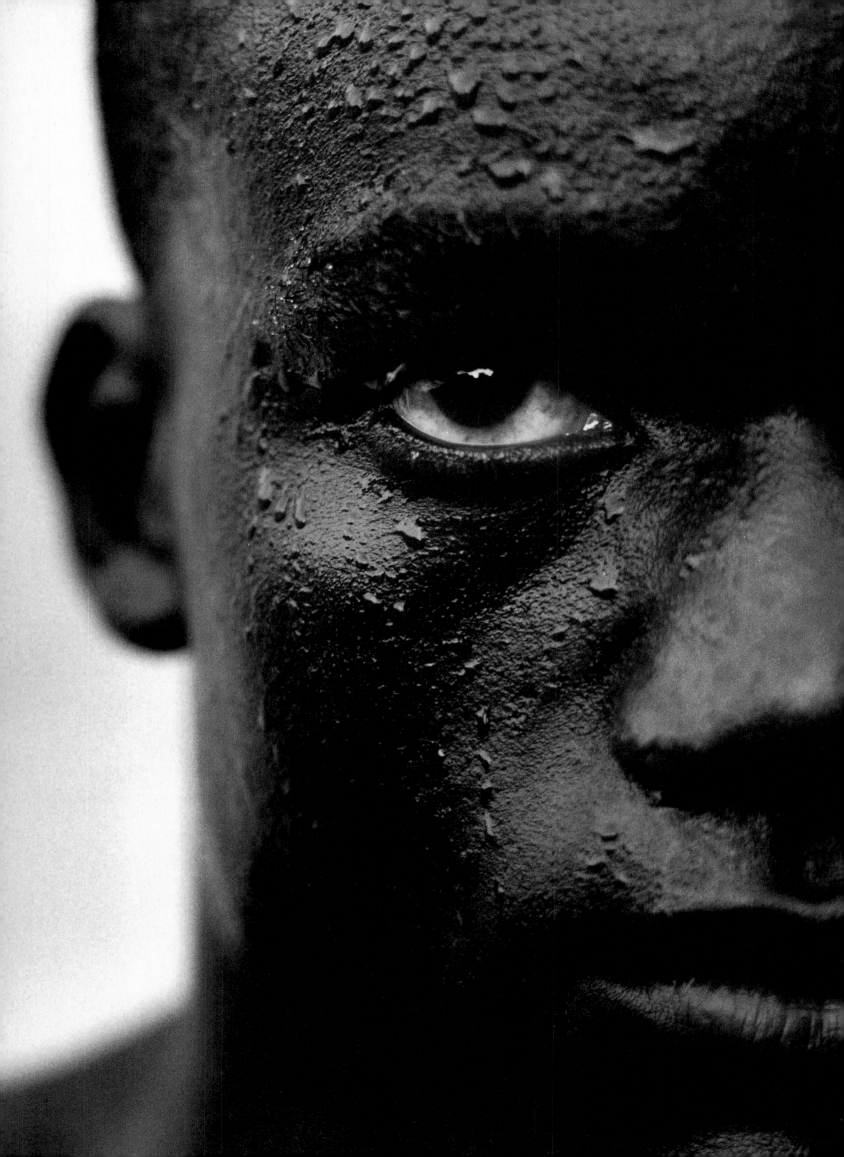

YOU WOULD TOO

by Gregorio Deshawn McDonald

Hoops are the point
as your eyes point toward the rim
I leap
no fly up fast
to slap your shot out the sky.
Now the rock is mine.
And my crossover is sharp-tight.
Left hand commands respect for serious handles
as right hand vandalizes the mind with blinding speed
leaving graffiti across the side of your dome
as I spin quick past you
blast-off to the rim and slam it home:
leaving your behind, behind
wondering if it's my shoes
My cool dark complexion exudes a spectator blues
as you attempt to play D.

Check ball G
here I come again.
Quick half-spin left
bring it back right
stop pop a J for three ...
Money!
Why you challenged me
I'll never know
but this is my show
and I play the way I do because I can
and if you could
you would too.

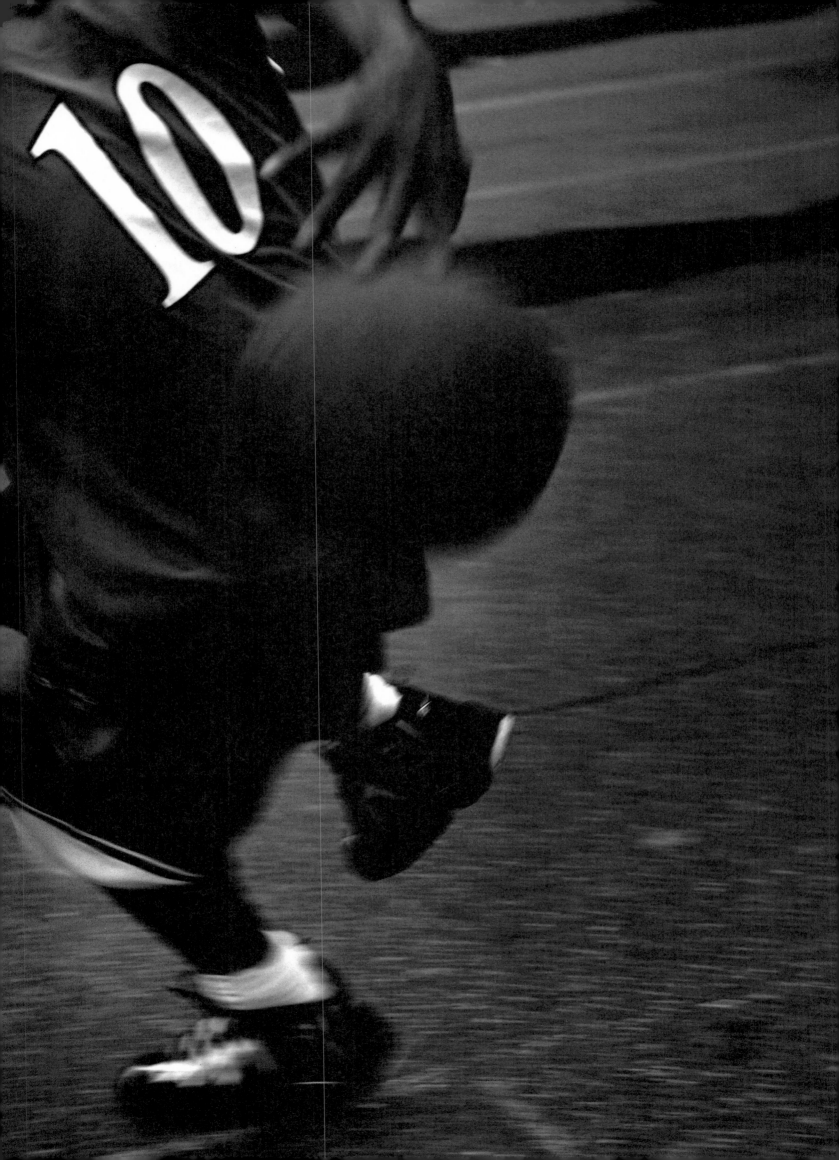

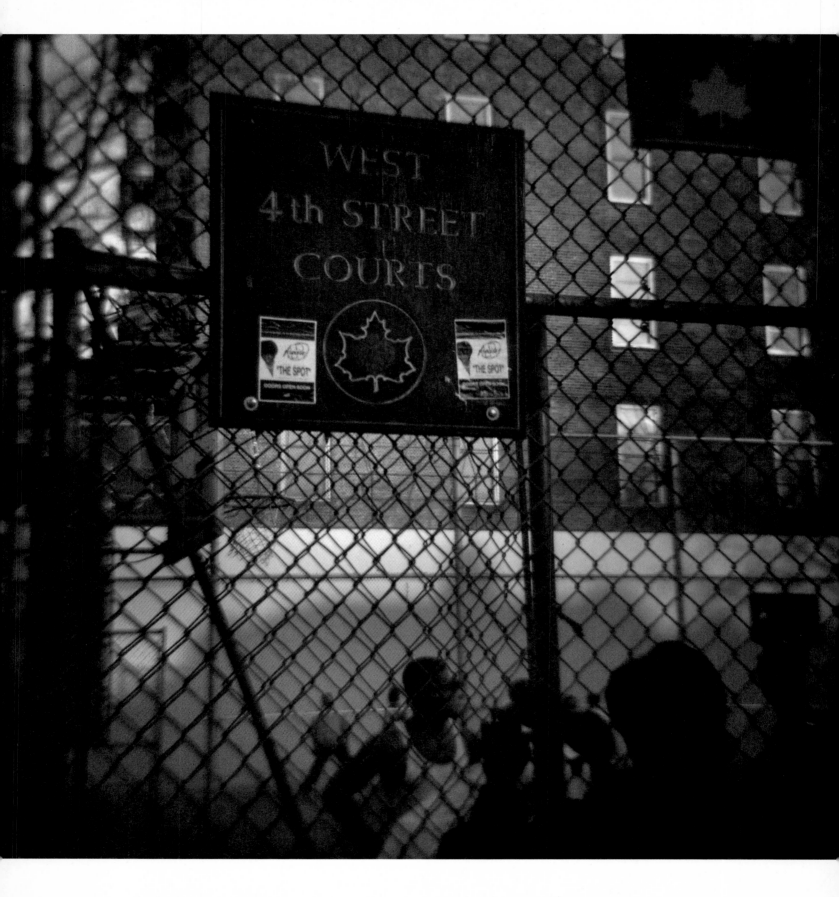

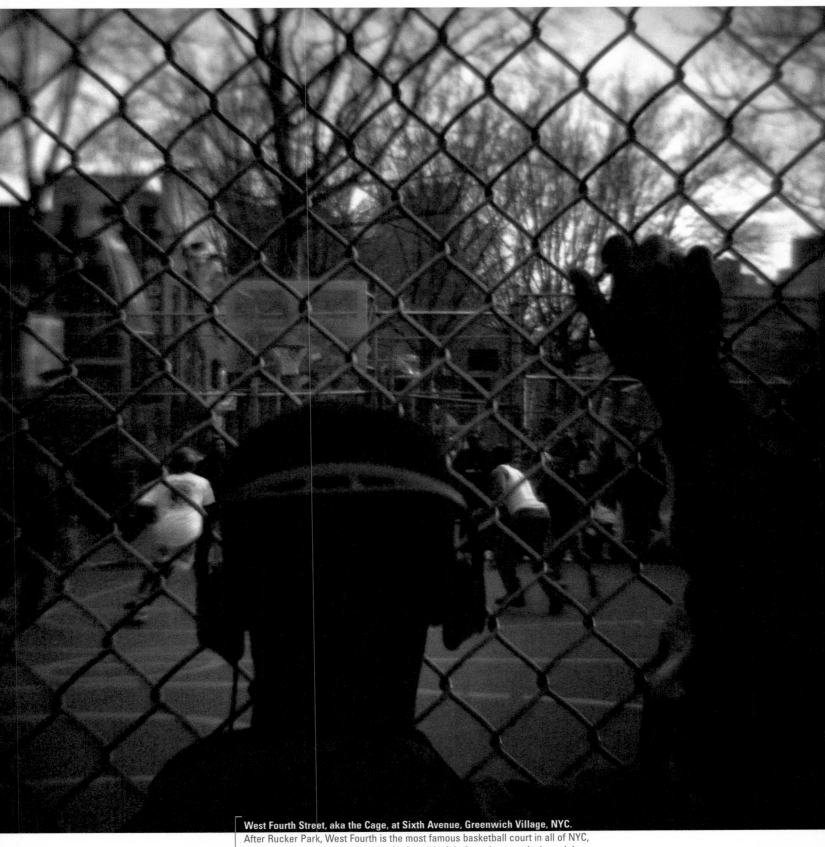

West Fourth Street, aka the Cage, at Sixth Avenue, Greenwich Village, NYC.
After Rucker Park, West Fourth is the most famous basketball court in all of NYC,
which is rather amazing, since it's far from ideal. In fact, the court is downright
substandard. It's probably half regulation size (two dribbles and you're across half
court); it's slanted, and the concrete is cracked. But this doesn't stop the city's most
outstanding players from flocking to the Cage's annual summer tournaments.

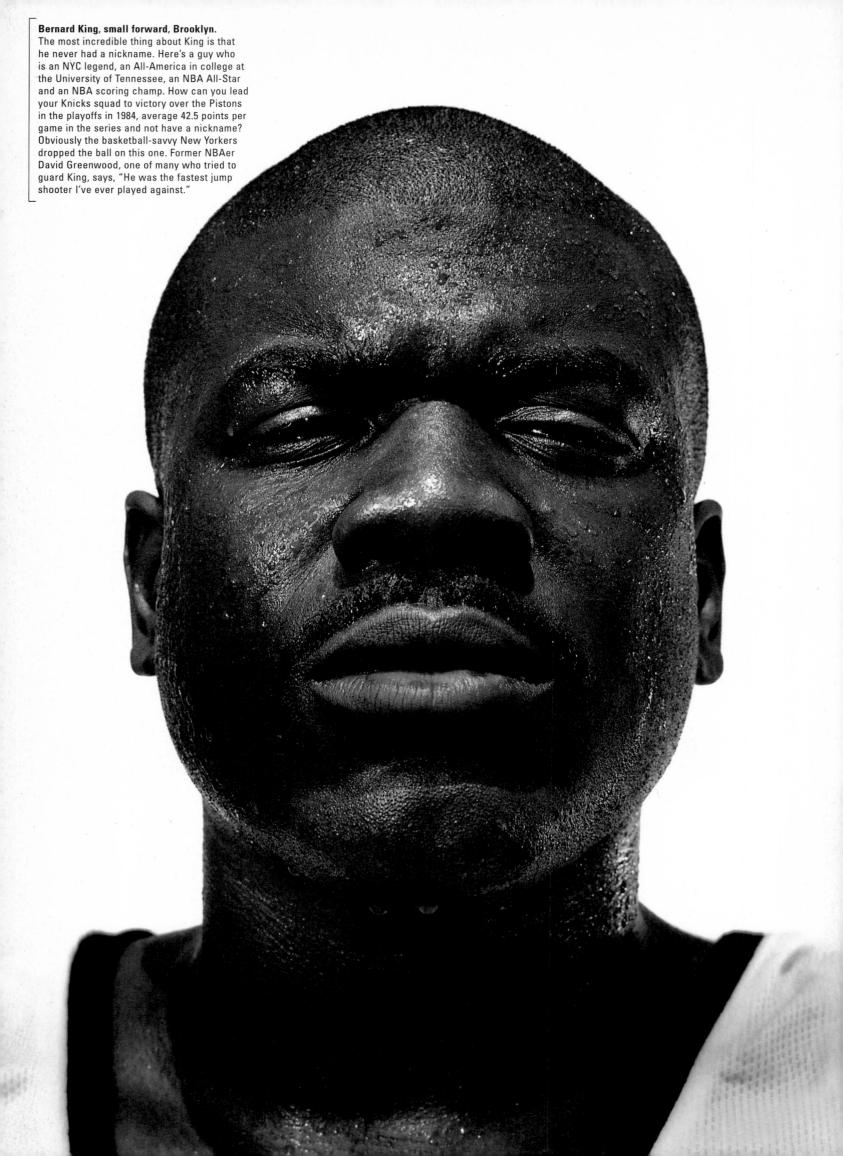

Bernard King, small forward, Brooklyn.
The most incredible thing about King is that he never had a nickname. Here's a guy who is an NYC legend, an All-America in college at the University of Tennessee, an NBA All-Star and an NBA scoring champ. How can you lead your Knicks squad to victory over the Pistons in the playoffs in 1984, average 42.5 points per game in the series and not have a nickname? Obviously the basketball-savvy New Yorkers dropped the ball on this one. Former NBAer David Greenwood, one of many who tried to guard King, says, "He was the fastest jump shooter I've ever played against."

GOOD TO BE KING
by Gerald Quickley

Brooklyn in the House
time for the brothers
to work it on out

Fort Greene
long prior to buppy scene
the concrete was being run by King

one-on-one arias
that would sing

Patented spinning baseline facials
left them screaming for help from the maid
yelling Hazel! Hazel!

Bernard marched down Shore Road
to Fort Hamilton and got
40-inch hops
left them as frozen as if
Simon Bar Sinister said
Stop Underdog Stop

Did his college time in Tennessee
and offered up Division I beat downs
like Mush Mouse and
Pumpkin Puss in 3-D

Yes it's good to be King
The Garden rocked
as we watched 30-point
A-Team averages sing

Detroit tried and couldn't stop him
42.5 playoff average
knocked dropped and got them

Where could he possibly
have learned
that crazy baseline technique

Running the concrete
in Fort Greene
Oh yes it's good to be King

On those same streets
new players move to
new jack new style
seven eight offbeats

Creating innovations on Bernard's thing
Oh yes my man you did fine work
It's good to be King

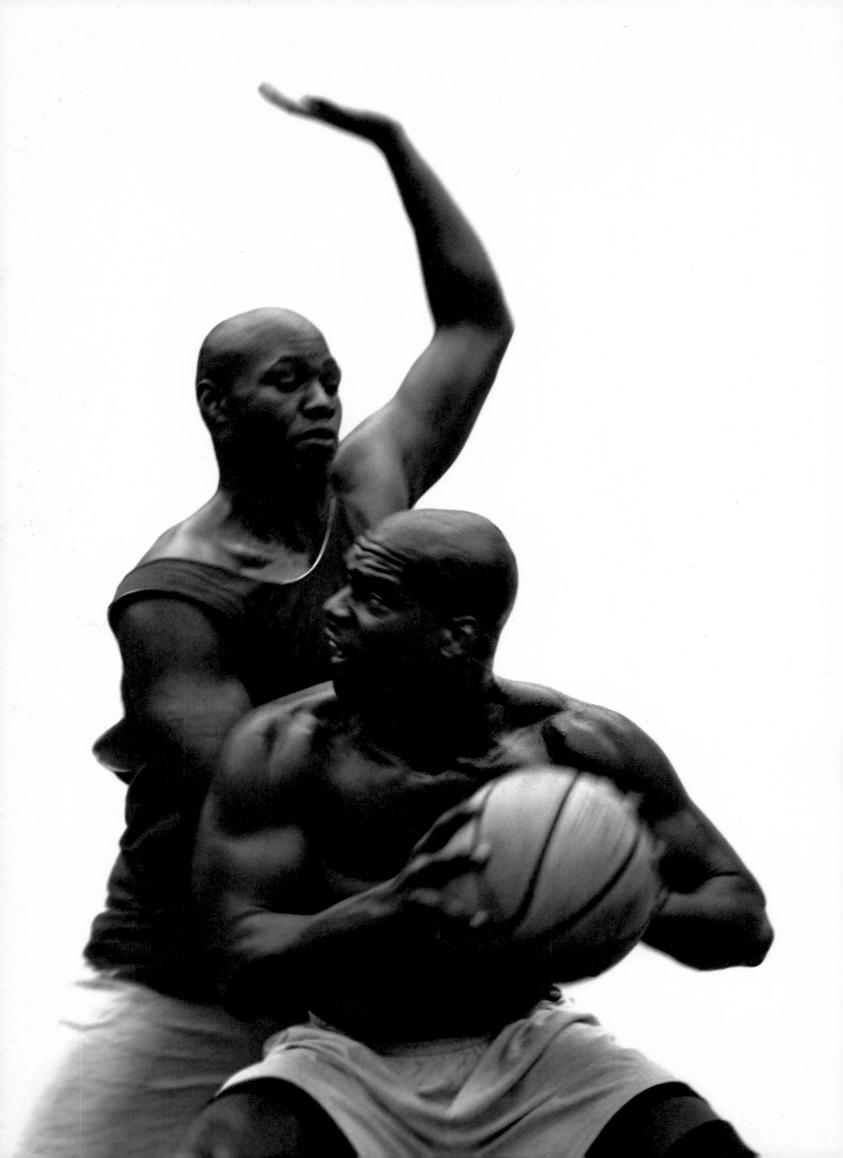

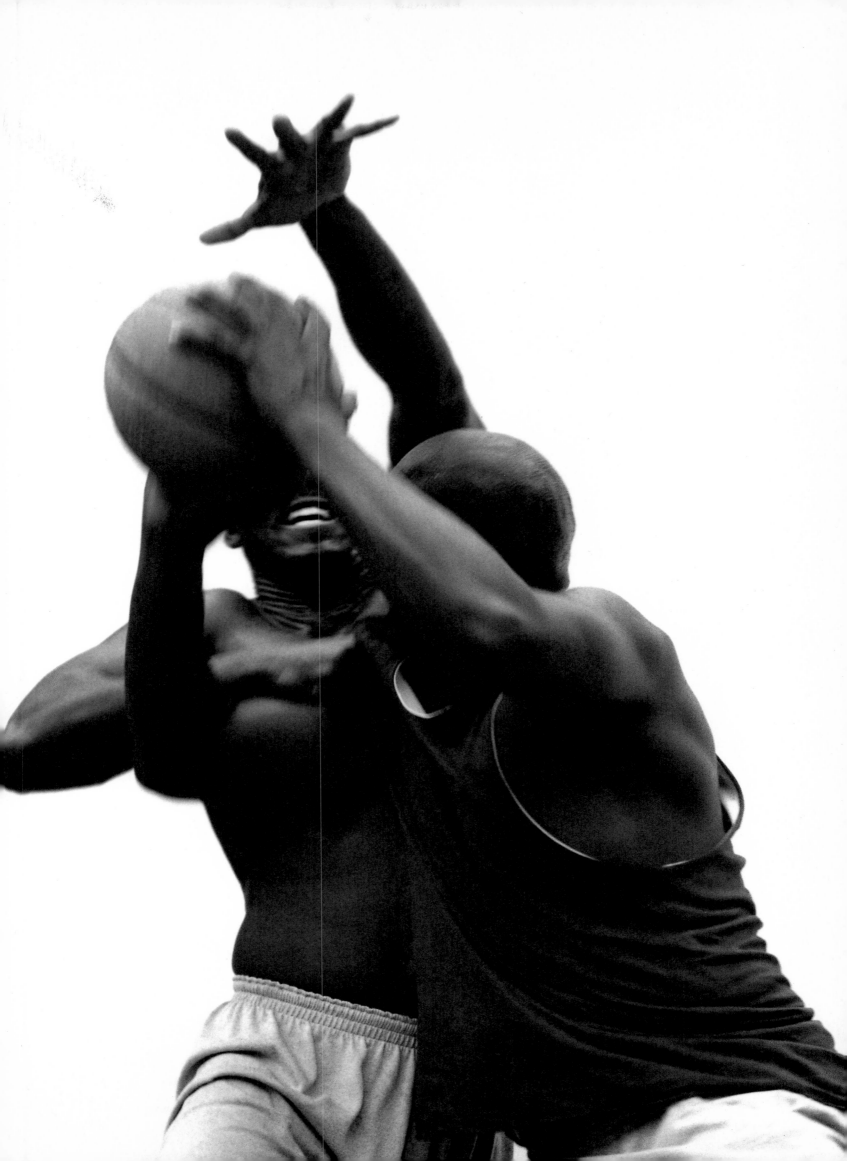

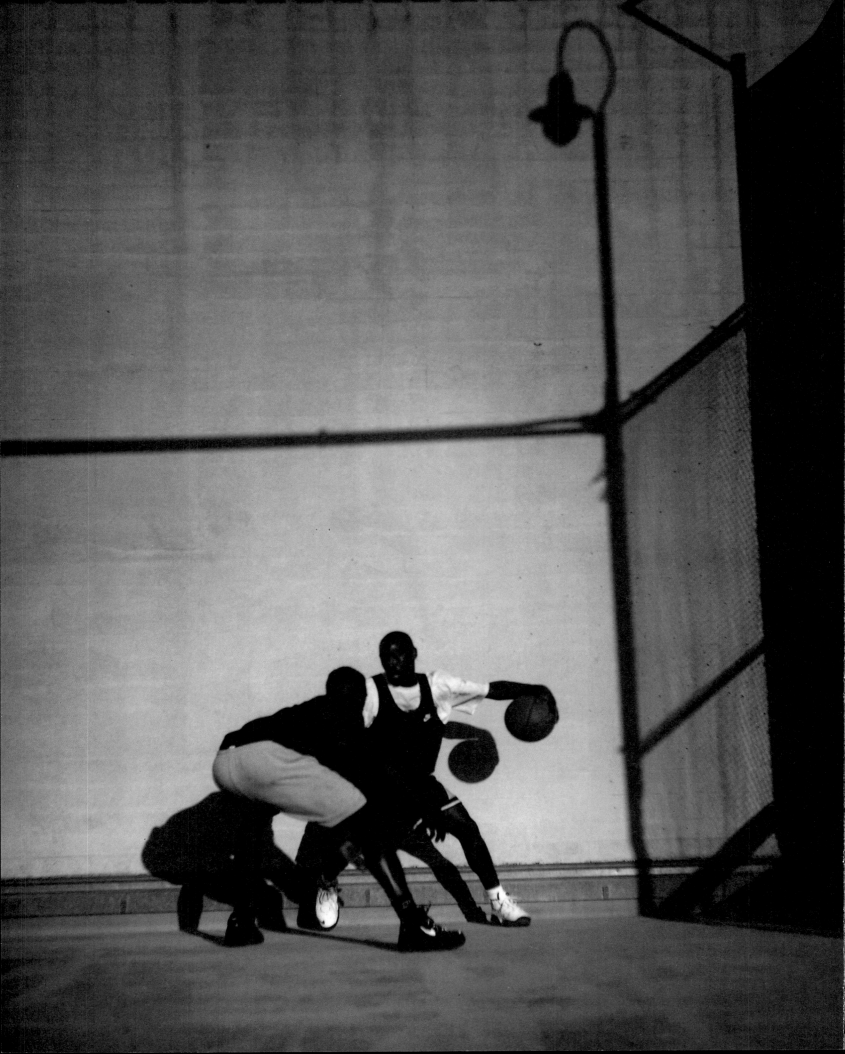

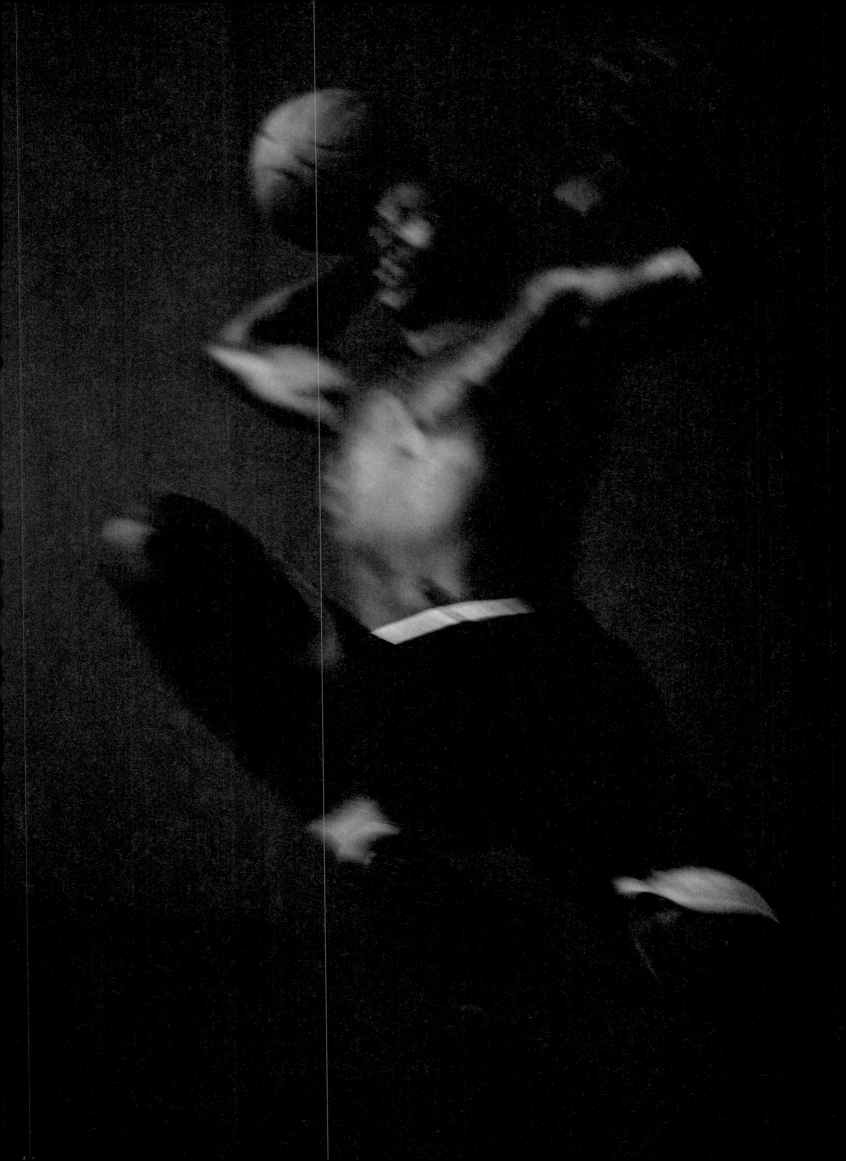

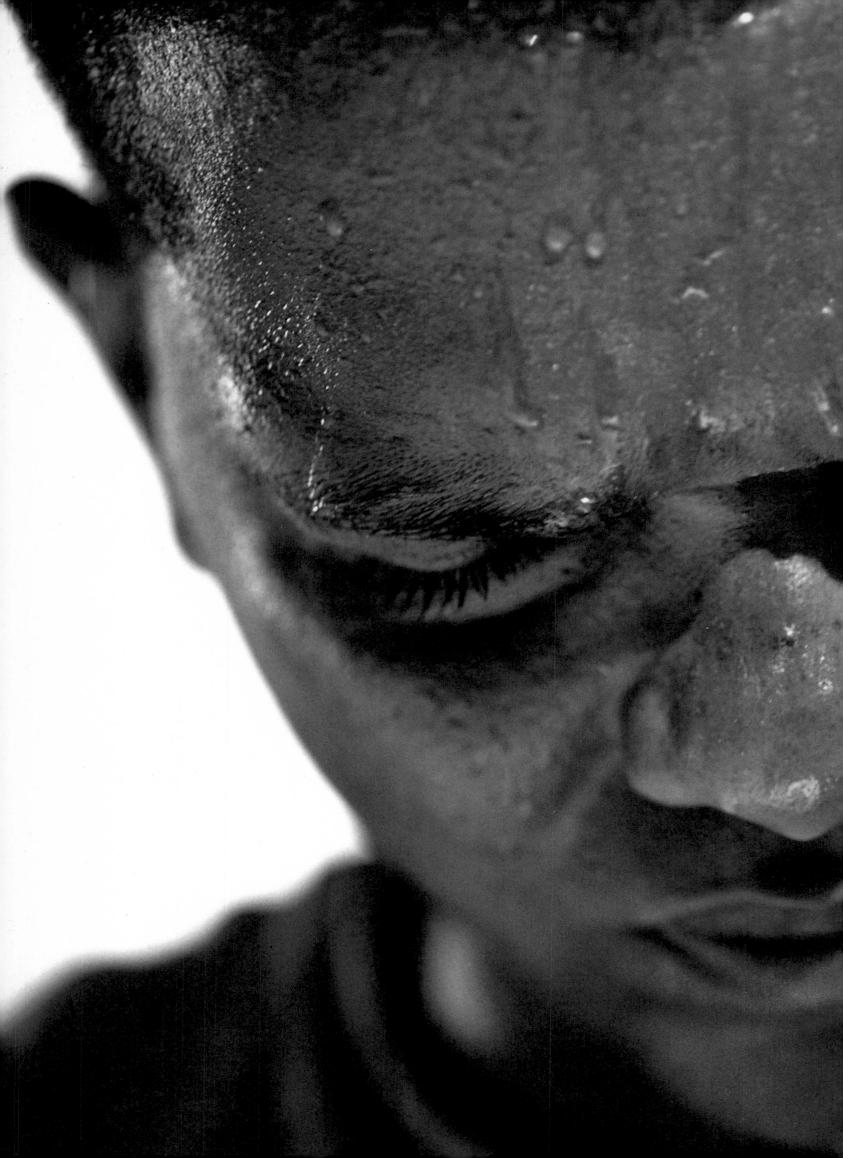

Marques Johnson

Small forward, Los Angeles.

Johnson will always be remembered as the guy who helped bring University of California at Los Angeles's coach John Wooden his last championship, in 1975. Johnson will also be remembered for the spectacular way in which he reintroduced the dunk to college basketball. When the NCAA reinstated the dunk for the 1976–77 season, Johnson led the nation with 72 slams and received the first John Wooden Award (named after his retired coach and given to the best college player in the U.S.).

"I used to work out in the summer with a good friend of mine, Malik Abdul-Mansour," Johnson says. "He came up to me and said, 'Dunk the ball.' I was like, 'What?' He said, 'The key for you this year is dunking the basketball.' I said, 'What you talkin' about?' He said, 'Hey, the dunk's back in. People ain't seen it in college for 10 years. You get out there and do some deep dunks. Everything else'll fall into place.' So we worked on that all summer long. I owe a lot to Malik as far as winning Player of the Year."

Johnson became a five-time NBA All-Star, spending his most productive years with the Milwaukee Bucks, where he averaged 20.8 points per game.

"We had guys that trash-talked in the '70s," he says. "But it was more good-natured. I never really got into it. I always wanted to act like whatever I had done—either dunk on a guy or block a shot—wasn't gonna be the last of it. It's just starting, you know. It's nothing out of the normal. This is just the way we gonna be playin' today. You gonna be shootin', I'm gonna be blocking it. I'm gonna be jumping and dunking on you. That's just the way it is. It isn't anything to talk about."

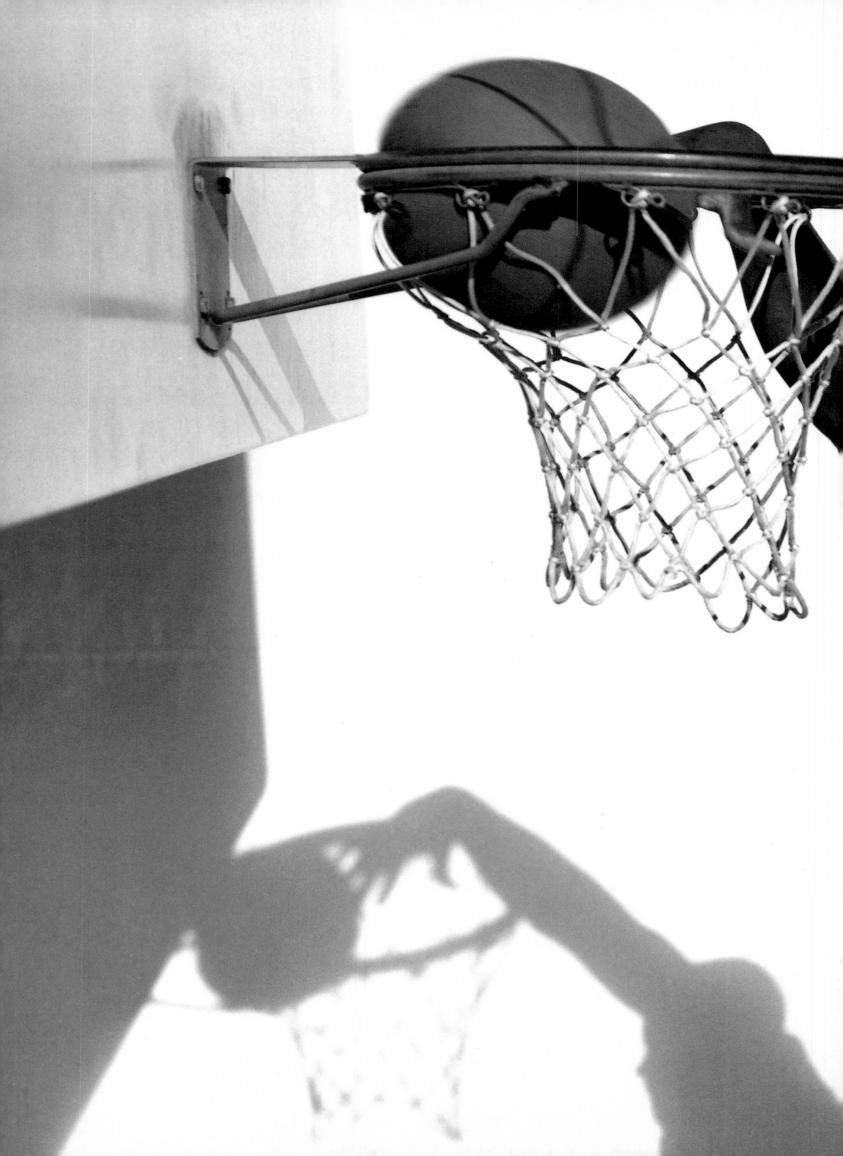

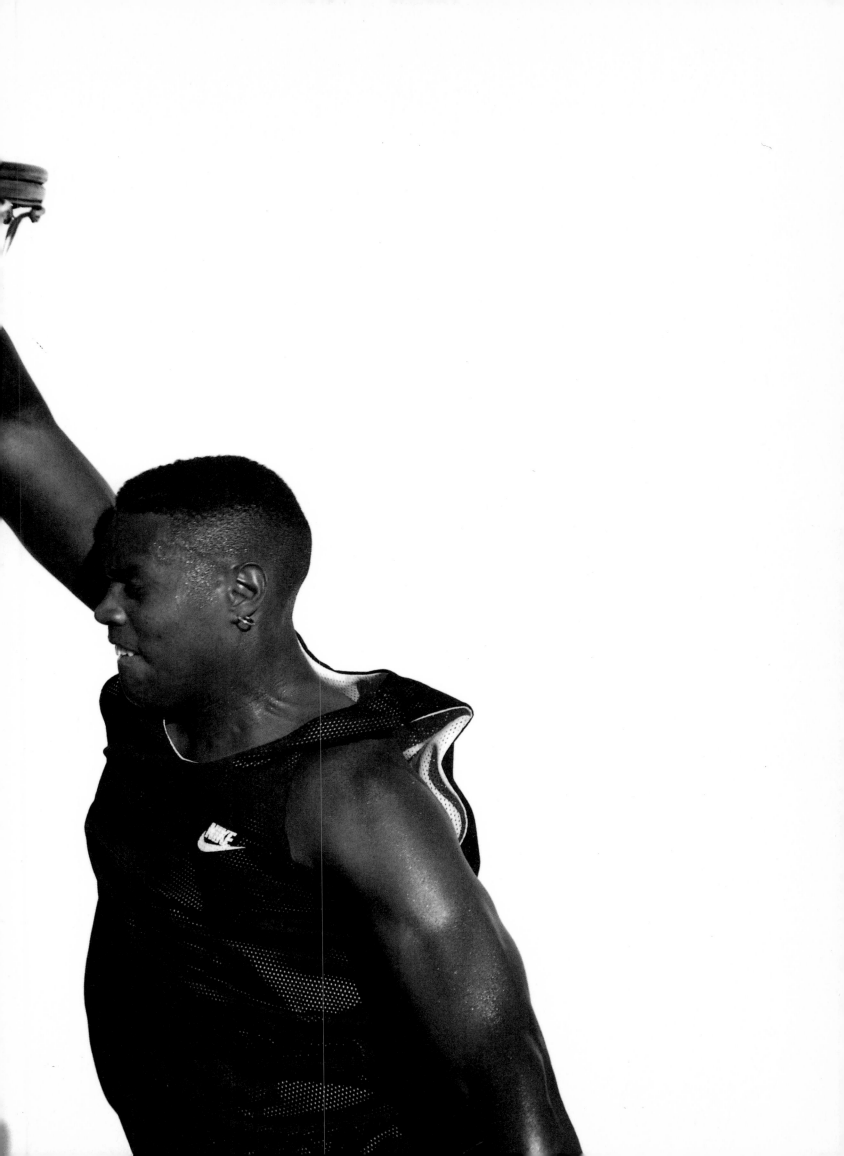

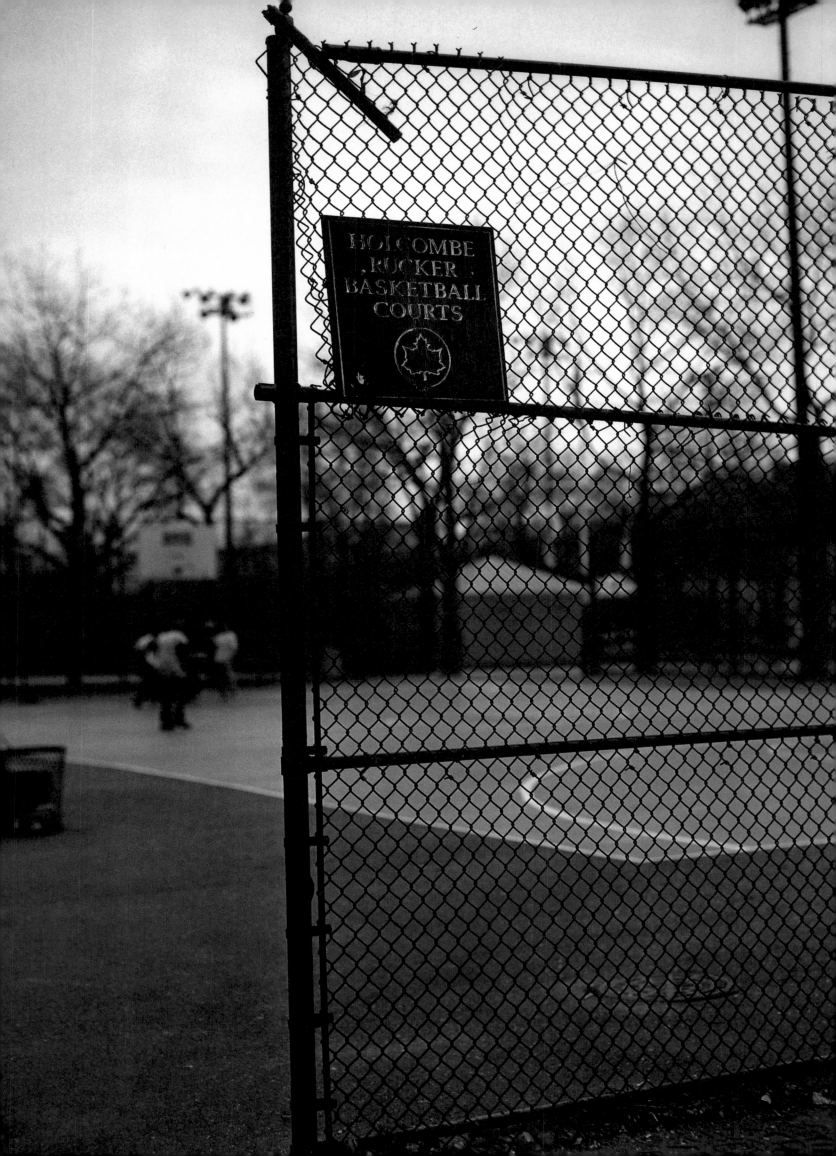

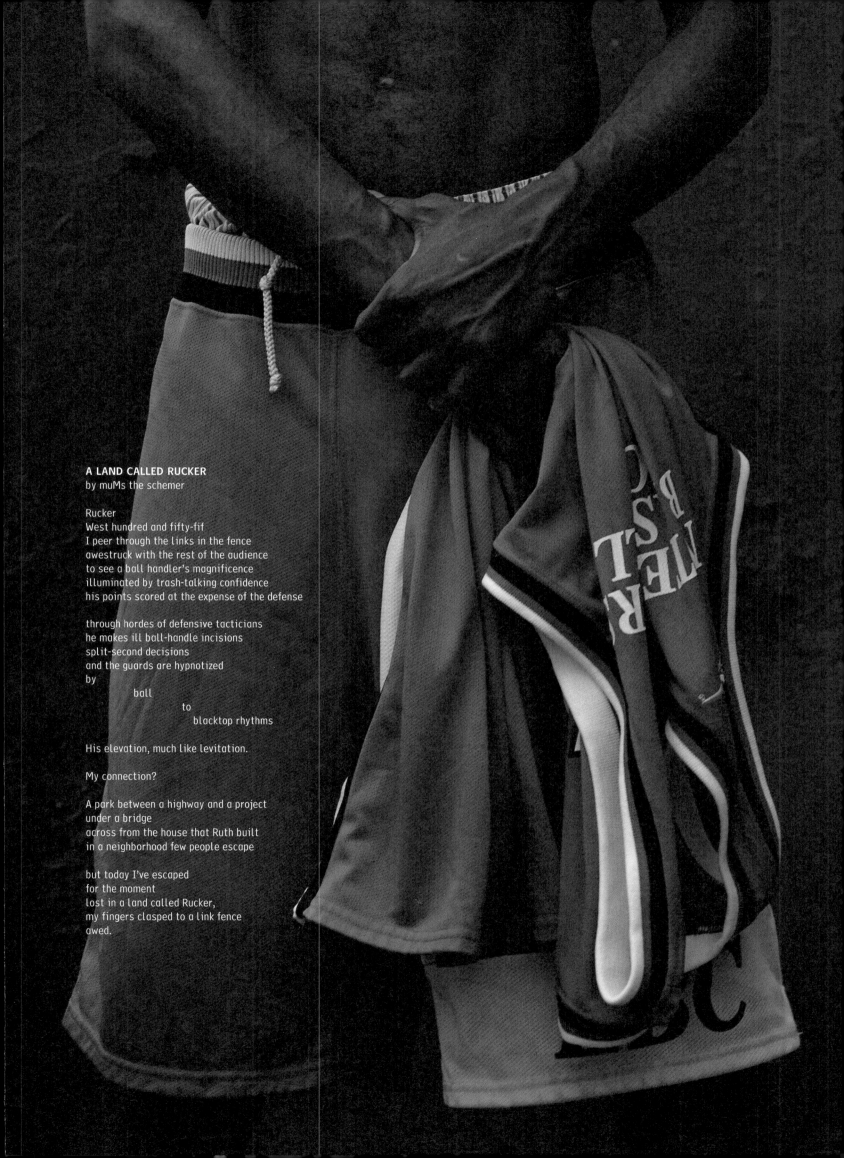

A LAND CALLED RUCKER
by muMs the schemer

Rucker
West hundred and fifty-fif
I peer through the links in the fence
awestruck with the rest of the audience
to see a ball handler's magnificence
illuminated by trash-talking confidence
his points scored at the expense of the defense

through hordes of defensive tacticians
he makes ill ball-handle incisions
split-second decisions
and the guards are hypnotized
by
 ball
 to
 blacktop rhythms

His elevation, much like levitation.

My connection?

A park between a highway and a project
under a bridge
across from the house that Ruth built
in a neighborhood few people escape

but today I've escaped
for the moment
lost in a land called Rucker,
my fingers clasped to a link fence
awed.

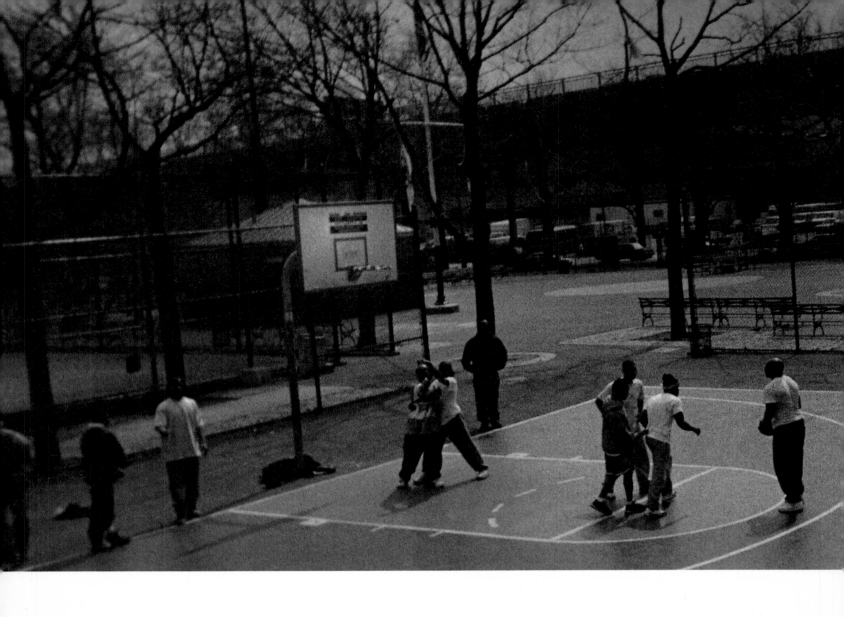

Holcombe Rucker Park, aka One Five Five, 155th Street and Frederick Douglass Boulevard, Harlem, NYC.

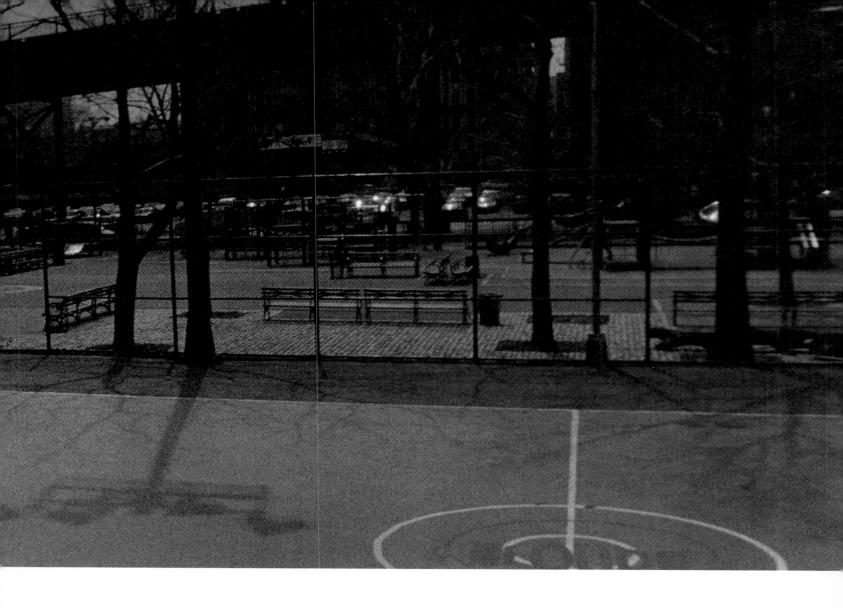

Harlem's Holcombe Rucker Park was named in honor of
a man who established the most legendary basketball
tournament in history. Up until his death in 1965 at age
38, Rucker was a teacher, coach and father figure to
many of the city's greatest players. Seeing how crime
and drugs were corrupting Harlem's youth, he started
an annual summer tournament in 1950 to keep kids off
the streets. His tournament soon blossomed to include
leagues for grade-schoolers, junior high and high
schoolers, and college-age kids, as well as pros.

Originally run at a park at 130th Street and 7th Avenue,
the Rucker Tournament had moved by the late '60s to its
now-famous court across the street from the Polo
Grounds Towers housing project. Formerly site of the
New York Giants' Polo Grounds baseball stadium and
across the Harlem River from Yankee Stadium, this
park is hallowed ground in the sports world.

Rucker's pro tournament was a magical event in
its heyday, a place where NBA players like Wilt
Chamberlain, Kareem Abdul-Jabbar, Connie Hawkins,
Tiny Archibald, Julius Erving and Earl Monroe battled
streetball legends like Joe "the Destroyer" Hammond,
Richard "Pee Wee" Kirkland, "Jumpin'" Jackie
Jackson, Frank "Shake and Bake" Streety, Herman
"Helicopter" Knowings and Pablo Robertson. Though
the pro tournament was discontinued more than
a decade ago, its spirit lives on in the Entertainer's
Basketball Classic, where young stars like Stephon
Marbury, Joe Smith and Kevin Garnett have showcased
their skills. Today at Rucker Park, a new generation of
players tries to make impossible plays possible and
ensure its place in the oral history of NYC basketball.

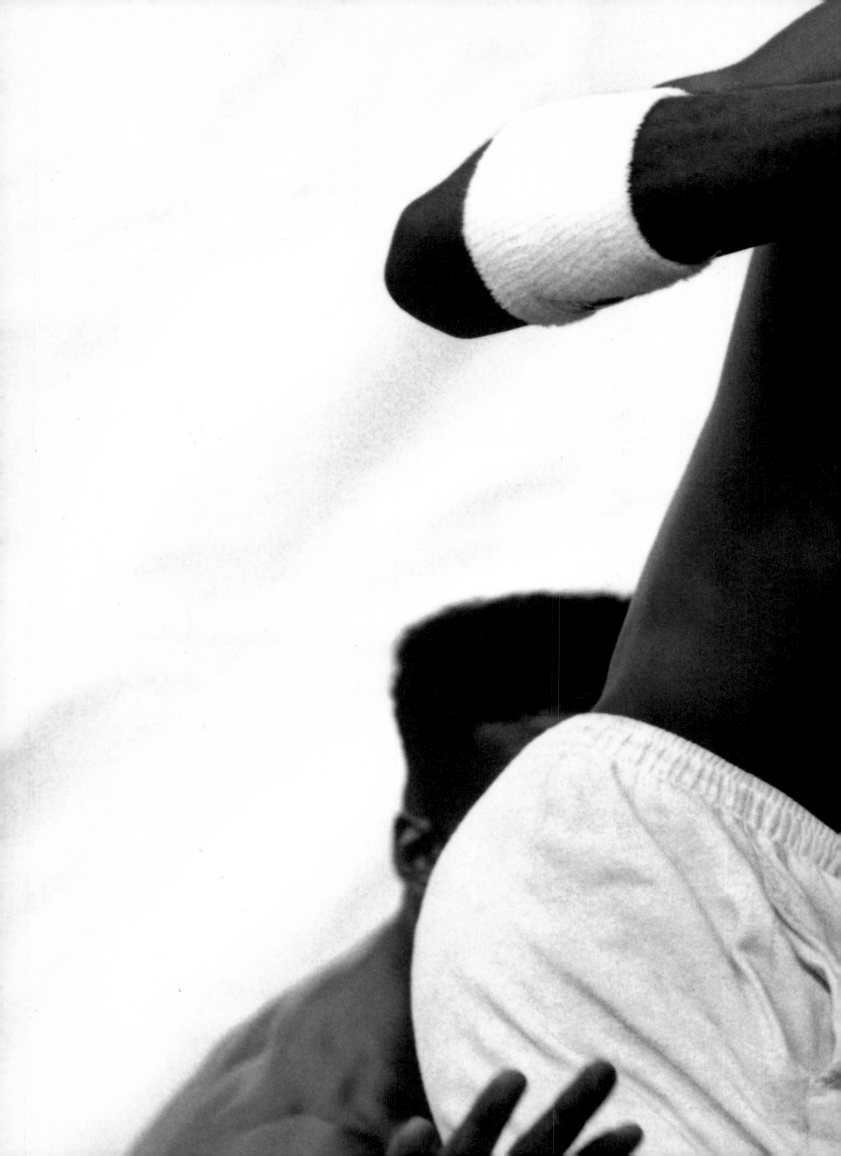

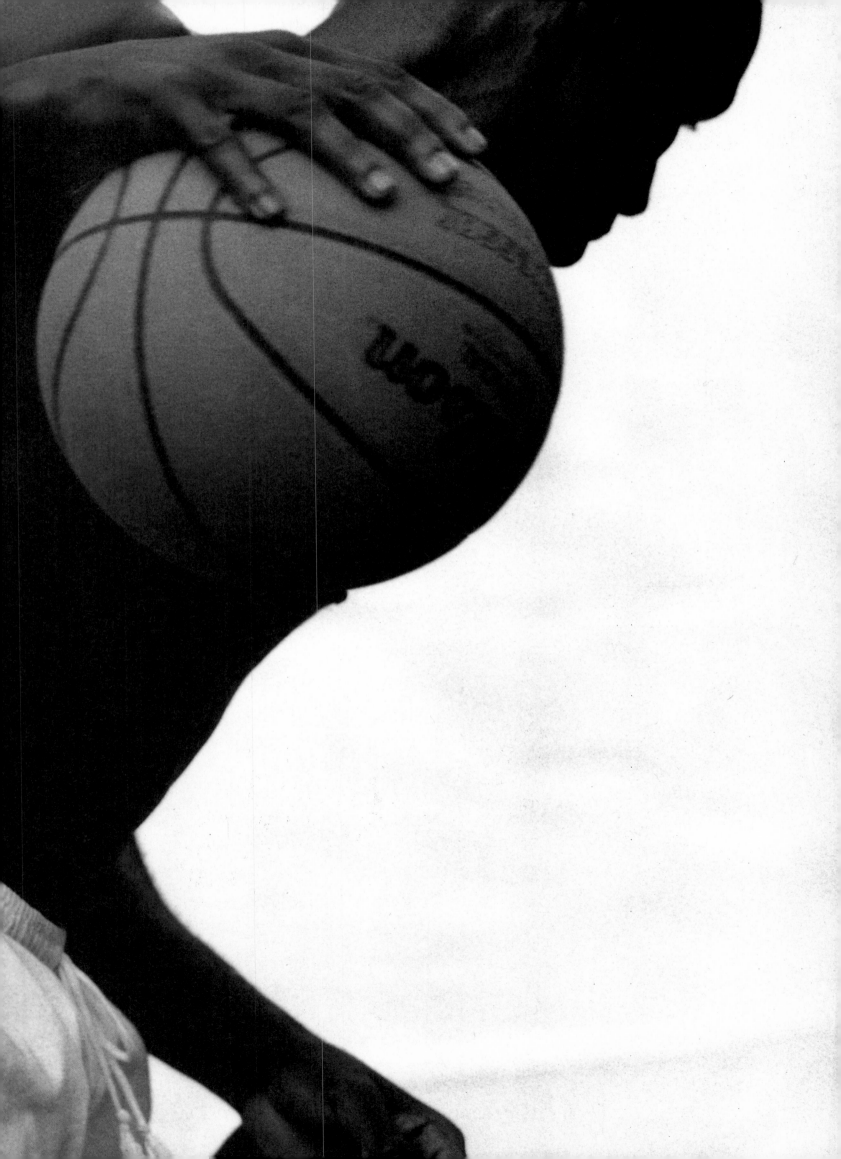

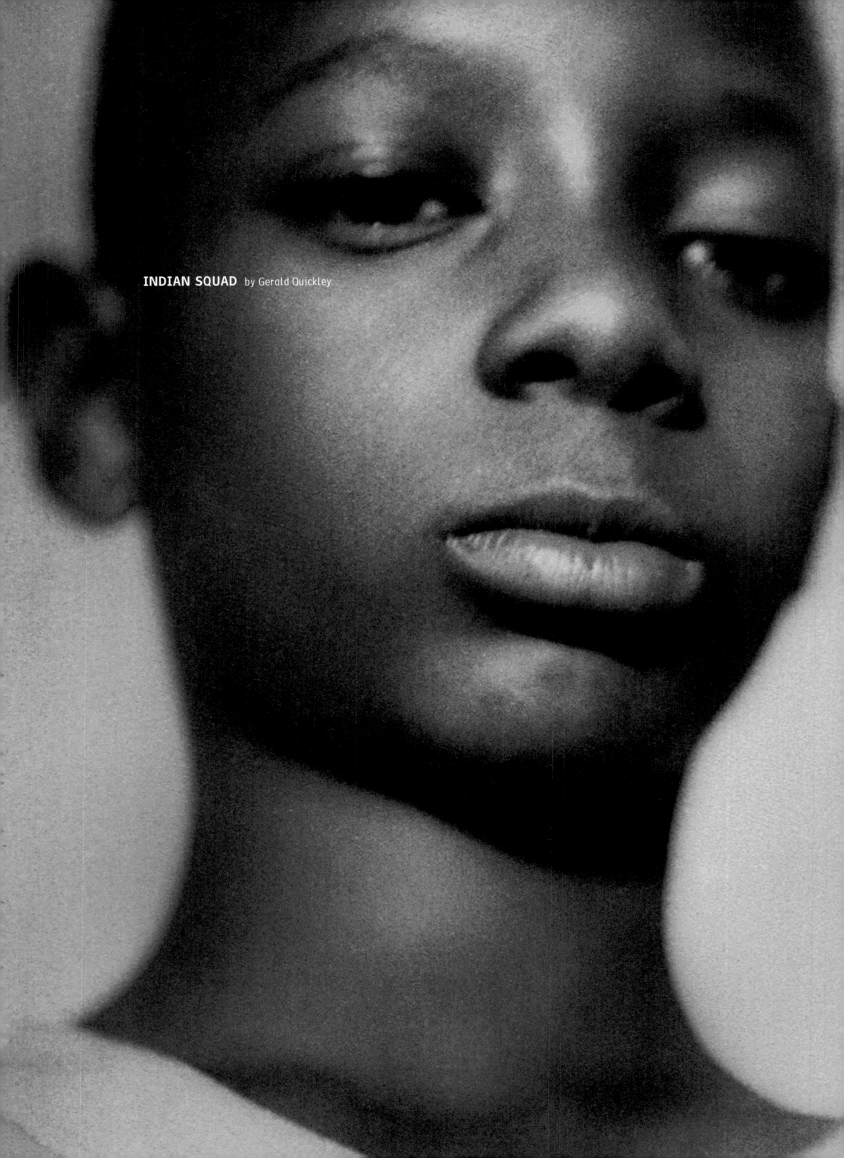

INDIAN SQUAD by Gerald Quickley

Mark, Jerome, Curtis, Thomas 10, 13, 16, 18 and me
They were brothers all separated in age by a couple of years
Mark was my age and in my same fifth grade class

Sometimes the five of us would play full court pick up
on the courts in the Stanley Issacs Projects
When we'd win sometimes they'd call us the Indian Squad

Within a two-year period everyone but Mark
went out the same way Thomas was playing uptown
stabbed through his right kidney He bled to death on the court
in minutes I went to the funeral with Mark

Curtis was next he was ballin' at Christ the King
He got mixed up with a beauty who shone like a coke furnace
and had the habit to prove it her ex-man
just-released and angry man found him at her crib
I went to the funeral with Mark

Jerome was last he got cut playing down in John Jay Park
He was supposed to make it until the city butchers got done with him
he hallucinated spoke in tongues and passed one night
with his sleeping mother holding his hand
We put on our good suits and shoes again

On the walk back to the apartment There was nothing left to say
It was over
The arc lights 90-degree suspensions lit up the sidewalks in sharp pools
And we walked in and out of the light both preferring the dark

Of a like mind we went to the playground and shot a game of h-o-r-s-e
in the dark the game became intense wild one on one
both of us pushing and shoving sliding all over the court with our leather
soles
and not giving an inch scraping and putting holes
in our good polyester and knowing that we had to play
not knowing why sweat-soaked denied battered but not broken
The sharp ping of the ball ricocheting off the buildings
We eventually stopped and promised to continue early the next day

When I got home my stepmother was angry she asked
what happened to my suit I told her I was just playing ball
and I went to bed

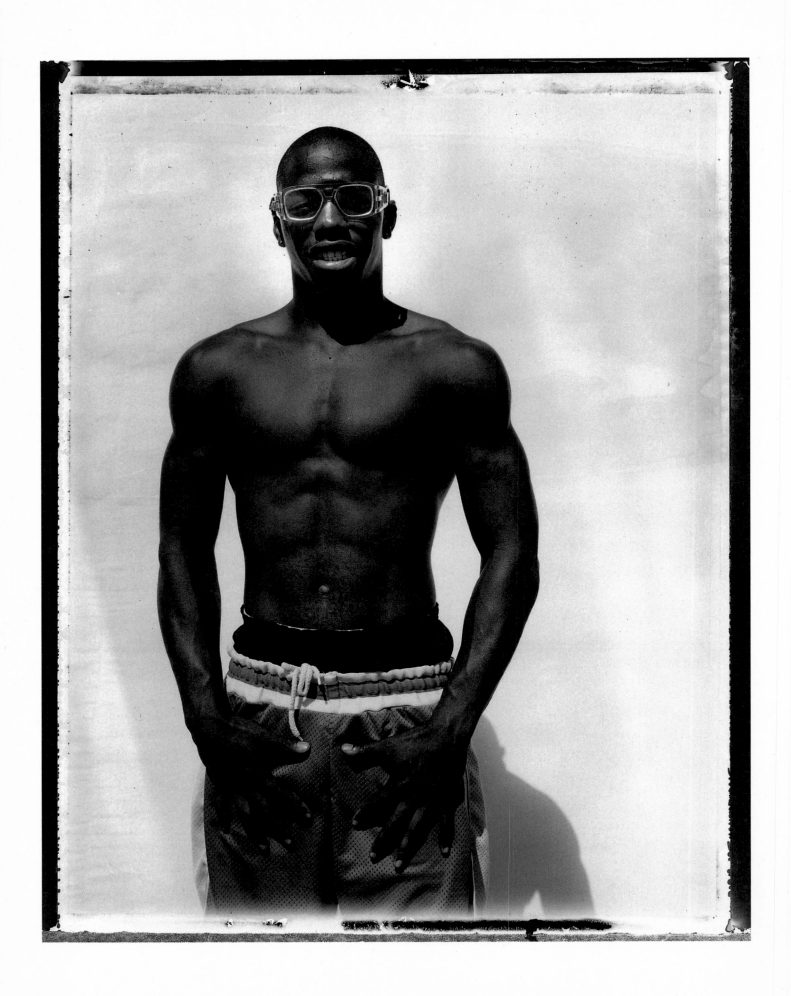

Antoine Burrwell, shooting guard, Los Angeles.

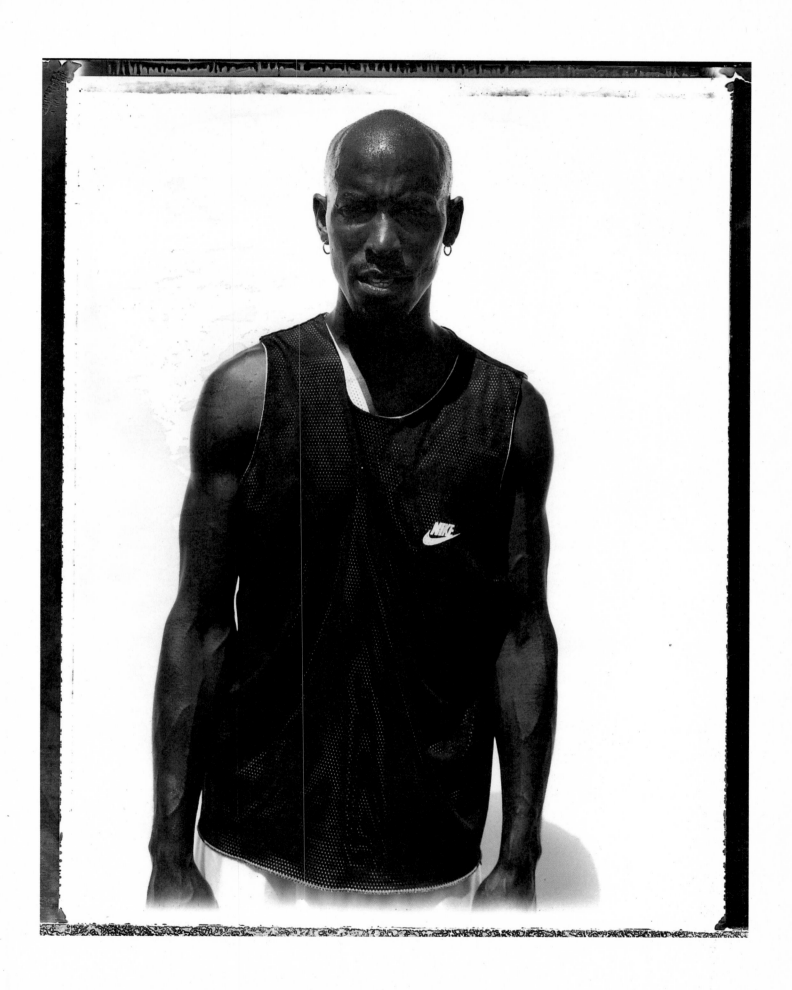

Don Johnson, shooting guard, Los Angeles.

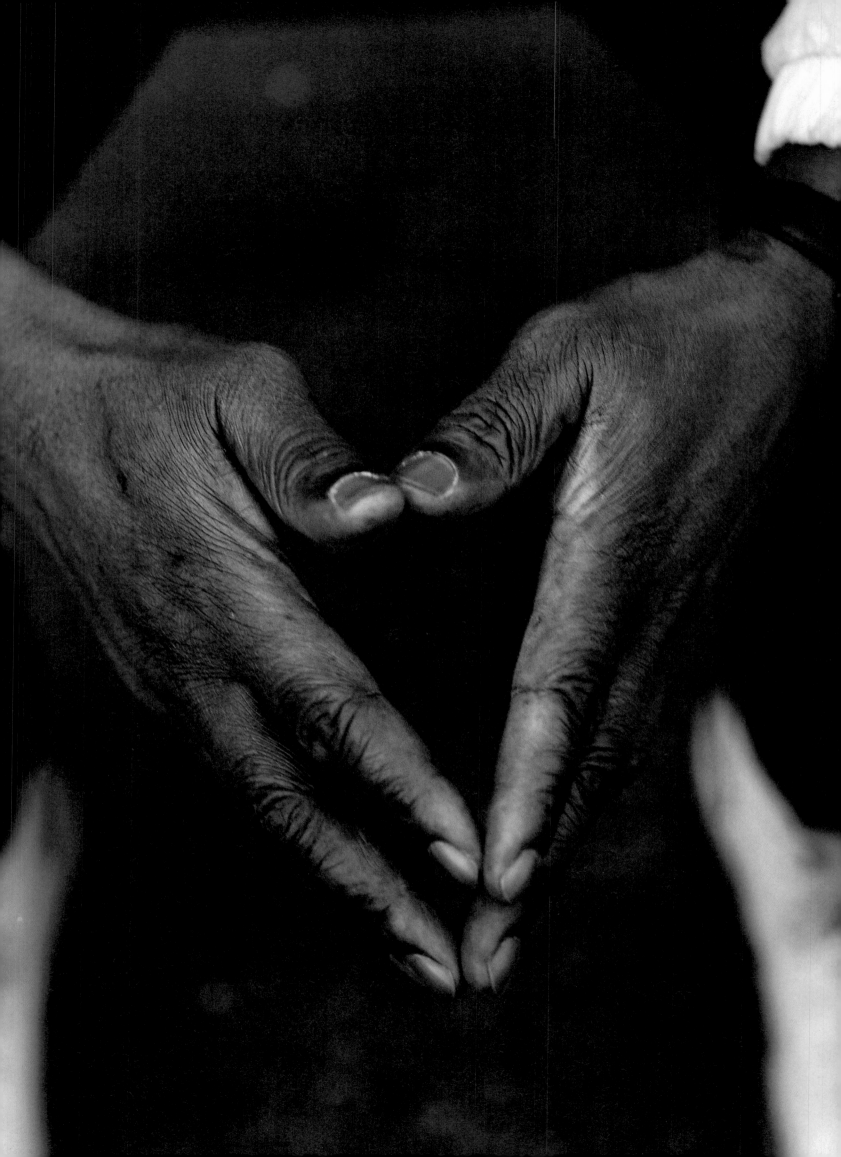

The Goat

On 99th Street and Amsterdam Avenue, Goat Park is named after the NYC legend who came before the rest.

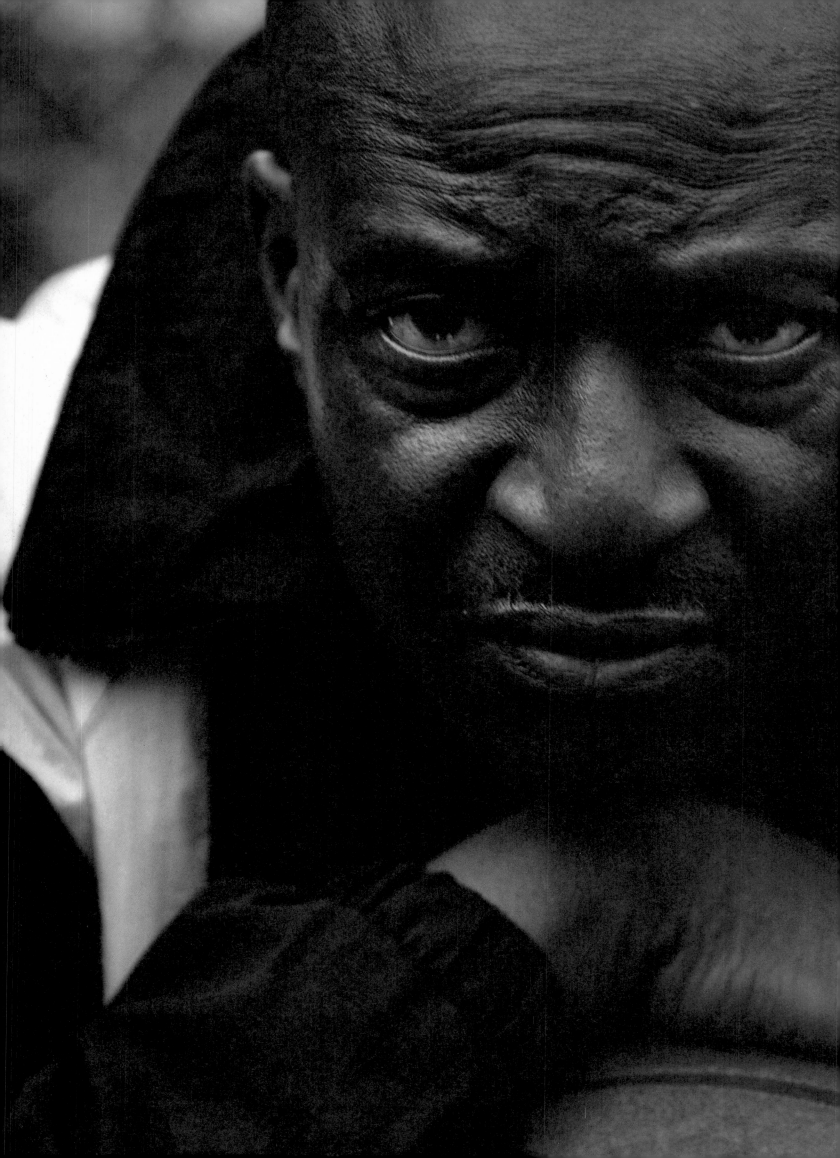

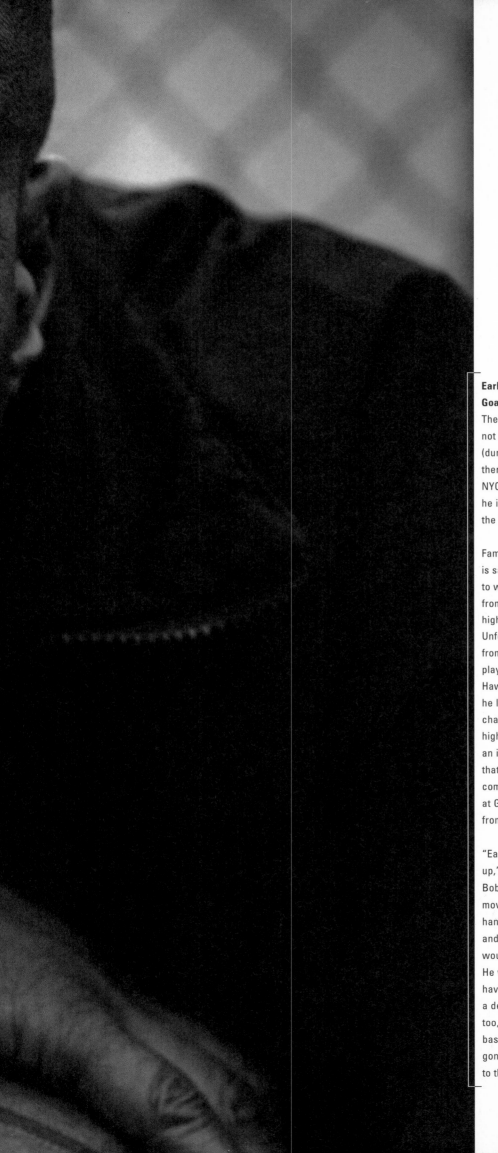

**Earl Manigault, aka Goat, at his house,
Goat Park, NYC.**

There may be some dispute as to whether or
not Manigault actually executed a double dunk
(dunking the same ball twice on one jump), but
there is no disputing that Manigault is a bona fide
NYC legend. According to Kareem Abdul-Jabbar,
he is the greatest player never to have played in
the NBA.

Famous in his day for in-your-face slams, Goat
is said to have once dunked 36 times backwards
to win a $60 bet. Once considered unstoppable
from 15 feet in, Goat is probably one of the
highest fliers ever to have come out of the city.
Unfortunately, he never flew far enough away
from home. He made his name in city tournaments,
playing against the likes of Abdul-Jabbar, Connie
Hawkins and Earl Monroe. As a sophomore in 1962,
he lead Benjamin Franklin High School to the city
championship. By the time he was dismissed from
high school during his senior year, he had begun
an infamous descent into the heroin underworld
that almost claimed his life. Remarkably, Goat has
come back to run an annual summer tournament
at Goat Park and warn a new generation away
from his mistakes.

"Earl was just so affectionate with all of us comin'
up," says the New York street player and DJ
Bobbito Garcia. "He would show me this one
move where he would drop the ball with his left
hand. He'd wrap his right foot behind his left foot,
and he'd kick the ball and look right but the ball
would go left. Earl had that trickster mentality.
He was definitely a player. Being 6-foot-1 and
having the hops that he did when he played, he's
a definite legend. Earl was a big inspiration,
too, because he instilled in me an approach to
basketball that spilled over to life: If you're
gonna try to do something, then you just do it
to the best of your ability."

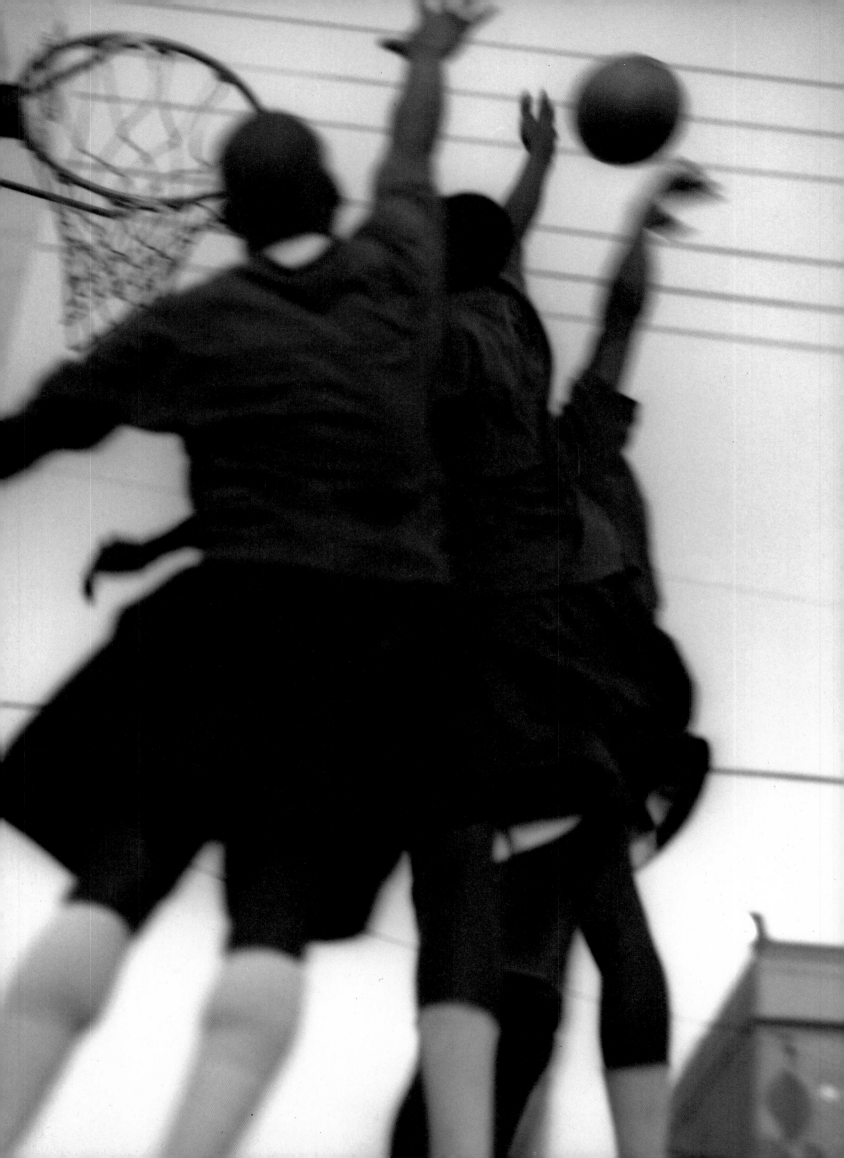

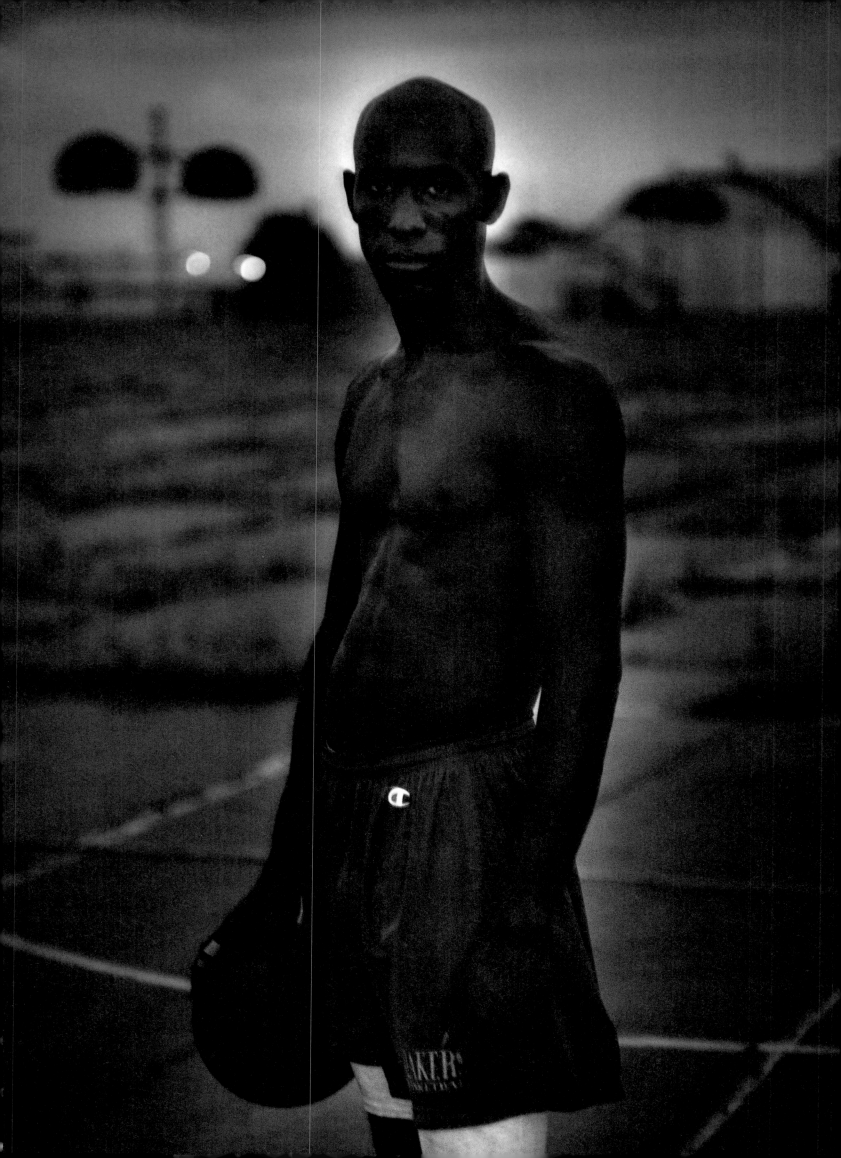

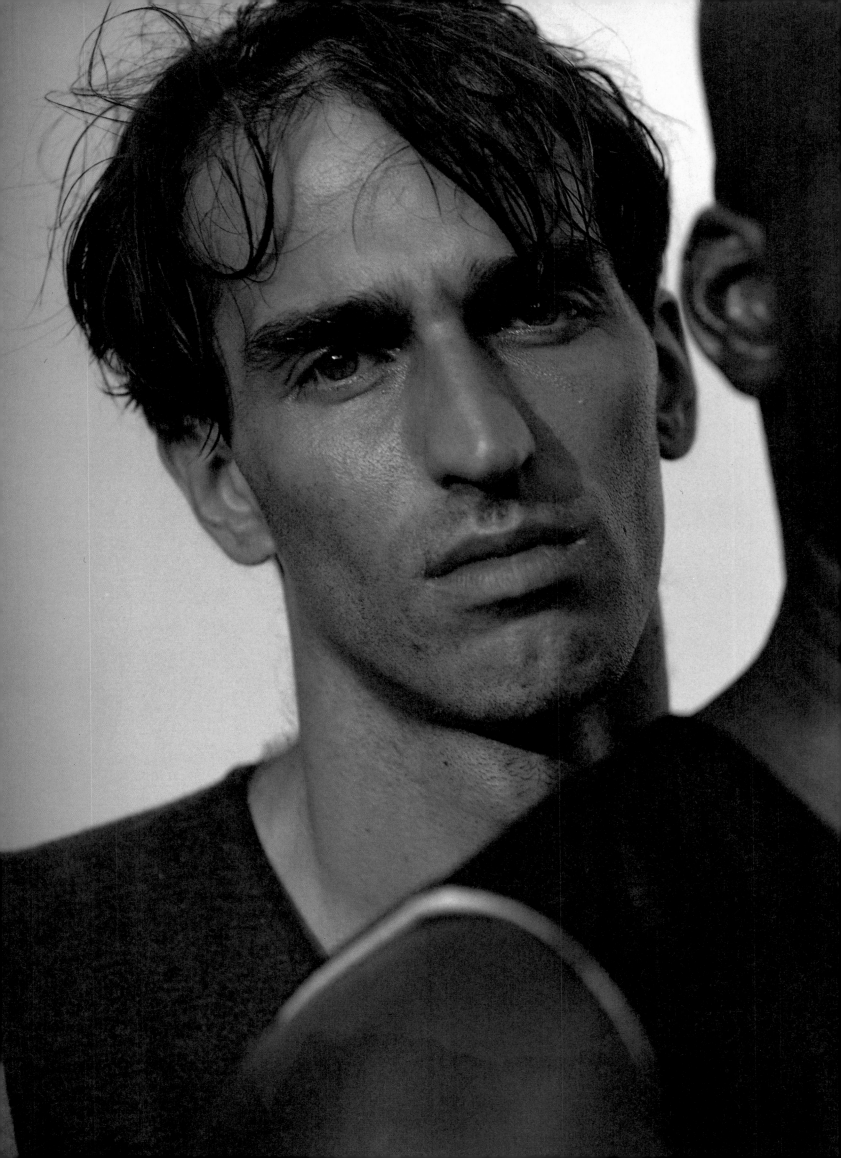

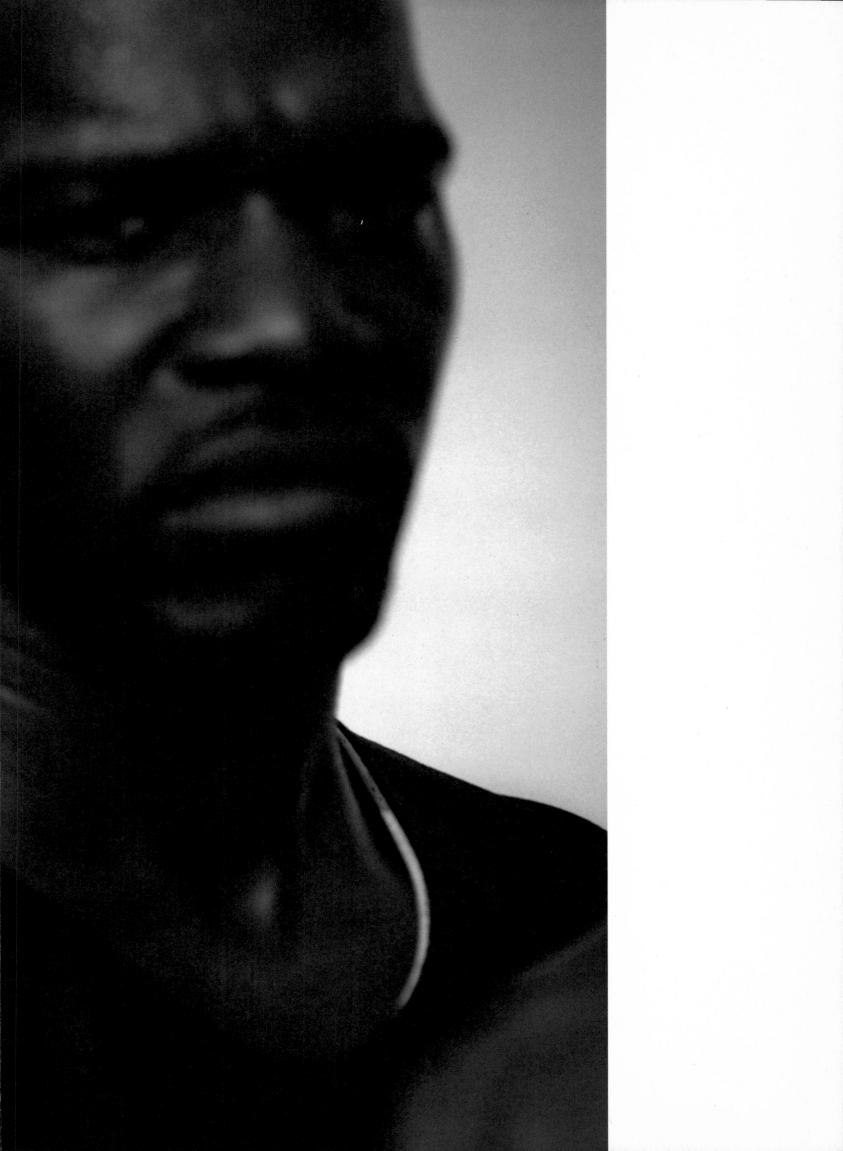

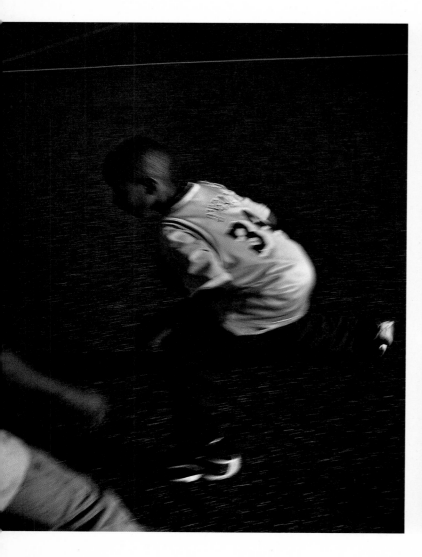

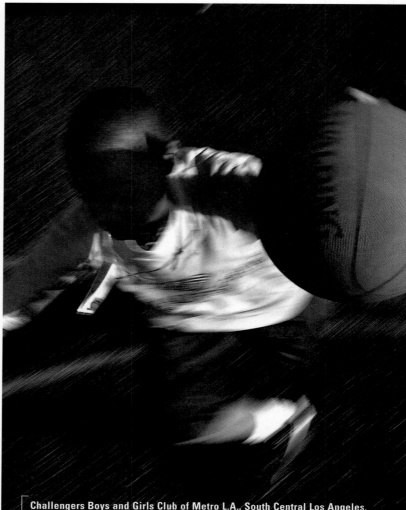

Challengers Boys and Girls Club of Metro L.A., South Central Los Angeles.
Founded by Lou Dantzler, the importance of this facility to the community as a safe place for its children to play was demonstrated during the 1992 uprising after the first Rodney King verdict. Although buildings were set on fire to its left and right, Challengers was left unscathed.

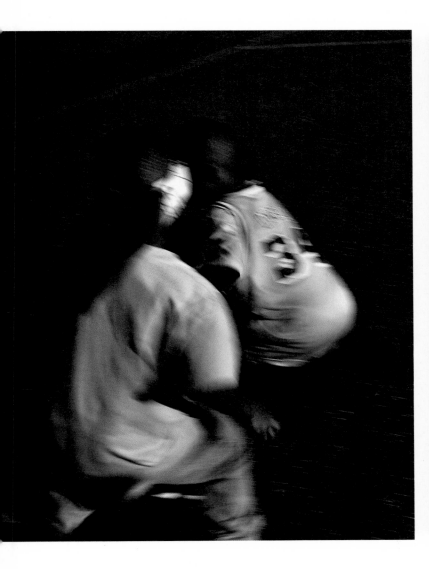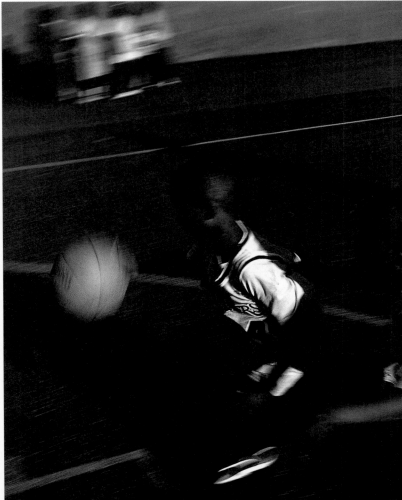

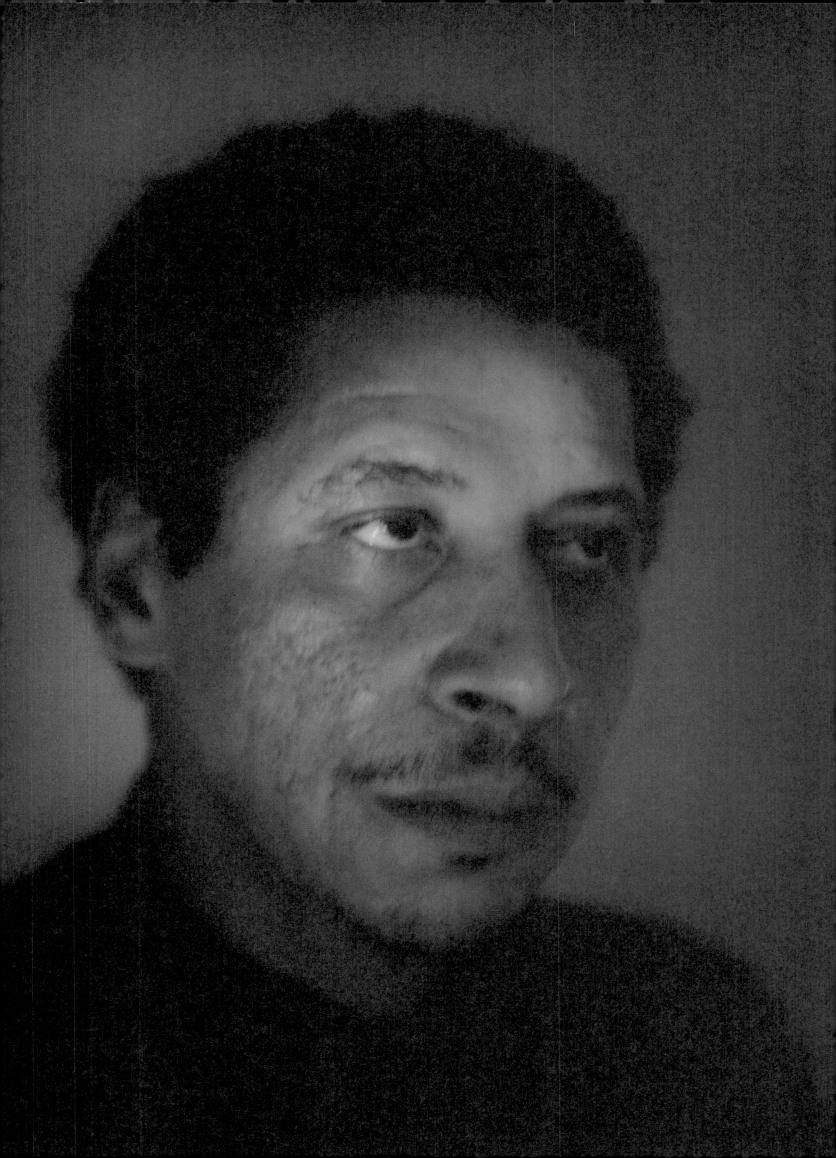

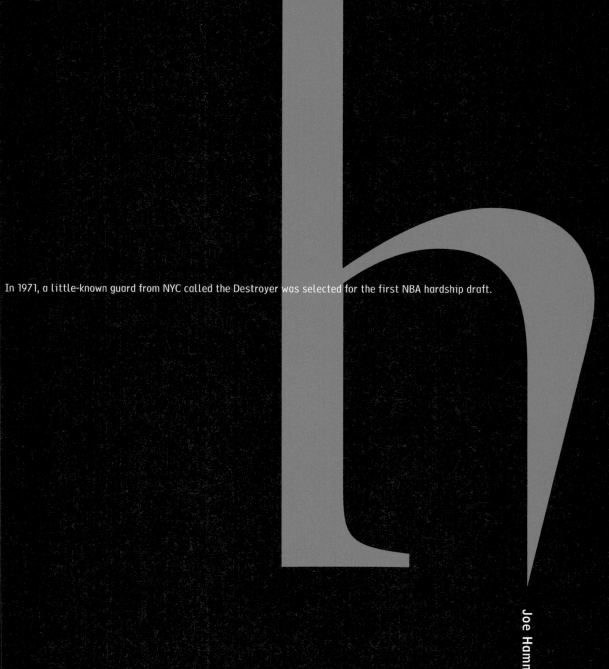

In 1971, a little-known guard from NYC called the Destroyer was selected for the first NBA hardship draft.

Joe Hammond

Joe Hammond, aka the Destroyer,
shooting guard, Harlem, NYC.
Another nickname people could have given
Hammond was At Will. Because that's what he
did, score at will. He could break you down off
the dribble. He could jump over you and jam it.
Or he could kill you with his specialty, a jumper
from downtown off the glass. He was known to
routinely hit 18, 19 and 20 shots without a miss.
To understand just how good he was, you should
know that Hammond was drafted by the Los
Angeles Lakers in 1971, the season the Lakers
would win 69 games, then an NBA record. The
1971–72 team included Wilt Chamberlain, Jerry
West and Gail Goodrich. But this is only half the
story. The astonishing thing about Hammond's
drafting is that unlike Darryl Dawkins, Kevin
Garnett and Kobe Bryant, Hammond never even
played high school ball, let alone college. The
interest from the pro ranks was based solely on
the Destroyer's performances at Rucker Park.
Among the many New Yorkers who recognized
Hammond's talent early on was Howie Evans,
at the time a youth center director in Harlem.
Evans became a coach, mentor and friend,
making many futile attempts to guide Hammond
toward a pro basketball career.

"He was an ice cube on the court. He could do anything. He could shoot, he could jump, but he didn't want to do it in the NBA."

Joe was a cult figure around the country. People
had heard about him. Some had seen him play. But
the NBA had no records of him. He didn't have a
phone number, and nobody ever knew where he
was. He had grown up in East Harlem. I had to go
back to his school, find a birth certificate and get
his school records to prove that he did truly
exist. When I presented all of the documents to
the NBA, they put his name on a hardship list.
And with Phil Chenier and Cyril Baptist, he was
one of the first six players in the NBA draft where
guys could leave school early. Out of the whole
crew, I think only two eventually really played, of
course. Phil Chenier became an All-Star and played
in the league for many years.

Joe was drafted by the Lakers. And they did everything they possibly could to get him to come to L.A. After he went and tried out, I took him down to Pace University, where the visiting teams in the NBA practiced at the time. That summer he had broken his ankle, so he hadn't played that much. When Joe went to try out, Wilt Chamberlain was still with the team, and so were Jerry West and Gail Goodrich. They had just drafted Jim Cleamons, and the coach then was Bill Sharman.

Sharman put Joe in some shooting games, and he put Joe on the team with Wilt Chamberlain and all the big guys. It was a game called 21. The first team that makes 21 points wins the game, and they shoot from designated spots on the floor. Joe made 18 points in a row. And Wilt Chamberlain was going crazy, like, "Just shoot the ball, young boy," he was saying. I can hear him now. So they won. And then the coach switched sides, and Joe made 14 out of the 21 points for the other team. So by now Sharman is trying not to notice, but he's kinda like giving Joe the look. They had not yet signed Jim Cleamons, who was holding out. And so Sharman came over to me, and he said, "Howie, look, here's the situation. We really like this kid, but I want to see him in a physical situation."

The teams were going to the locker room, and he brought back one guy to scrimmage against Joe in this one-on-one. Joe was on one leg practically, and he beat this guy to death. You know who that guy was? Pat Riley! Joe just had the guy falling on the floor. And it got to the point where he was so frustrated from trying to stop Joe that he started being very physical with him. Just trying to muscle him, 'cause Pat was at that time physically larger than Joe— about the same height, but larger. Joe was the type of player who never ever sweat. I don't care how hot it was, he never sweat. And he never ever showed emotions. Guys would slam him on the concrete, and he would just get up and go to the free-throw line and shoot. It was the same in that case.

They wanted Joe to come out to the L.A. summer league, and they were going to pick up his tab, put him up in a house and so forth. And Joe wouldn't go. Jerry West was retiring. They had a spot for Joe, and he wouldn't go. I mean, they did this for darn near two years. All of Joe's mail was coming to my address. So I had all his mail, I had his birth certificate,

I had everything. But he just didn't want to go. Because Joe is a very loyal individual. When he was growing up, he didn't have a stabilizing home life, and people took care of him. He would sleep here and he would sleep there, with friends. As he got older, he became the leader of all of these people, guys and girls. He remembered them. He would always look out for them. He actually took care of these people. So when he got this offer to go to California, he asked me to ask the Lakers, "Can I bring them with me?" That's the only way he would have gone. He would have gone if he could have taken them with him. He said, "I'm not gonna leave them."

One day I'm sitting in the office. Joe came over, and we were talking about different things. And he said, "You know something? You know, I love you, man. But you want me to play basketball more than I want to play." After that I never mentioned it to him again. I never ever tried to get him to play again. But he was probably, in my lifetime, one of the greatest basketball players I've ever seen. There wasn't one thing that he couldn't do. He was an ice'cube on the court. He could shoot, he could jump. He could do anything that you wanted, but he didn't want to do it in the NBA. He was just happy playing basketball, and it didn't have to be in the NBA. He could go out in the street and just play with kids, play one-on-one with somebody, and he was just as happy.
—Howie Evans, Sports Editor,
 AMSTERDAM NEWS

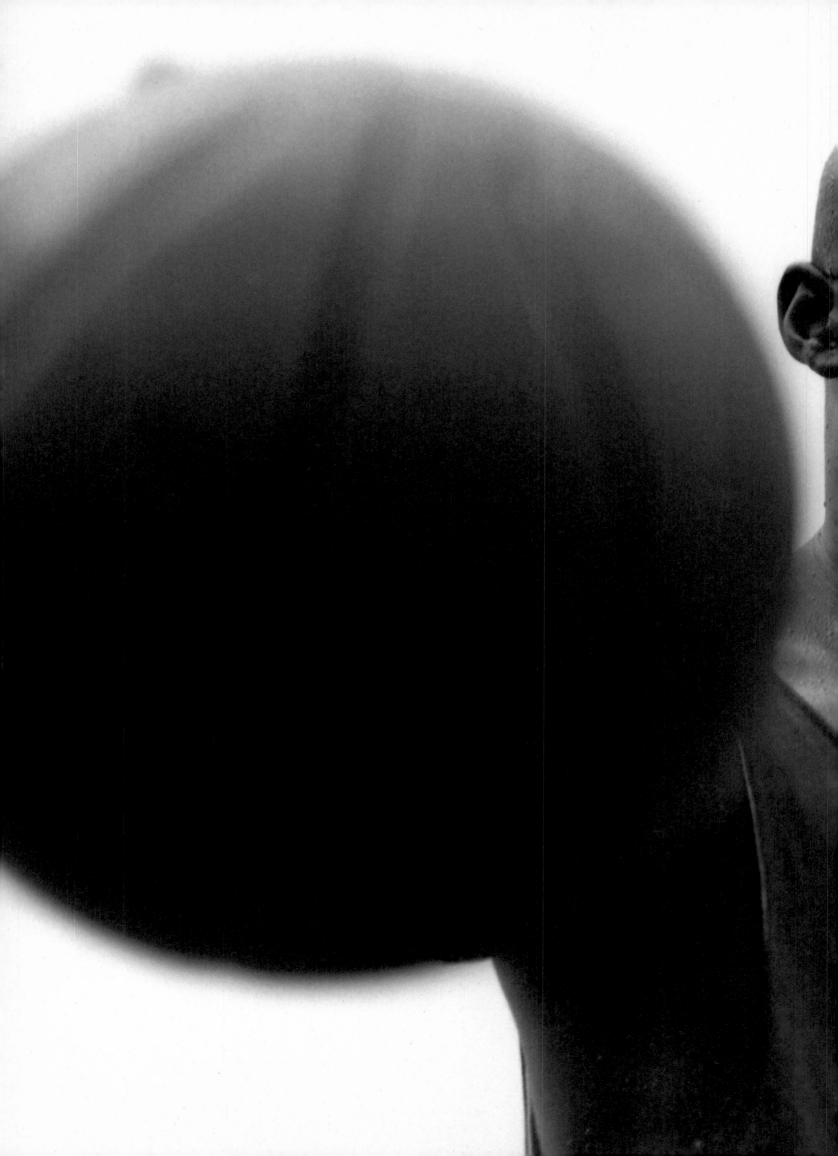

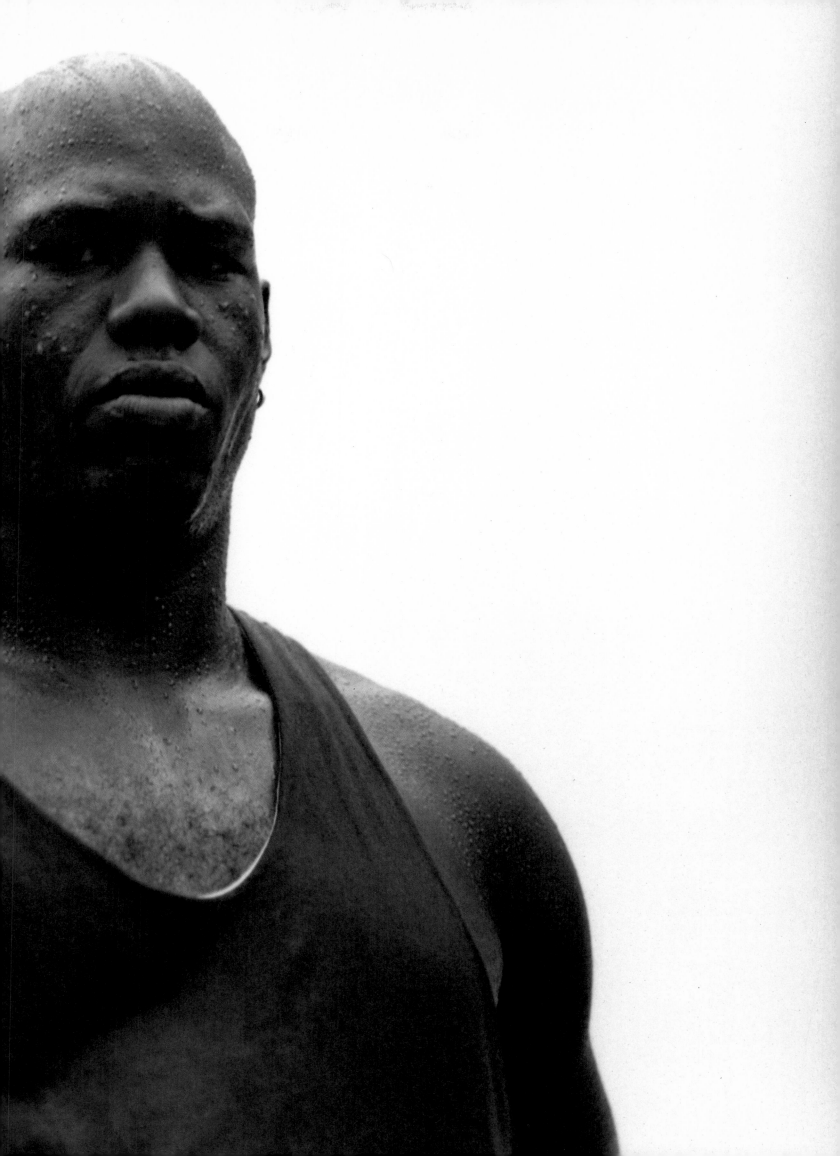

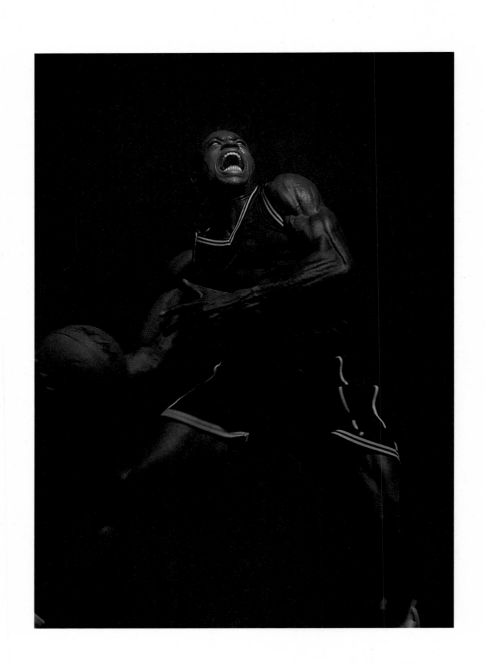

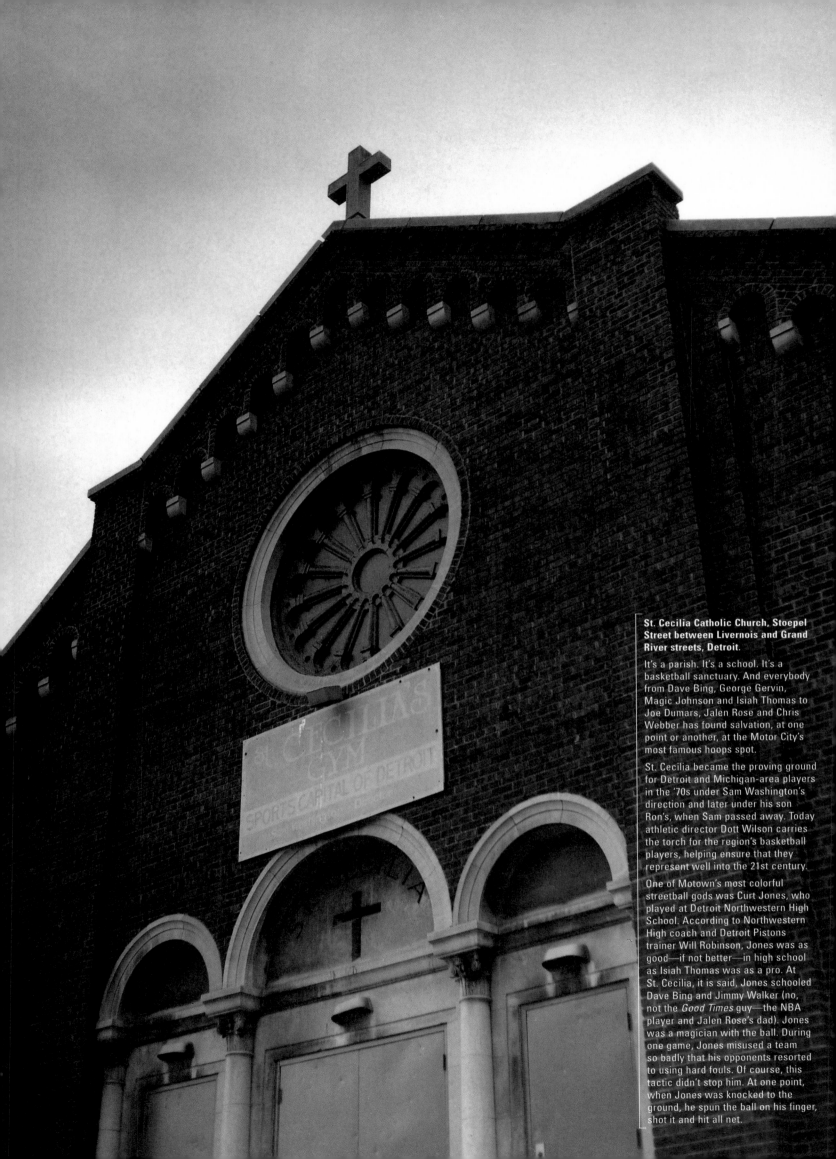

St. Cecilia Catholic Church, Stoepel Street between Livernois and Grand River streets, Detroit.

It's a parish. It's a school. It's a basketball sanctuary. And everybody from Dave Bing, George Gervin, Magic Johnson and Isiah Thomas to Joe Dumars, Jalen Rose and Chris Webber has found salvation, at one point or another, at the Motor City's most famous hoops spot.

St. Cecilia became the proving ground for Detroit and Michigan-area players in the '70s under Sam Washington's direction and later under his son Ron's, when Sam passed away. Today athletic director Dott Wilson carries the torch for the region's basketball players, helping ensure that they represent well into the 21st century.

One of Motown's most colorful streetball gods was Curt Jones, who played at Detroit Northwestern High School. According to Northwestern High coach and Detroit Pistons trainer Will Robinson, Jones was as good—if not better—in high school as Isiah Thomas was as a pro. At St. Cecilia, it is said, Jones schooled Dave Bing and Jimmy Walker (no, not the *Good Times* guy—the NBA player and Jalen Rose's dad). Jones was a magician with the ball. During one game, Jones misused a team so badly that his opponents resorted to using hard fouls. Of course, this tactic didn't stop him. At one point, when Jones was knocked to the ground, he spun the ball on his finger, shot it and hit all net.

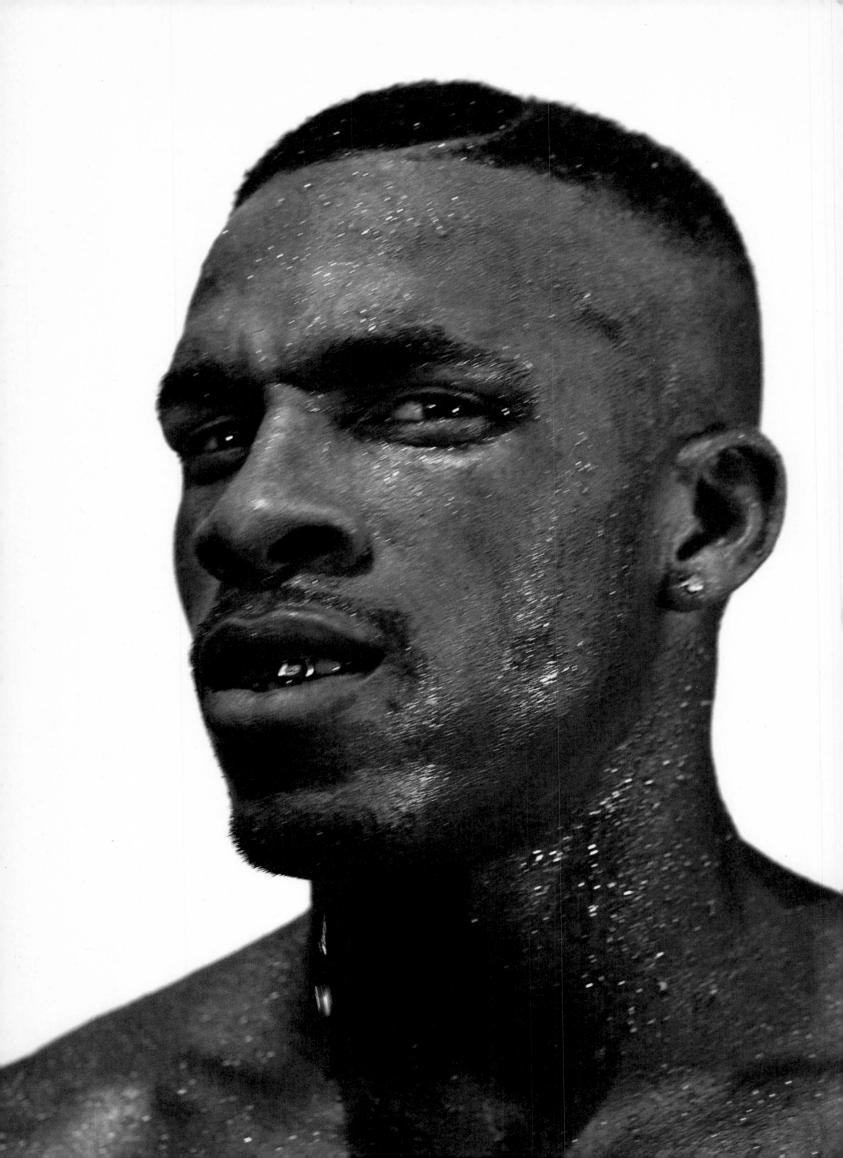

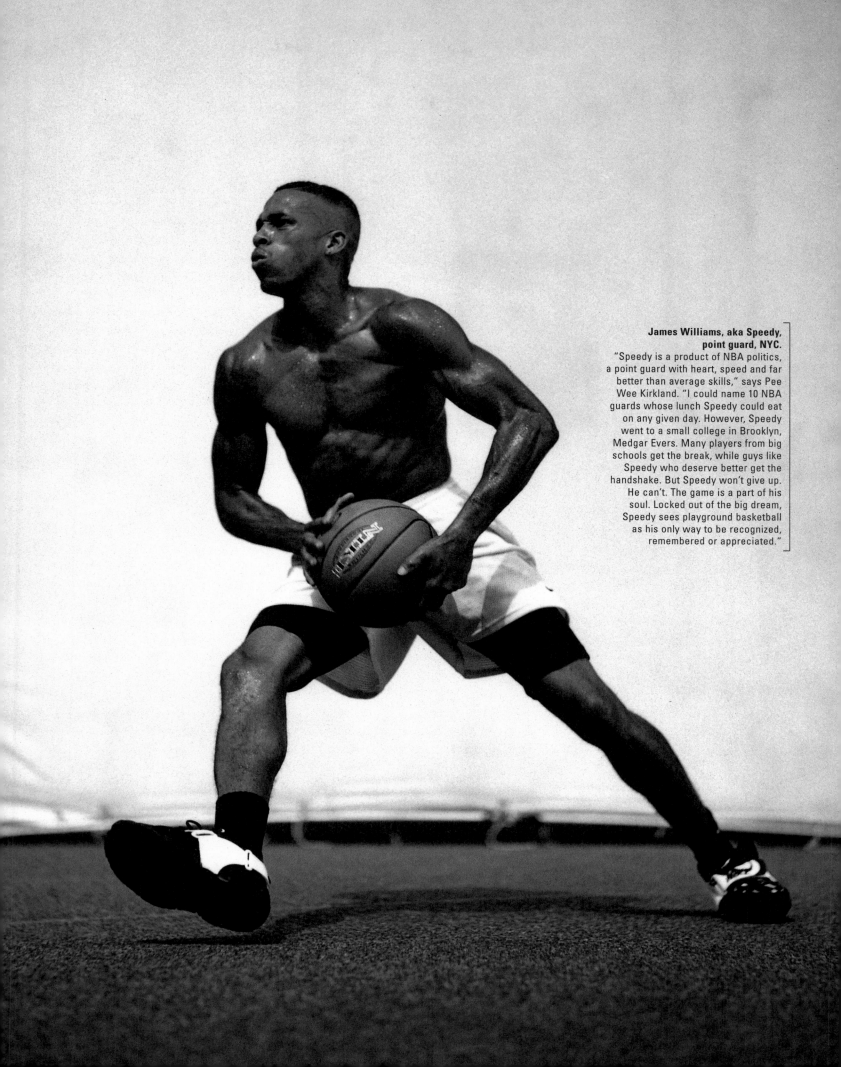

James Williams, aka Speedy, point guard, NYC.
"Speedy is a product of NBA politics, a point guard with heart, speed and far better than average skills," says Pee Wee Kirkland. "I could name 10 NBA guards whose lunch Speedy could eat on any given day. However, Speedy went to a small college in Brooklyn, Medgar Evers. Many players from big schools get the break, while guys like Speedy who deserve better get the handshake. But Speedy won't give up. He can't. The game is a part of his soul. Locked out of the big dream, Speedy sees playground basketball as his only way to be recognized, remembered or appreciated."

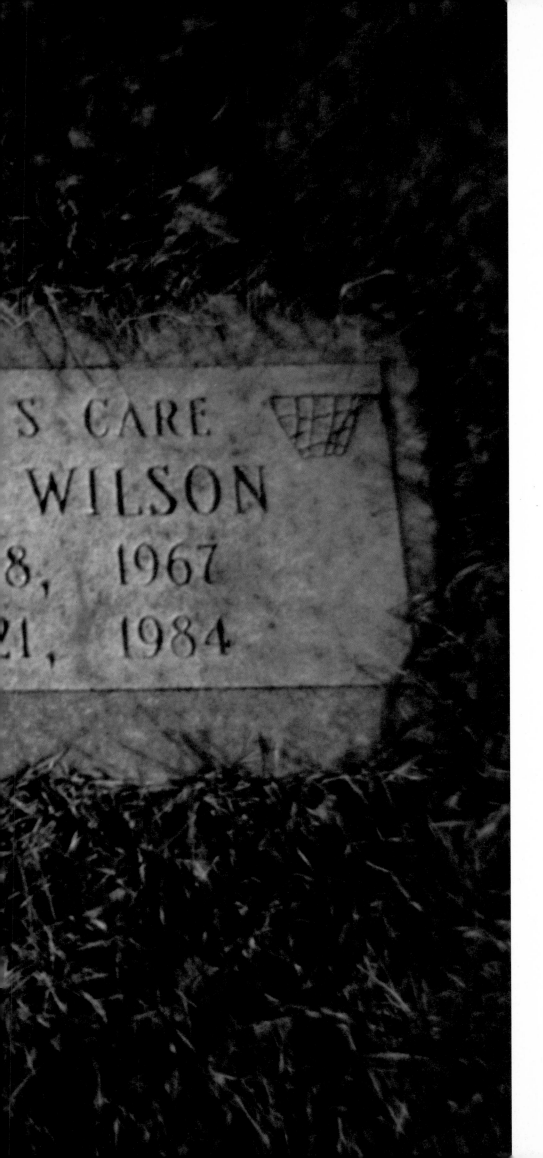

No. 25 by Poetri

Nat King Cole Park, a mysterious figure is shooting in the dark.

His physique is unique, his 6-foot-9 frame handles the rock like Marques Haynes, but who is he? Magic? He looks younger, though, besides what's Magic doing playing at a Windy City playground, where in the winter the windchill is more than a factor, it's the way you dress.

He shoots 25-foot jumpers without effort, he was meant to dribble, but who is he? Ben ... Ben Wilson? This couldn't be. Ben Wilson was murdered in 1984, but I see his legacy at his old stomping grounds playing ball. I know his spirit is still alive in Chi-Town, but I see him, that's Benji. He is 17 years old, again. To be No. 1, if only for a moment. To do what Hersey, Isiah, Terry and Mick didn't accomplish. Swish, that's Benji. I see him releasing his J with the No. 25 on his jersey. The dedication is plain to see, passion and potential surround his soul, as he dashes like lightning to the hole.

My body becomes cold, a tear leaves my eye and rests on my cheek. Pop, Pop, Pop, the shots hit nothing but heart and liver, 17 hours later, the buzzer sounded, no overtime, the game was over and we lost. We lost. We didn't lose the first player in Chicago's history to be named the No. 1 high school player in the nation. We didn't lose the next Magic. We didn't lose a great athlete. We lost Ben Wilson, everything that represents a young black man's struggle.

One in five die before 25, and we lost No. 25. His basketball talent wasn't even his greatest contribution. If Martin Luther King Jr. could hoop, that's Benji. We lost a player who had an appetite for the game, powerful emotions for people and a strong desire for life. America lost Ben Wilson. And there ain't no rematch.

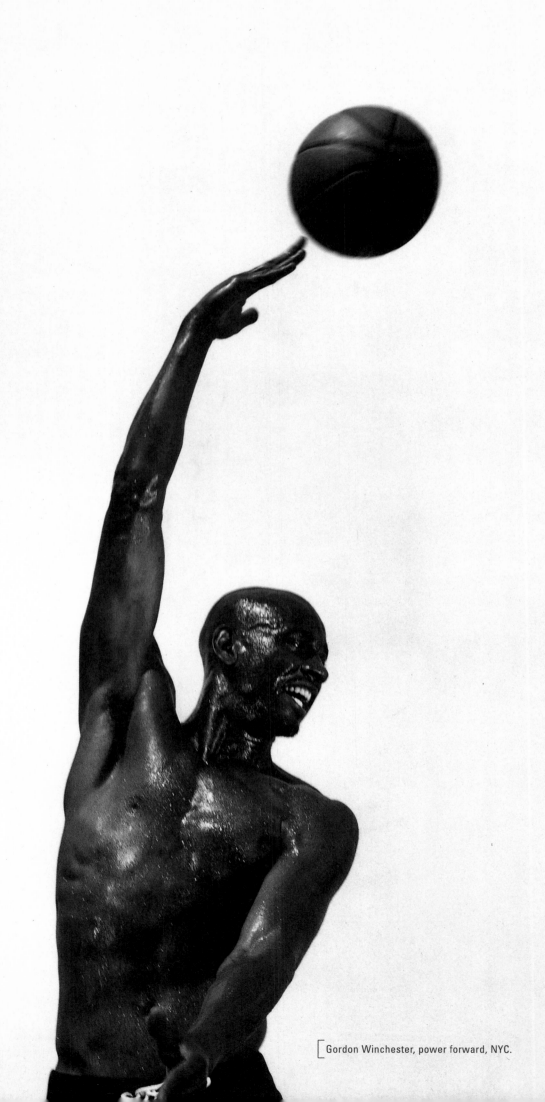

Gordon Winchester, power forward, NYC.

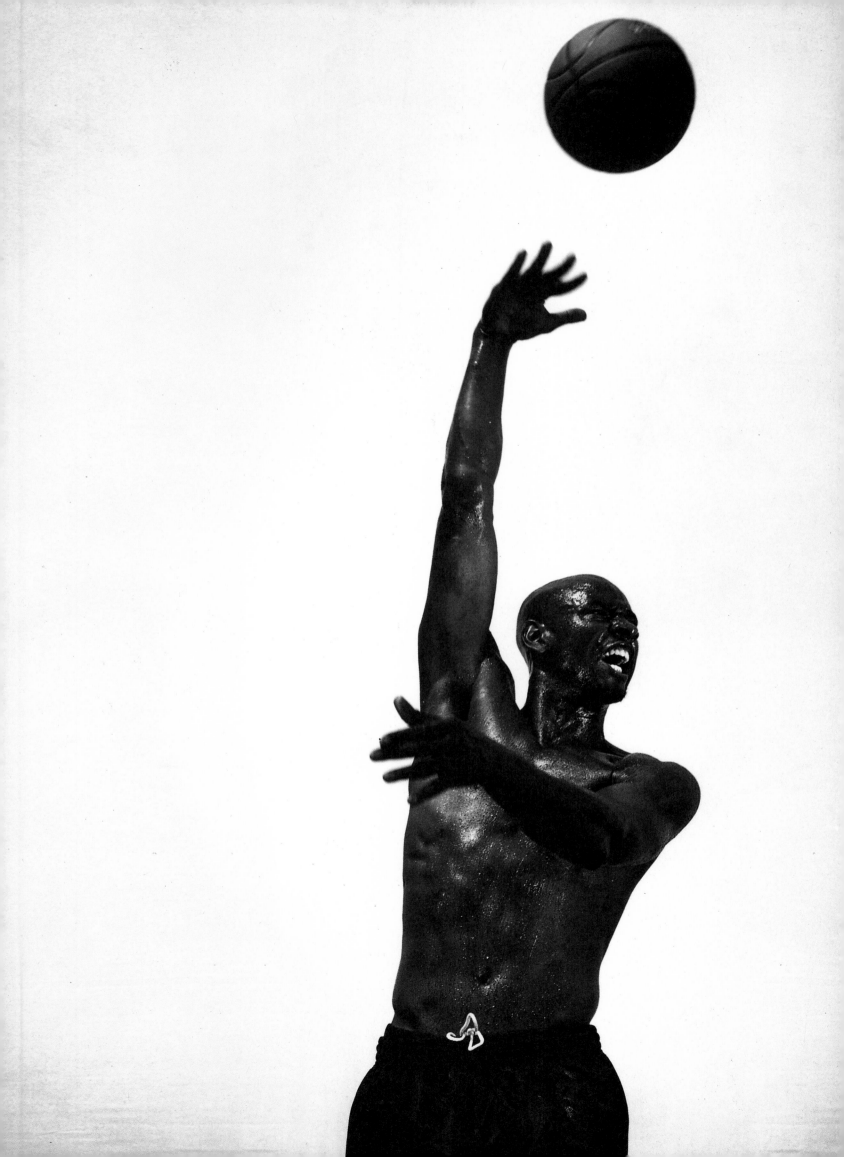

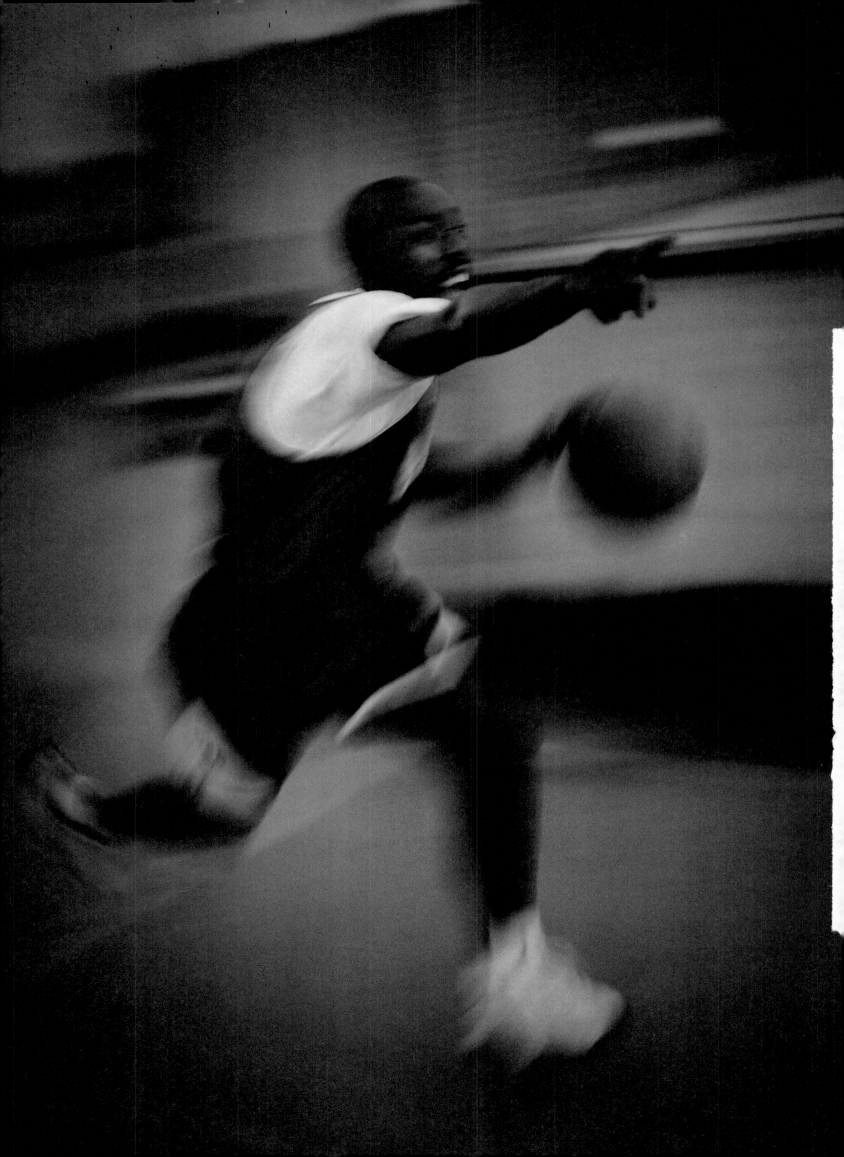

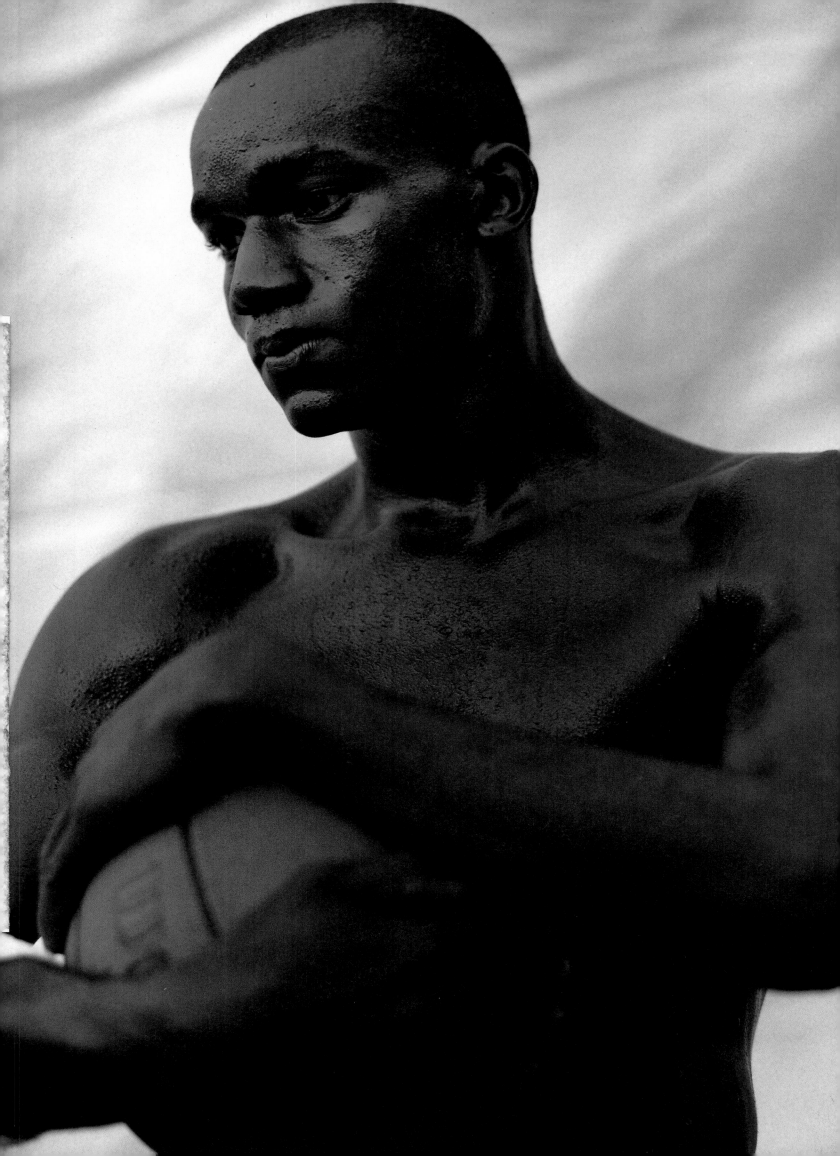

by Poetri

MY FREEDOM GOT A RIM

My release comes on asphalt or hardwood.

It has a backboard and a rim, bright lights to dim lights,

I shoot all night,

Cause my Freedom got a jump shot.

My liberty got a crossover.

My restraints come loose when I dribble down the pavement.

One hand behind my back, working on my left.

My Freedom got leather soul that I take wherever I go,

It bounces up and down as I clown you on the playground,

Cause my political independence got handles, y'all!

My Freedom got a rim, sometimes even a net or chains,

But my condition of being let go from oppression

Doesn't have to hear the swoosh of the nets or the chink of the chains

To let anybody know that I got hella game!

Just like I don't have to hear your lies,

It's all the same.

My Freedom got defense, pressed up on you like words to paper.

My liberation got animal instincts, I know where you're headed

So don't breathe till later.

My Freedom got a basketball. My Freedom got a rim.

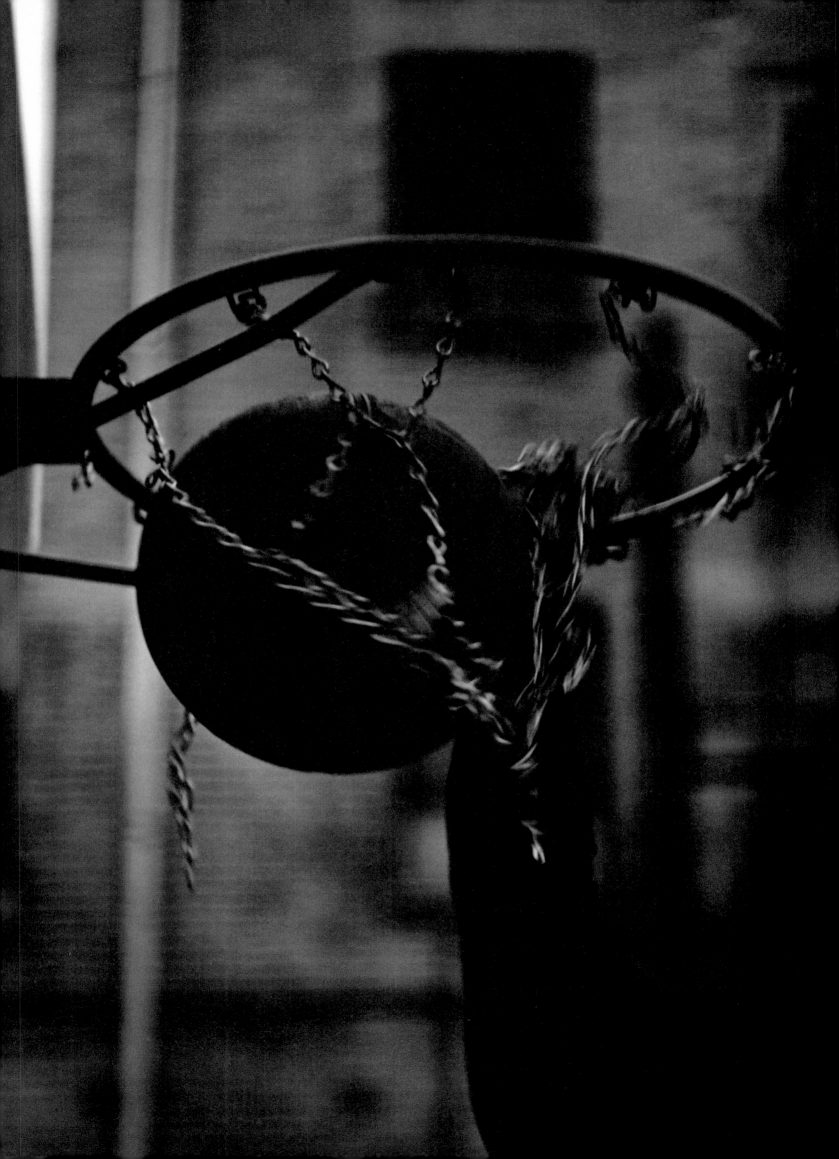

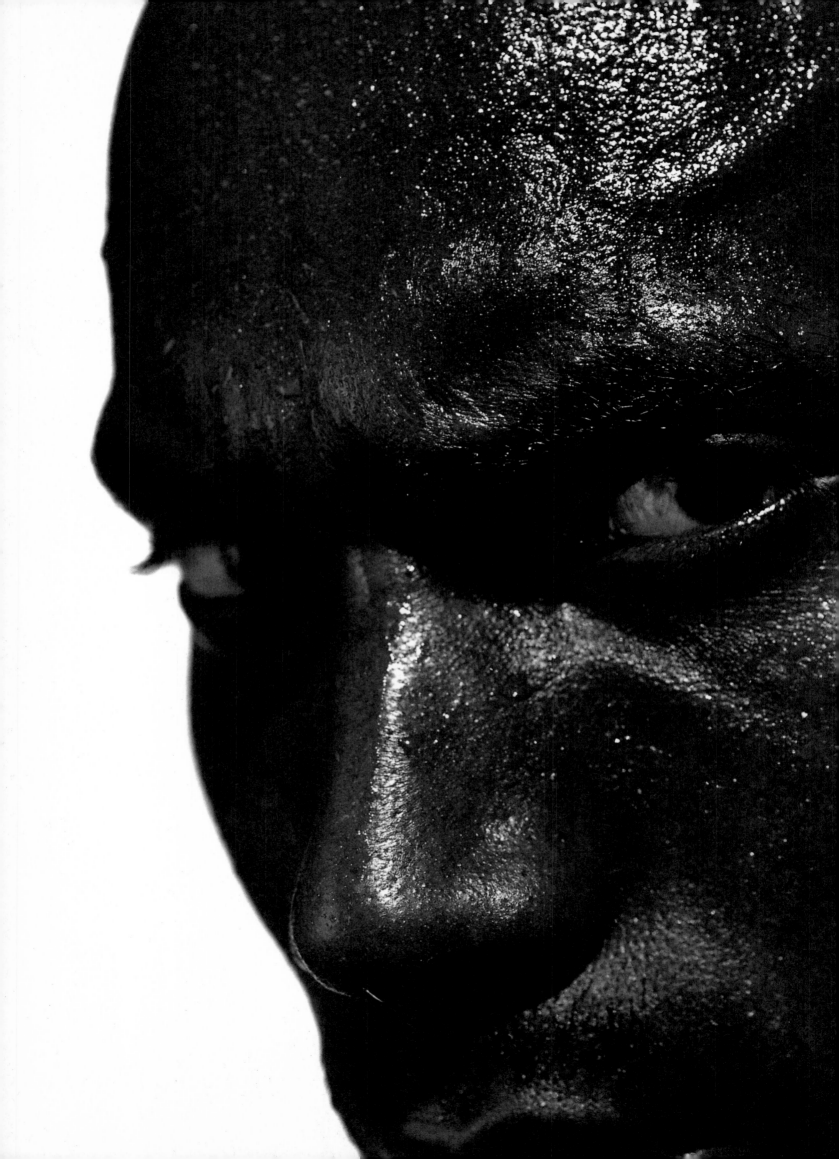

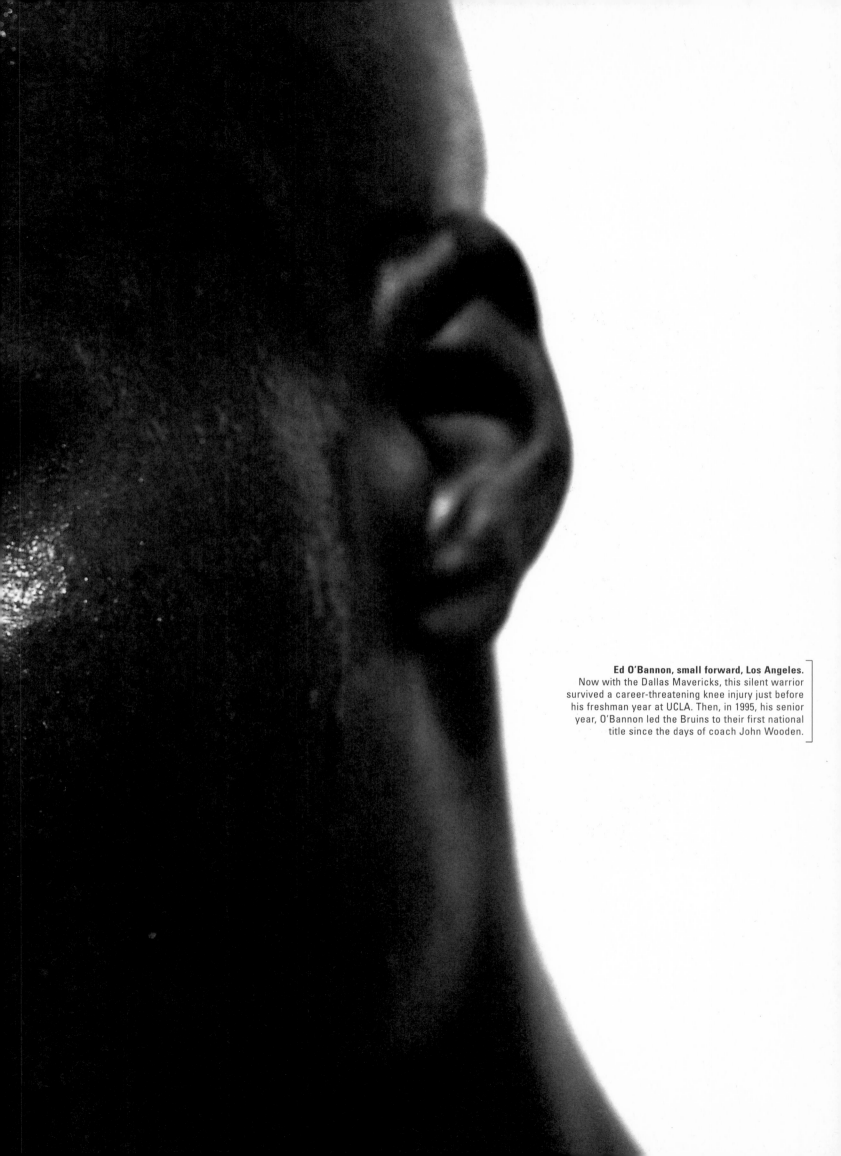

Ed O'Bannon, small forward, Los Angeles.
Now with the Dallas Mavericks, this silent warrior
survived a career-threatening knee injury just before
his freshman year at UCLA. Then, in 1995, his senior
year, O'Bannon led the Bruins to their first national
title since the days of coach John Wooden.

Coney Island, Brooklyn.

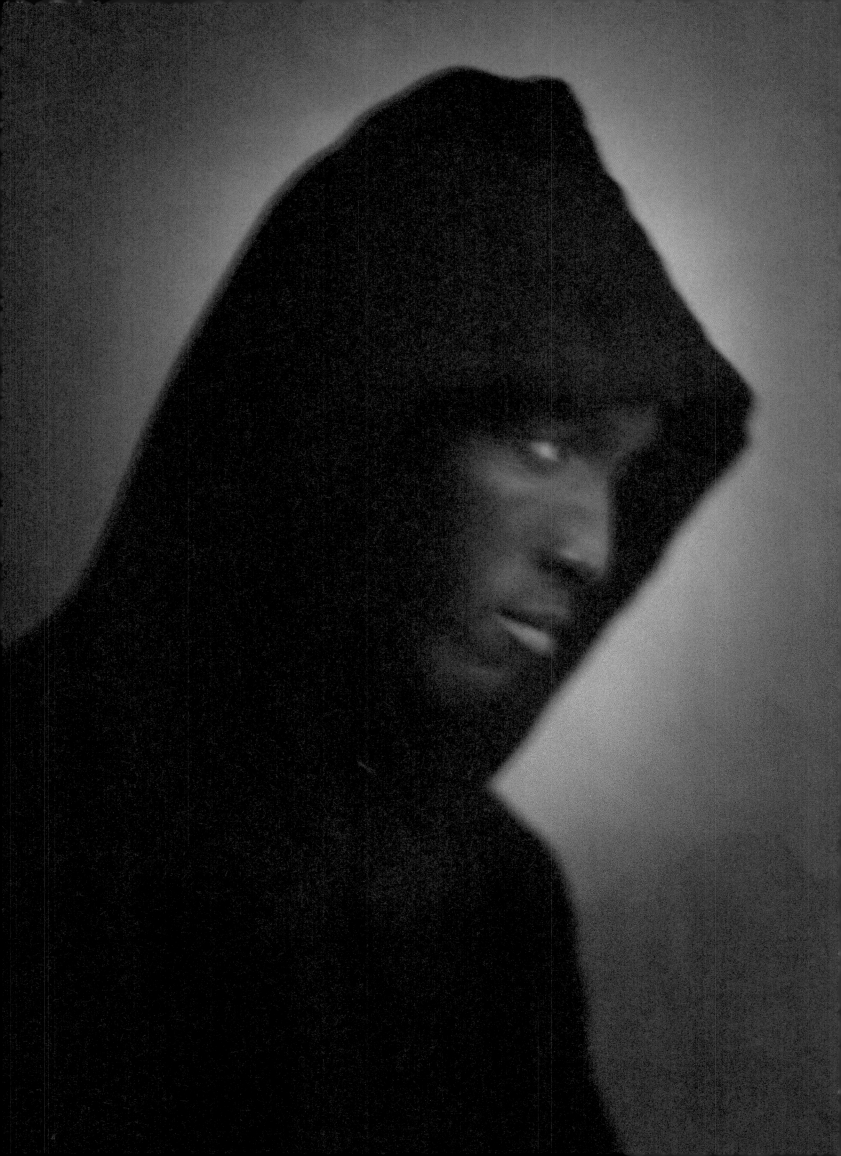

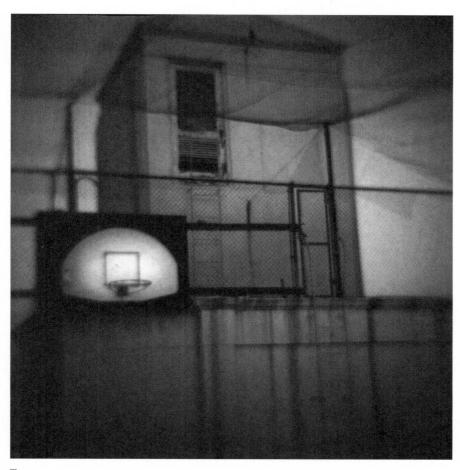

Rooftop court, San Diego.

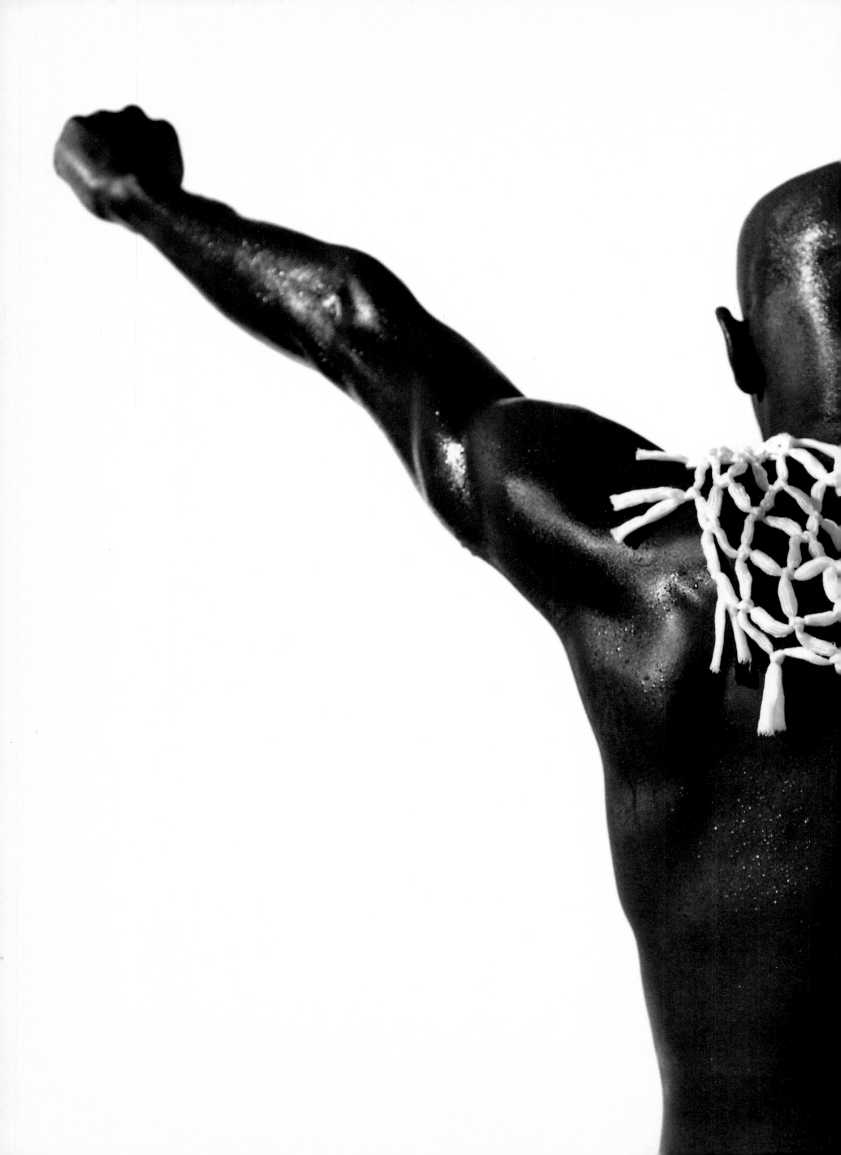

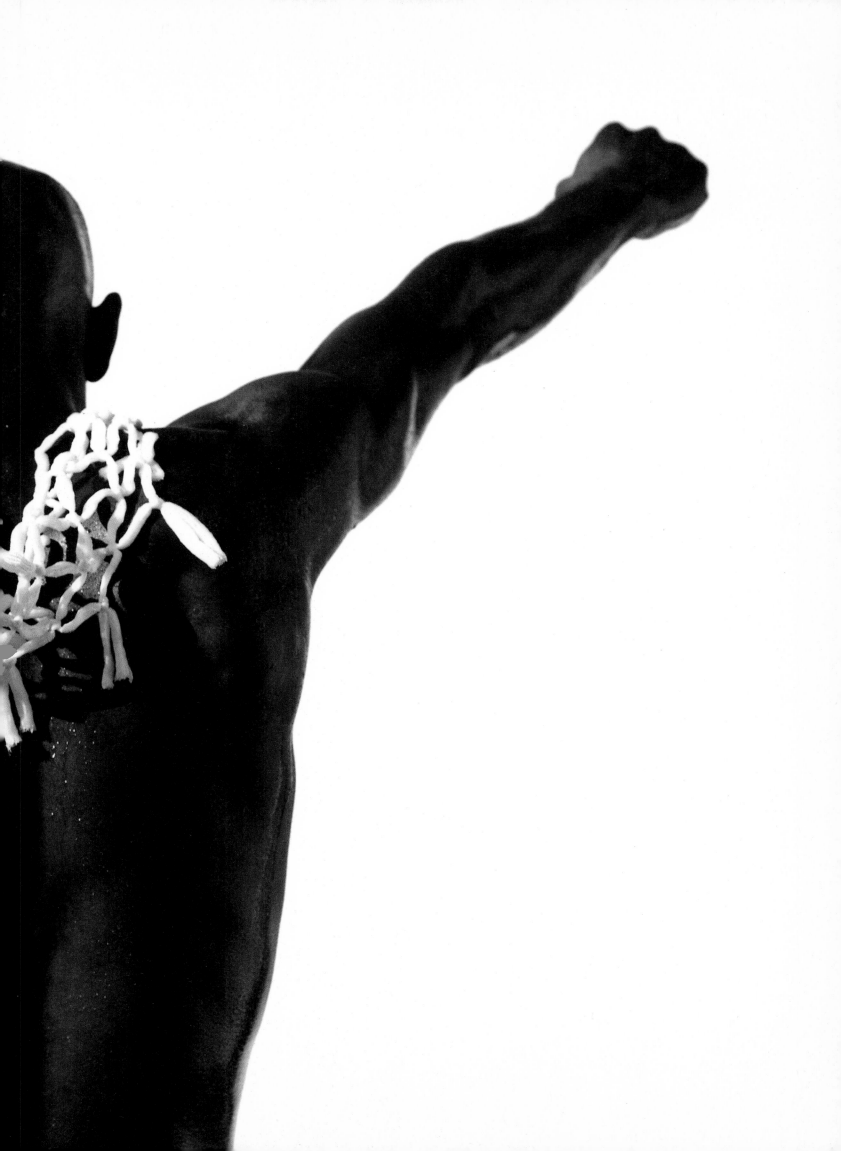

COIN ON THE TOP
by muMs the schemer

put the coin on the top
show off the trick

show why jumpin' my first name
put your quarter on the game
and your money on the wood
make the game go good

Leave all doubters awed
on the way down smack board.

imagine what I'd do with a ball
imagine what I'd do if that big-league call
telling me, "come on down
we got dollars for your niceness,"
but my love for this game,
priceless
and I always lived outside quotas.
so

I make my living like this—
put the coin on the top
let me show y'all this trick
show how a little hop
free a mind from poverty thick

keep my family fed

yeah, put the money on the wood
make the game go good

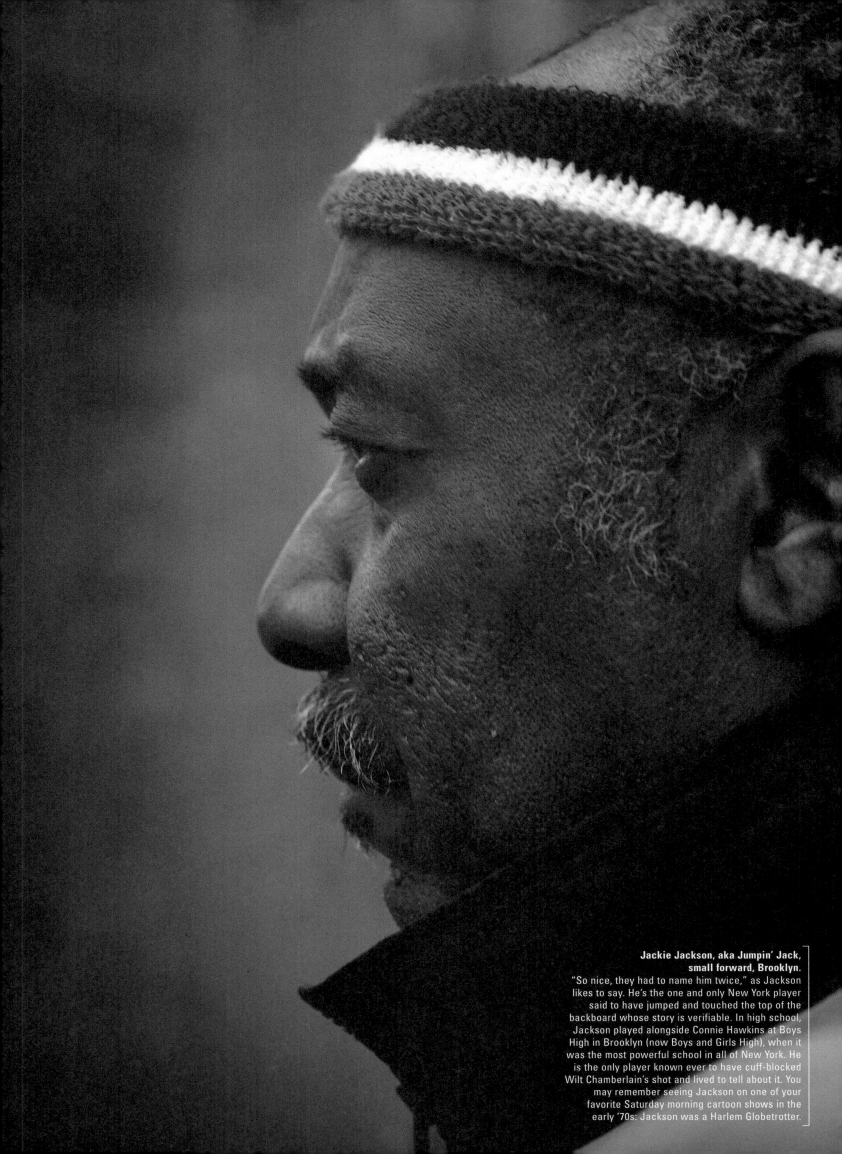

Jackie Jackson, aka Jumpin' Jack, small forward, Brooklyn.
"So nice, they had to name him twice," as Jackson likes to say. He's the one and only New York player said to have jumped and touched the top of the backboard whose story is verifiable. In high school, Jackson played alongside Connie Hawkins at Boys High in Brooklyn (now Boys and Girls High), when it was the most powerful school in all of New York. He is the only player known ever to have cuff-blocked Wilt Chamberlain's shot and lived to tell about it. You may remember seeing Jackson on one of your favorite Saturday morning cartoon shows in the early '70s: Jackson was a Harlem Globetrotter.

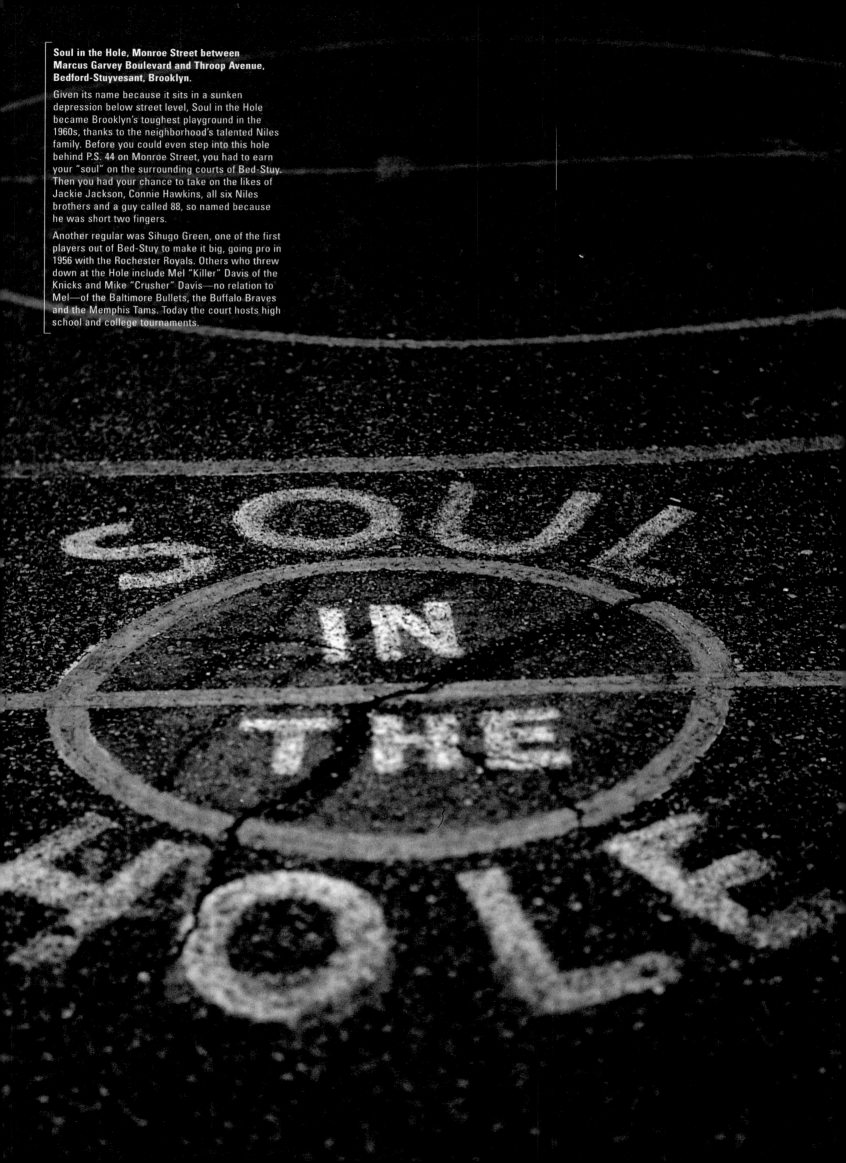

Soul in the Hole, Monroe Street between Marcus Garvey Boulevard and Throop Avenue, Bedford-Stuyvesant, Brooklyn.

Given its name because it sits in a sunken depression below street level, Soul in the Hole became Brooklyn's toughest playground in the 1960s, thanks to the neighborhood's talented Niles family. Before you could even step into this hole behind P.S. 44 on Monroe Street, you had to earn your "soul" on the surrounding courts of Bed-Stuy. Then you had your chance to take on the likes of Jackie Jackson, Connie Hawkins, all six Niles brothers and a guy called 88, so named because he was short two fingers.

Another regular was Sihugo Green, one of the first players out of Bed-Stuy to make it big, going pro in 1956 with the Rochester Royals. Others who threw down at the Hole include Mel "Killer" Davis of the Knicks and Mike "Crusher" Davis—no relation to Mel—of the Baltimore Bullets, the Buffalo Braves and the Memphis Tams. Today the court hosts high school and college tournaments.

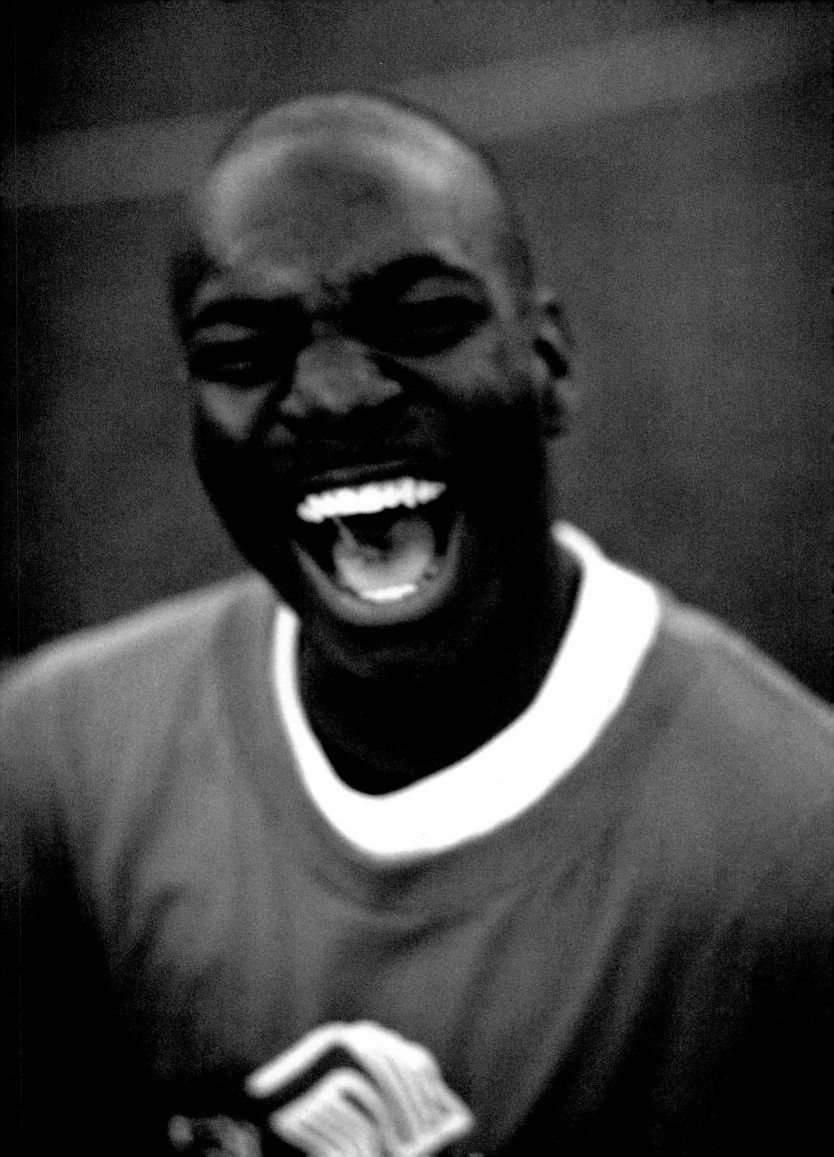

PLAYGROUND LEGEND
by Markhum Who?

From Venice Beach in Cali to the Urban Coalition in D.C.
The basketball court is where you'll always find me.
From Cabrini Greens in Chi-Town to the Bluff City Classic in Memphis,
Tennessee,
I'll be at least 25 feet from the basket, launching my high, arching
three.
I'm never far from a hoop and a round, bouncing ball.
If you're short one and have next, I'm the one you call.
If there was any justice I'd be ballin' in the NBA.
Instead I dominate the asphalt day after day after day.
I can do it all and I've never seen a shot I didn't like.
I school everybody out there and I'm way better than Mike.
They say he is the greatest ever, but from sunup to sundown
He doesn't even come close to me—I'm the Picasso of the playground.

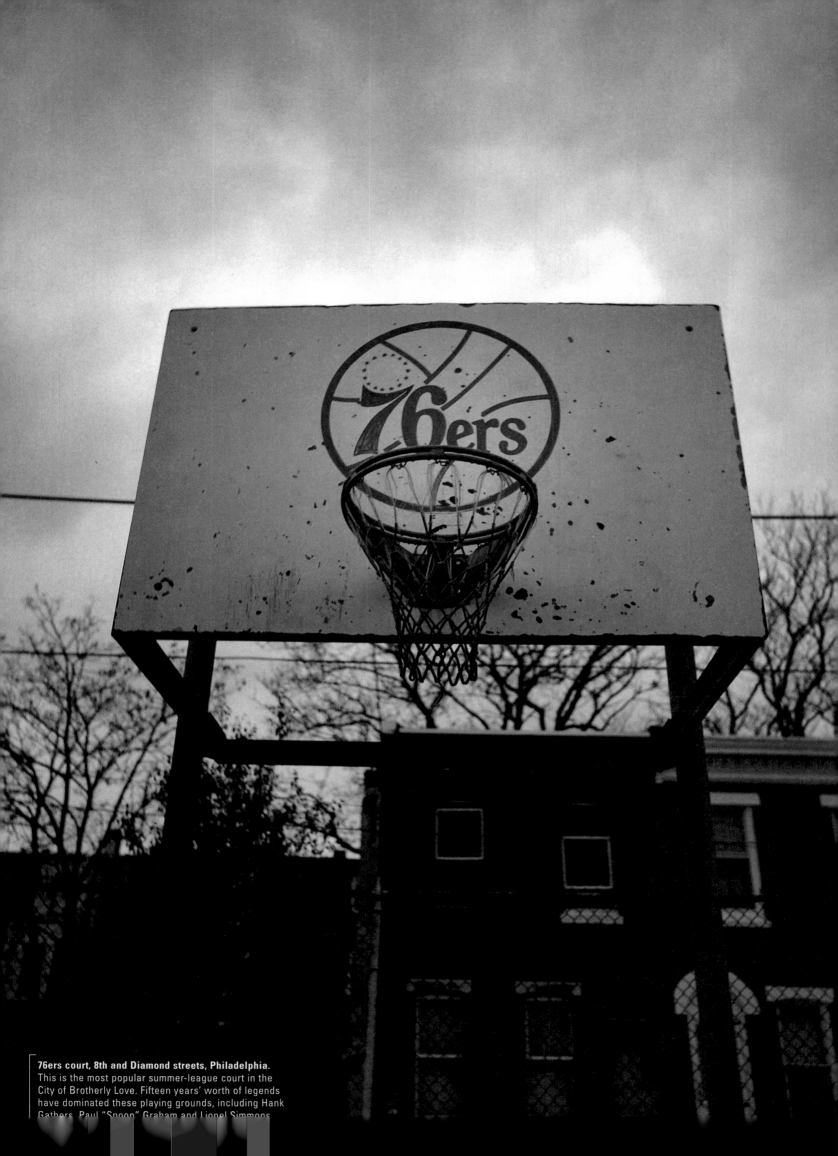

76ers court, 8th and Diamond streets, Philadelphia.
This is the most popular summer-league court in the
City of Brotherly Love. Fifteen years' worth of legends
have dominated these playing grounds, including Hank
Gathers, Paul "Spoon" Graham and Lionel Simmons.

Bryant Watson, aka Sad Eyes, shooting guard, Philadelphia.
Watson is a 6-foot-5, poised and talented offensive player with the
smarts of a point guard. He once scored 26 points in a 1995 game
against New York summer legends, including Speedy and Predator,
at West Fourth Street—all in the second half. Having gotten lost en
route, Sad Eyes rolled in at halftime and shot 12 for 13 from the field.

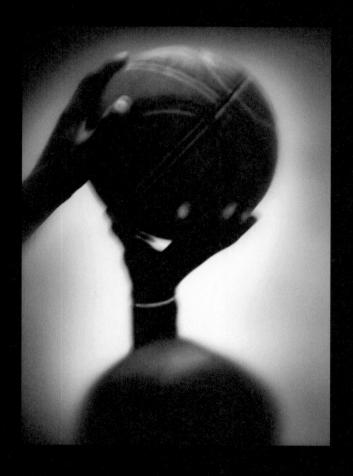

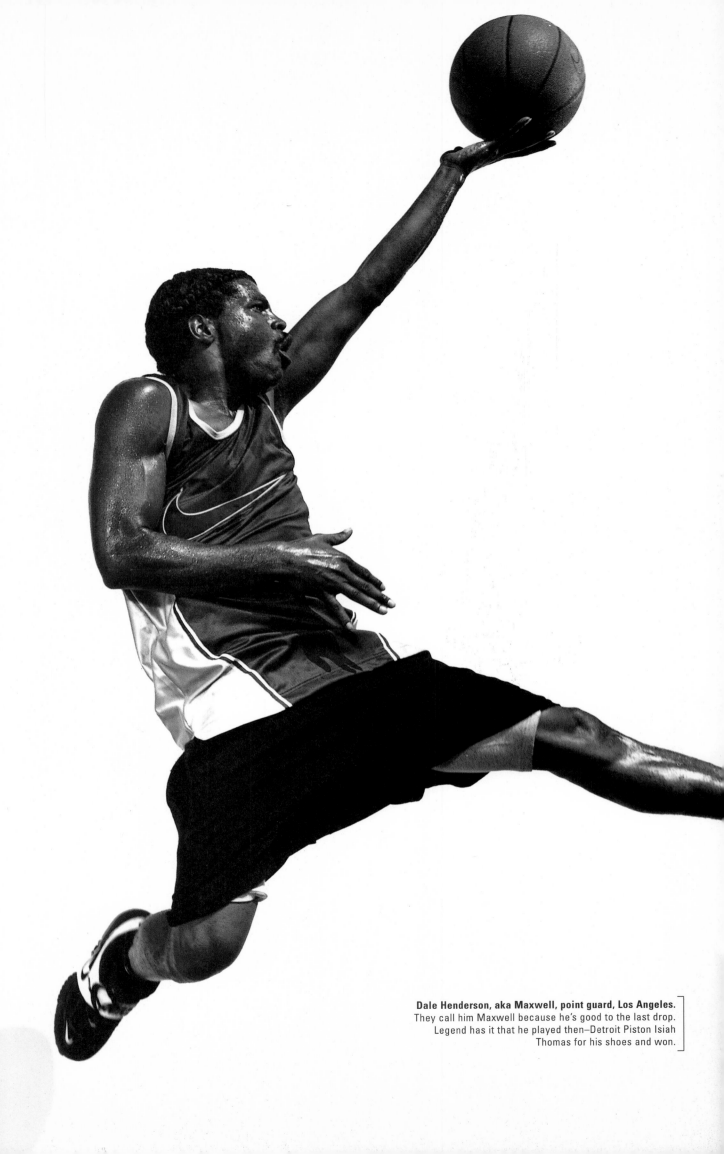

Dale Henderson, aka Maxwell, point guard, Los Angeles.
They call him Maxwell because he's good to the last drop.
Legend has it that he played then–Detroit Piston Isiah
Thomas for his shoes and won.

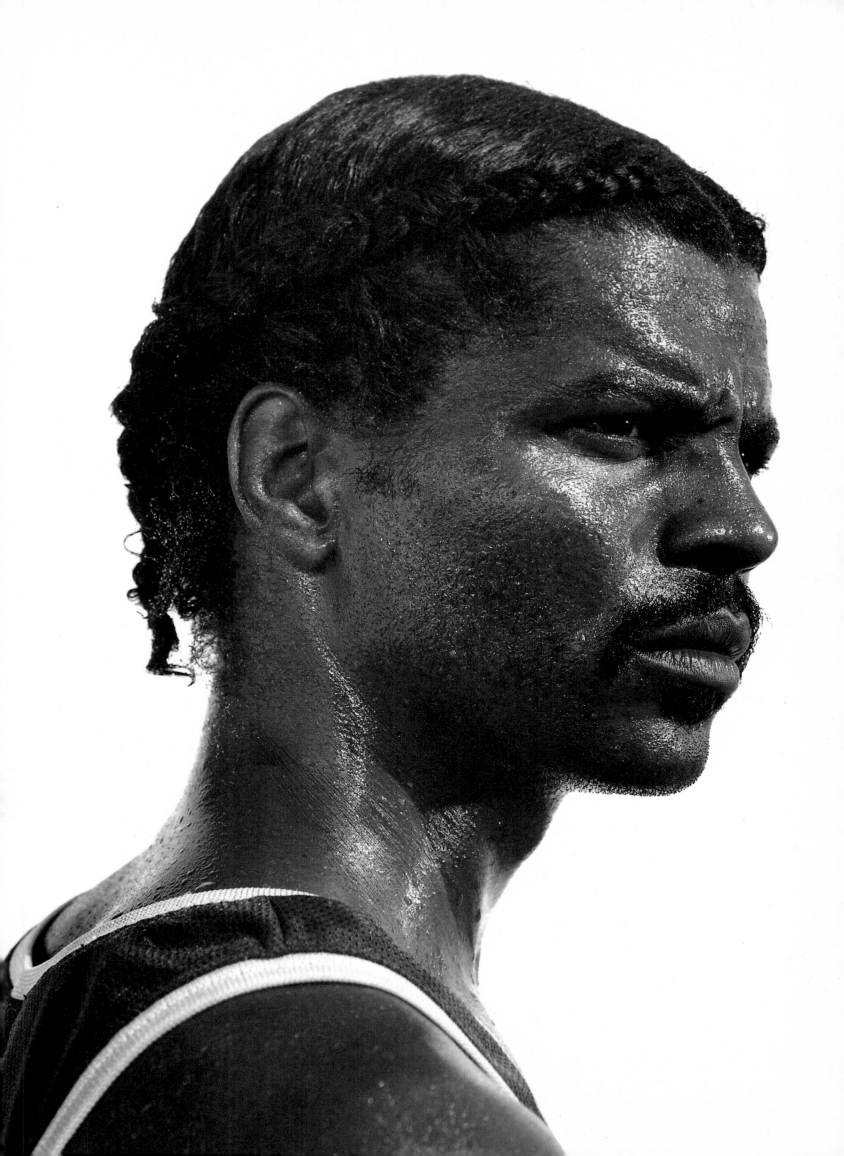

B-BALL
BE
JAZZ

by
Gregorio
Deshawn McDonald

B-ball be jazz.
Be musicians playing their favorite jams
dribbling solos down wood floors
slamming b-sharp note for fans.
B-ball be the bomb.
Bombing outside shots from dawn till dusk
hush the crowd with a wrist-snap
a piano-key finger-stroke.
Be the skill of picking notes between the frets
as easy as a pick-and-roll cut to the basket.
Countless hours of playing make it all move and groove and flow
like human nature
like exquisite sounds
big rebounds.
B-ball be big bands blowing harmony in juke joints all night long.
Be a jazz singer's song rising from his chest
dazzling his audience
giving them his best.
B-ball be young, fast and outrageous.
A contagious epidemic we hope we can catch
cause b-ball be jazz.
Be the razzmatazz of Dr. J
Magic's no-look pass
be style like Miles
and funk like Monk
be blocked shots
spin moves
clean steals
head fakes
drop steps
and slam dunks.
Be an entire universe balled up in an orange sphere
spinning on a fingertip axis.
Be the crystal-clear sound of jazz humming in our ears
and there's nothing else quite like it.

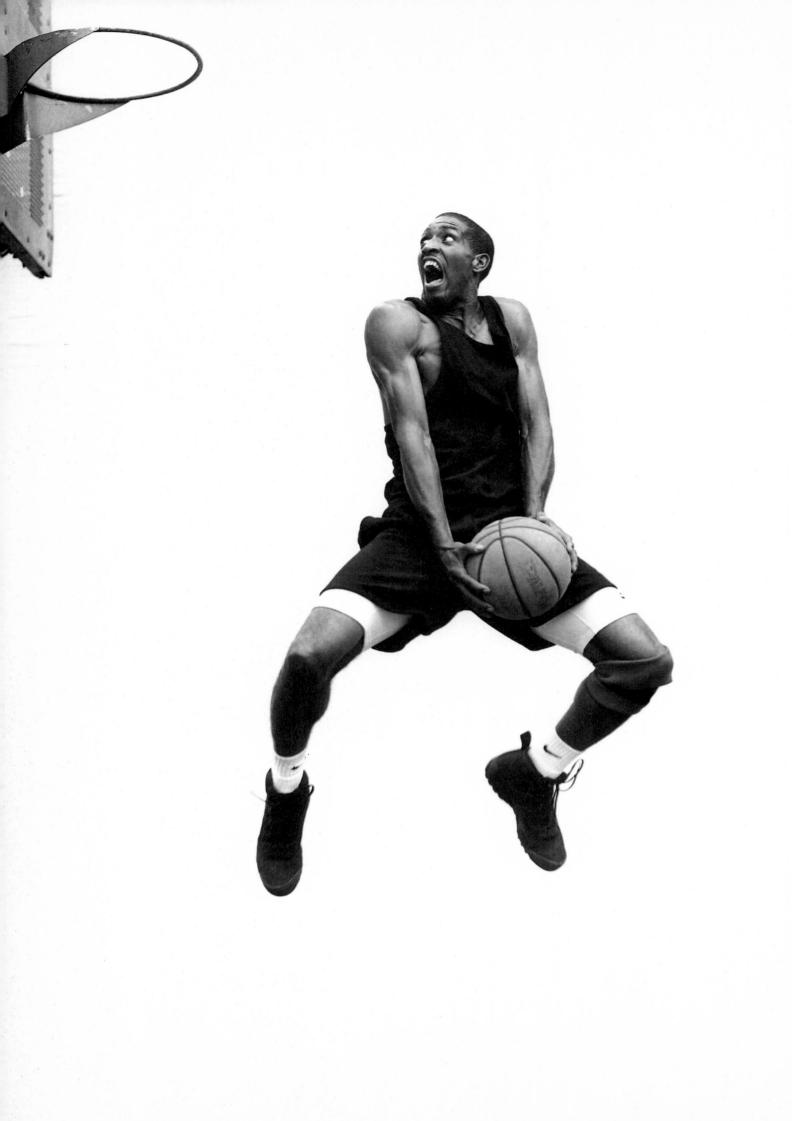

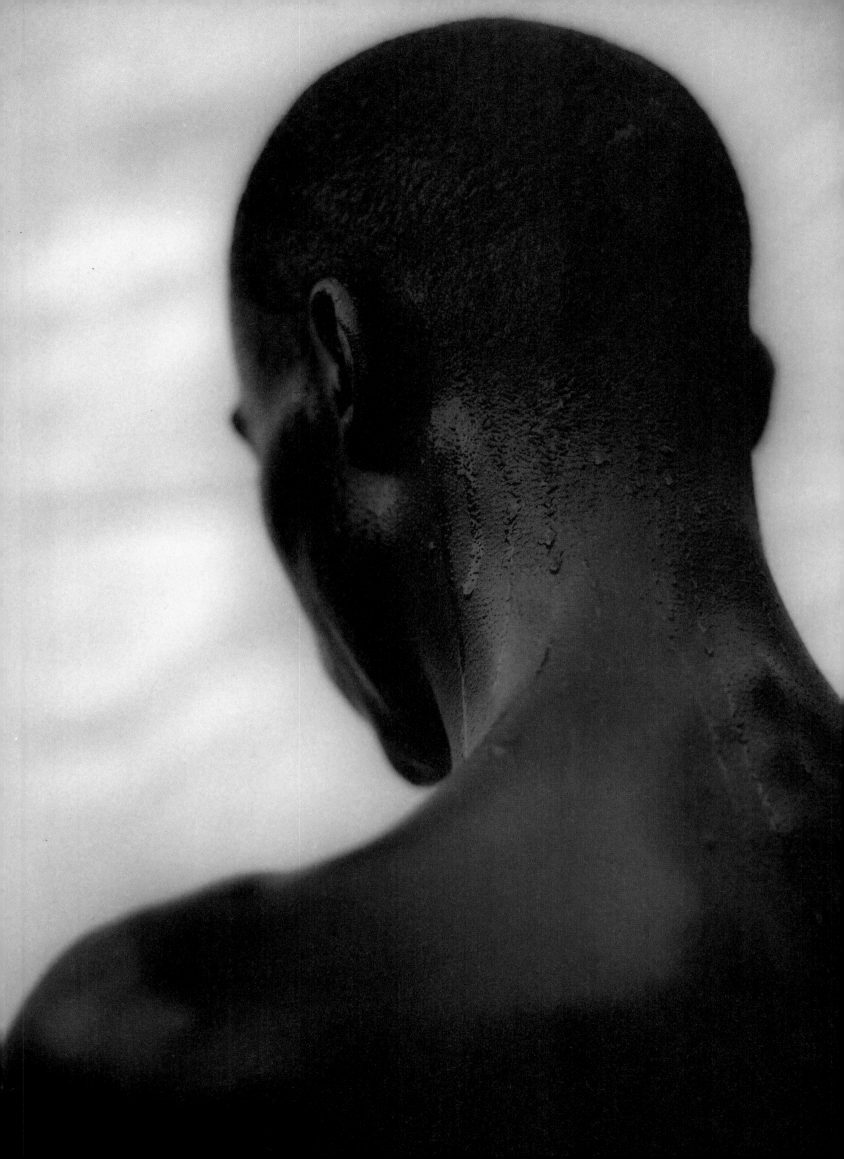

Arkansas Red

James Allen, aka Arkansas Red, point guard, Los Angeles.
This fiery point guard now resides in Los Angeles. According to Red, if the three-pointer had existed in his day, he would have averaged 100 points. Red's claim to fame came in college when he played for Arkansas Pine Bluff in a game against the Willis Reed–led Grambling squad. Hi own home fans were resigned to the belief that Arkansas–Pine Bluff was going to be crushed, but Red refused to accept this defeatist attitude. So he scored 60 points in a double-overtime win against Grambling.

After college, Red found his way to L.A., where he continued his legendary play at Los Angeles Trade Tech. Red's long-distance bombing was so deadly and accurate that his L.A. teammates soon began to refer to him as Radar.

Before his retirement from the game at age 45, Red's pure jump shot game inspired a young Watts ball player by the name of Raymond Lewis.

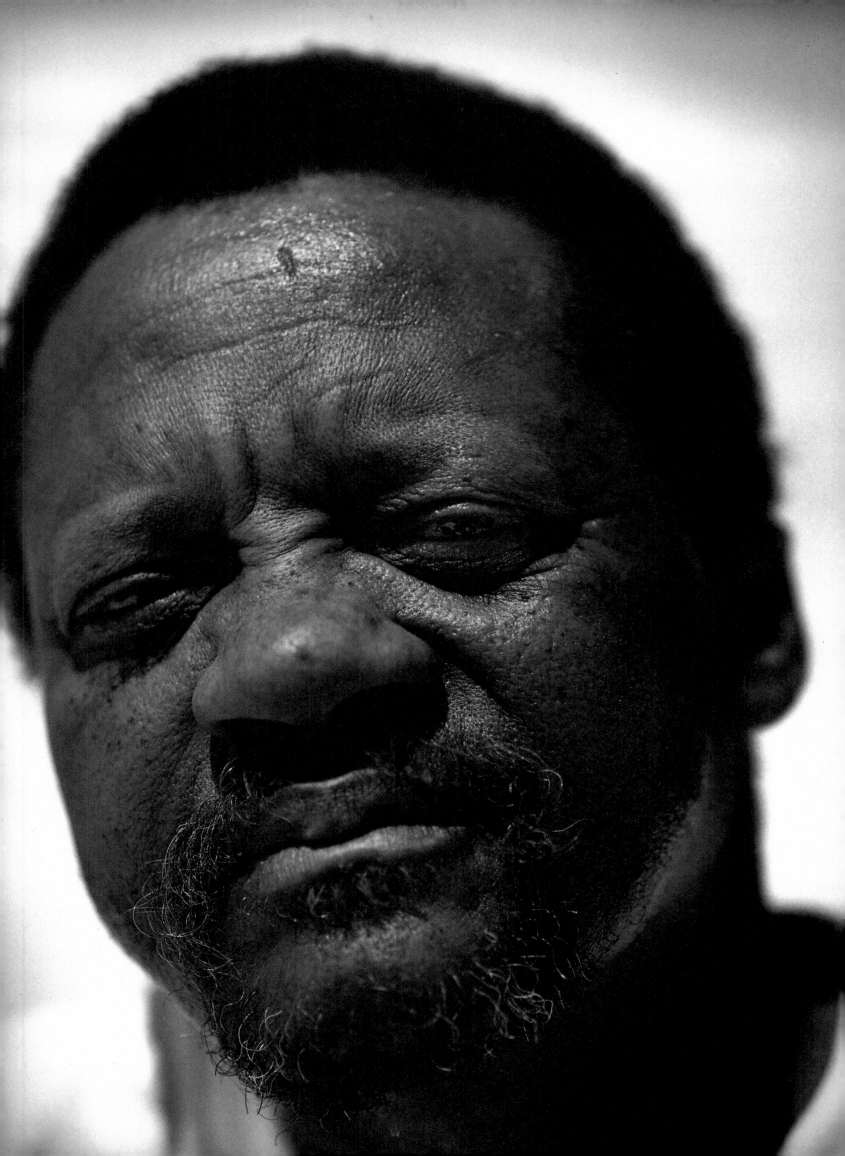

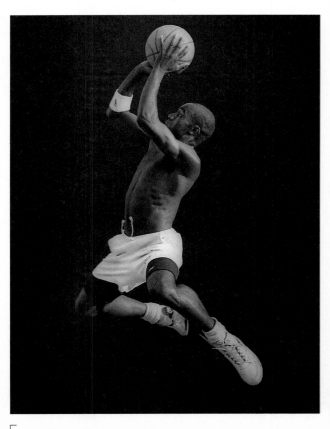

Peter Etienne, shooting guard, Boston.

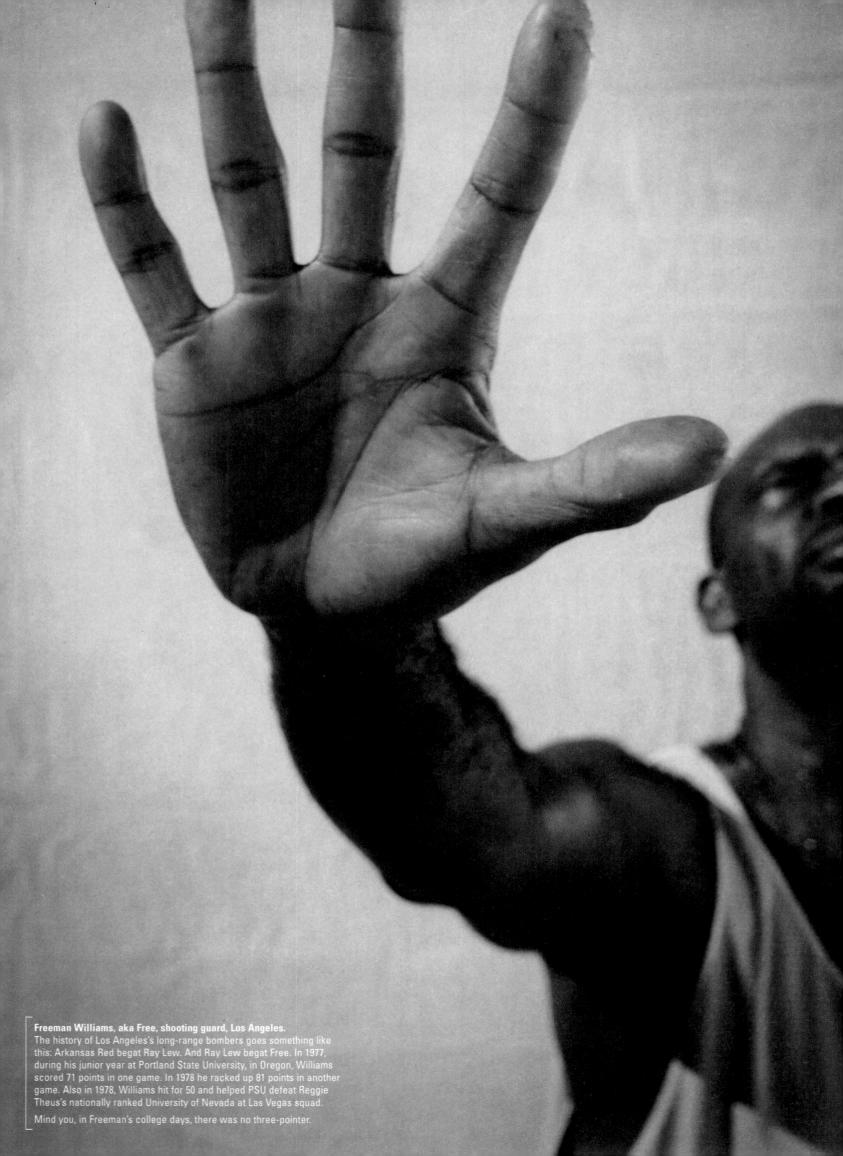

Freeman Williams, aka Free, shooting guard, Los Angeles.
The history of Los Angeles's long-range bombers goes something like this: Arkansas Red begat Ray Lew. And Ray Lew begat Free. In 1977, during his junior year at Portland State University, in Oregon, Williams scored 71 points in one game. In 1978 he racked up 81 points in another game. Also in 1978, Williams hit for 50 and helped PSU defeat Reggie Theus's nationally ranked University of Nevada at Las Vegas squad.

Mind you, in Freeman's college days, there was no three-pointer.

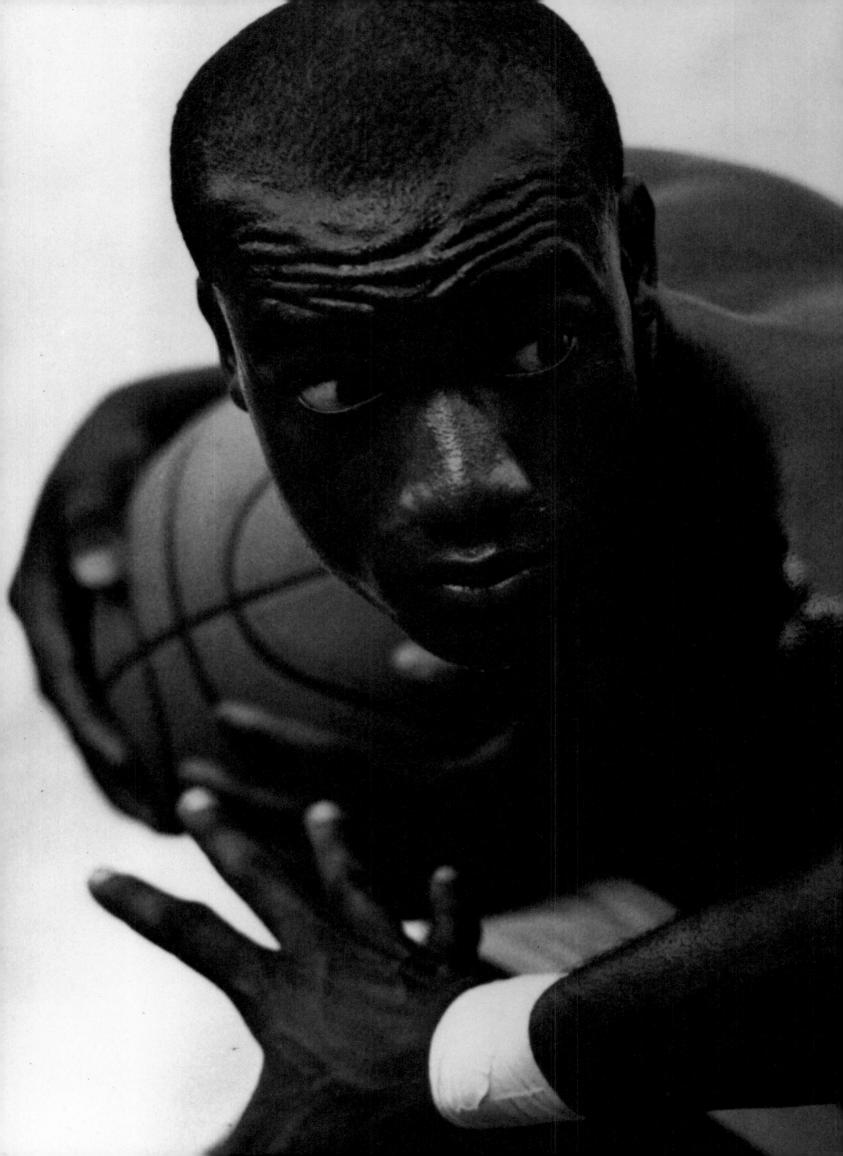

KID

by Poetri

What's up, kid, yeah,
I called you, kid. It ain't no
secret, I called you, kid,
'cause your hoop skills are
immature, so undeveloped,
so young, a child, a baby,
an infant, compared to the
adult hoop styles that I
possess. Yo, kid, grow some
hair on your chest before
you test adulthood. PG or
Rated R, as I watch your
game, I still see milk
dripping from its mouth,
without question you're
still a child. My victory
was meant to be, ain't it
scary, you're pop, kid,
while I'm adult contempo-
rary. It's necessary I get
you to understand, you're
not playing with action
heroes, you will never
compare to the reality of
my jumper, man, I mean,
kid. Wipe the tears from
your eye, cut all that
drama. You lied that you
can beat me and got a
spanking from mama.
Your game will always be
a child to me, you can
never be older than your
older brother. You'll never
grow up, kid, so allow this
jumper to put you to bed!

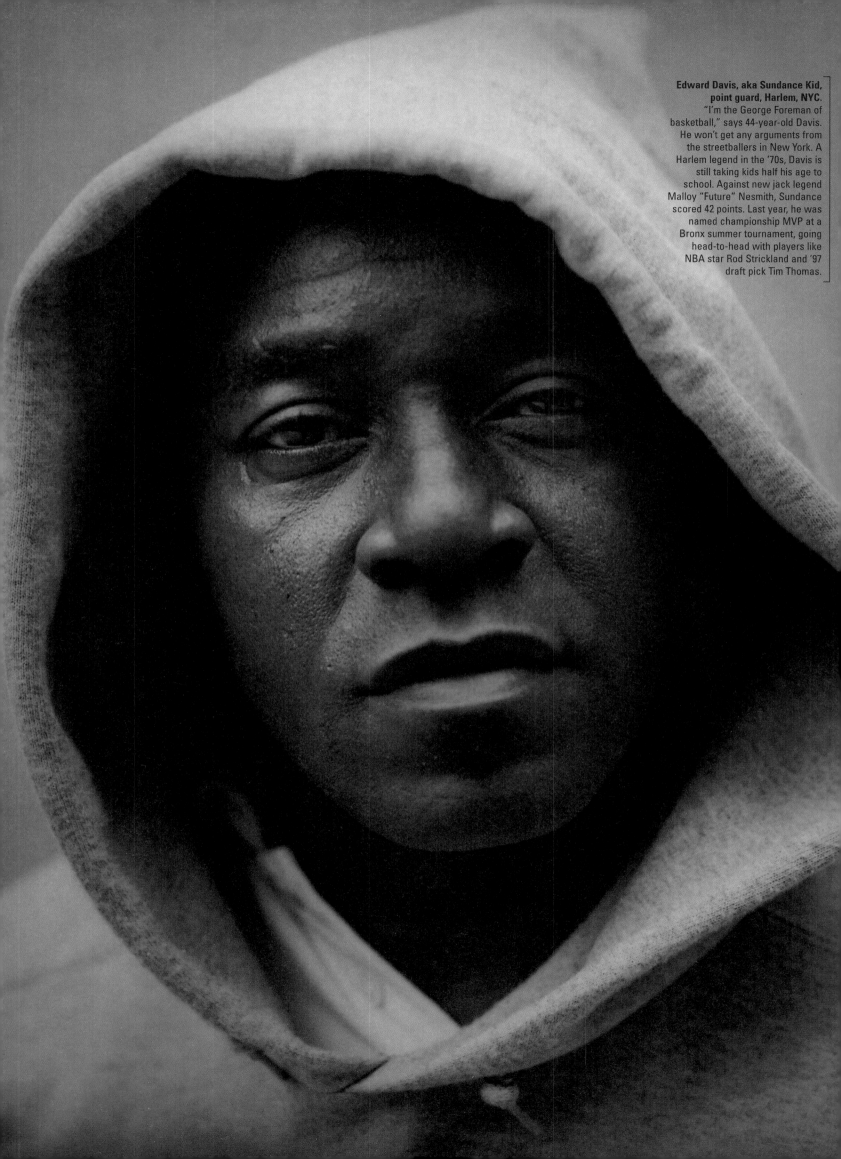

Edward Davis, aka Sundance Kid, point guard, Harlem, NYC. "I'm the George Foreman of basketball," says 44-year-old Davis. He won't get any arguments from the streetballers in New York. A Harlem legend in the '70s, Davis is still taking kids half his age to school. Against new jack legend Malloy "Future" Nesmith, Sundance scored 42 points. Last year, he was named championship MVP at a Bronx summer tournament, going head-to-head with players like NBA star Rod Strickland and '97 draft pick Tim Thomas.

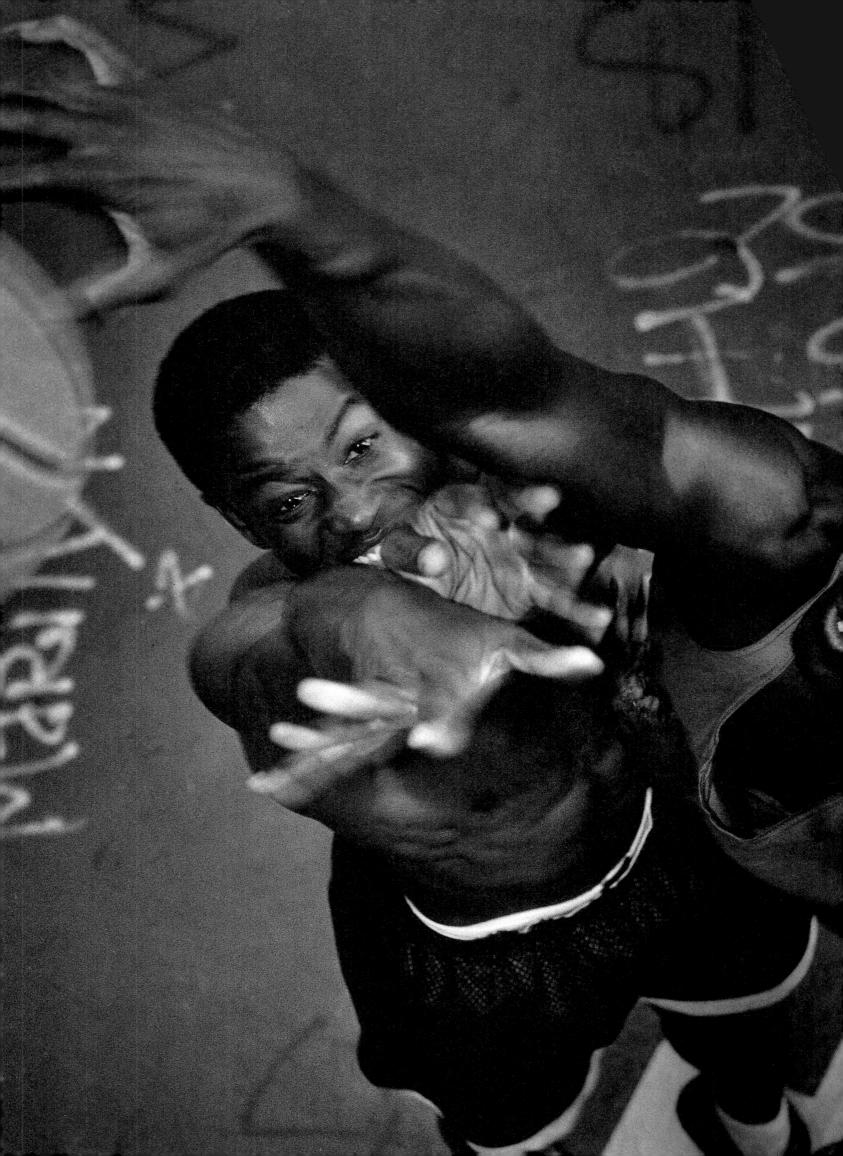

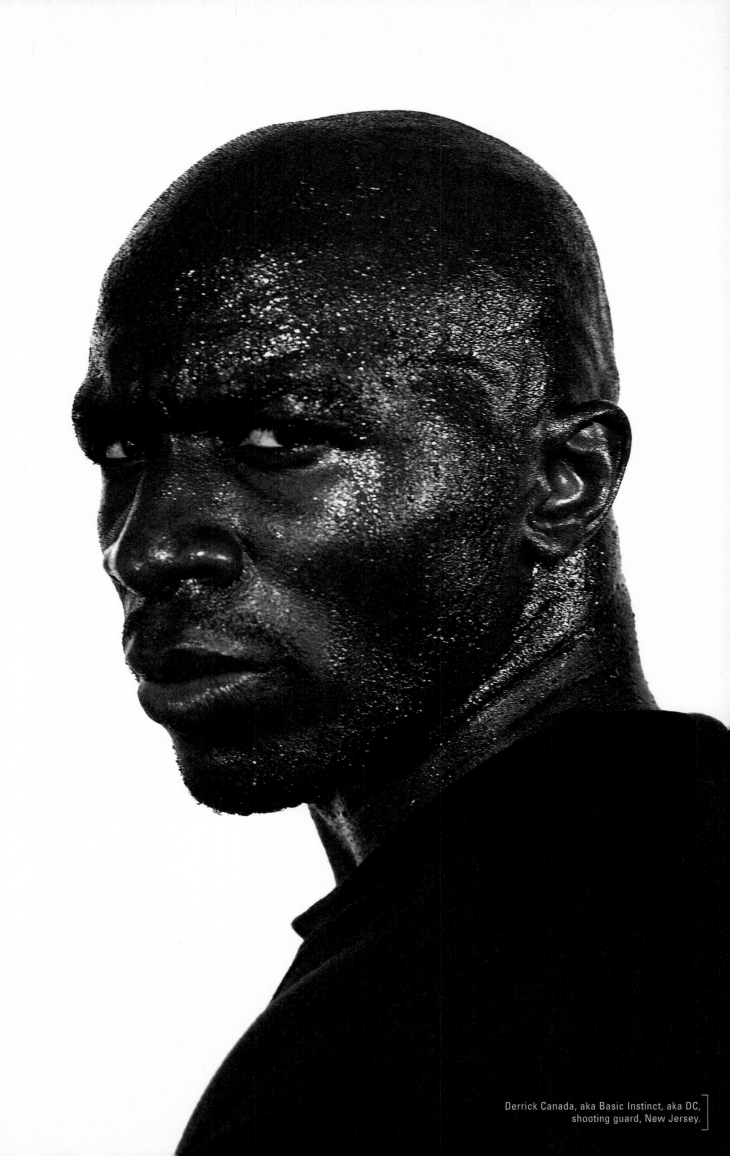

Derrick Canada, aka Basic Instinct, aka DC,
shooting guard, New Jersey.

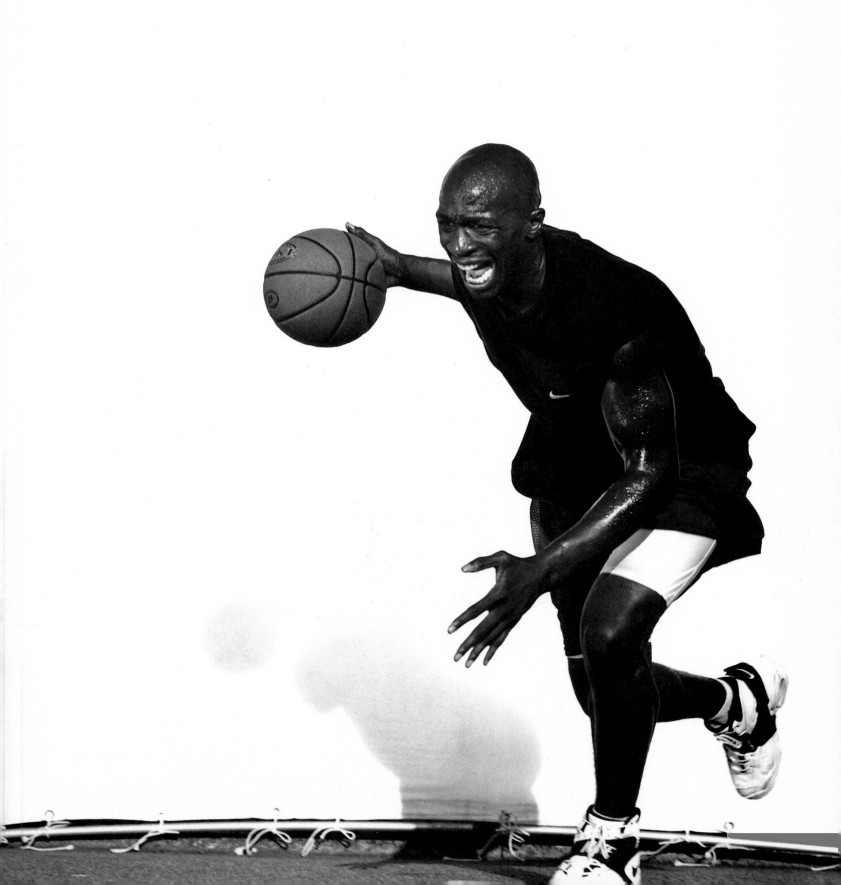

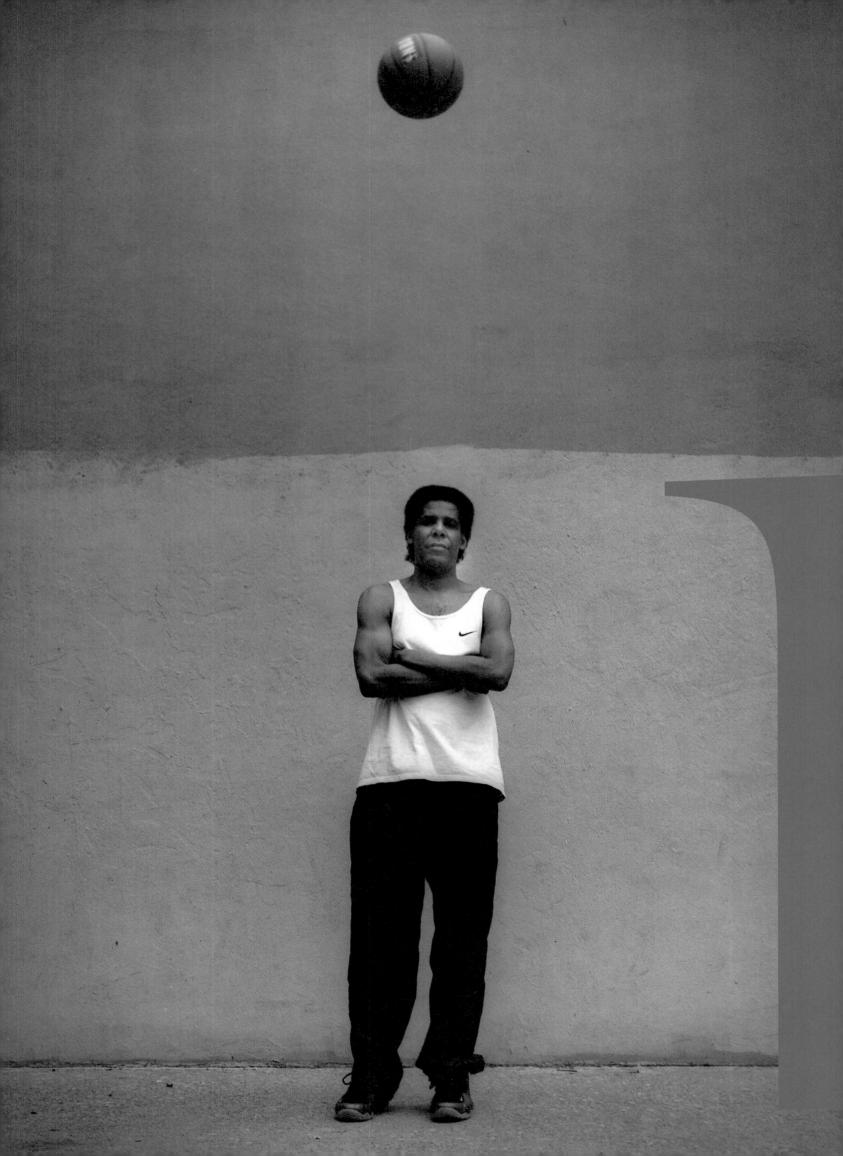

Pee Wee Kirkland

Richard Kirkland, aka Pee Wee, aka Stickman, point guard, Harlem, NYC.

Bob Cousy, Lenny Wilkins, Nate Archibald, Rod Strickland, Kenny Anderson, Stephon Marbury. These are some of the greatest point guards ever to come out of New York. But as great as they were and are, none may have been greater than Pee Wee Kirkland. In fact, Archibald, voted in 1997 one of the NBA's 50 greatest players, said that Kirkland provided him with his "toughest competition."

Upon graduating from NYC's Charles Evans Hughes High School, Kirkland went to Norfolk State University and played with future NBA great, Bobby Dandridge. More than a decade before Kareem Abdul-Jabbar and Magic Johnson's Lakers, Norfolk State perfected their own version of Showtime, running opponents off the court with an up-tempo, fast-break offense. At the time, *Sports Illustrated* claimed that Kirkland might be the fastest guard in the country.

Kirdland was drafted by the Chicago Bulls in 1968, behind another point guard, Norm Van Lier. In Kirkland's mind, he outplayed Van Lier in training camp, so he asked for more playing time. Unfortunately, Coach Dick Motta disagreed. With his honor at stake, Kirkland packed his sneakers and returned to where it all began—Rucker Park in Harlem.

He played alongside Joe "the Destroyer" Hammond on a squad called Milbank (named after a local community center). The coach was Roger "Buster" Bryant. Though his Milbank team never won a championship, Pee Wee's reputation flourished.

Kirkland says he had over a hundred moves. In his mind, a fake wasn't a fake without a little shake and bake.

Kirkland wasn't satisfied with just a simple crossover move. He wasn't satisfied with your basic hesitation fake. No, no, no! Oftentimes, Kirkland wasn't happy until he had executed a stutter step, triple reverse fake, head fake, between the legs, behind the back, crossover, hesitation move that would make not only his defender's legs lock, but the other four defensive players' legs stick to the ground as well (thus the nickname, Stickman).

It wasn't unusual for Kirkland to arrive at a game in a white, convertible Rolls-Royce, or to receive $15,000 for a single one-on-one game. These extravagances soon caught the eye of the IRS, and in 1971, Kirkland found himself sentenced to prison for 10 years. However, this didn't stifle his hoop skills. Playing in a Pennsylvania semipro circuit that included prison teams, Pee Wee scored 135 points in a game against a Lithuanian squad, making headlines across the country.

While in prison, a transformation occurred in Kirkland. He decided that instead of being part of the problem, he would be part of the solution. When he was released, Kirkland eventually returned to New York with the intent of helping kids. Today, his dream is being realized.

Kirkland is now the head of basketball operations at the Dwight School, a private school in Manhattan. In 1997, Kirkland led Dwight to its first high school championship. He also teaches at Long Island University, and runs a camp called School of Skillz, which teaches kids how to cope on and off the court.

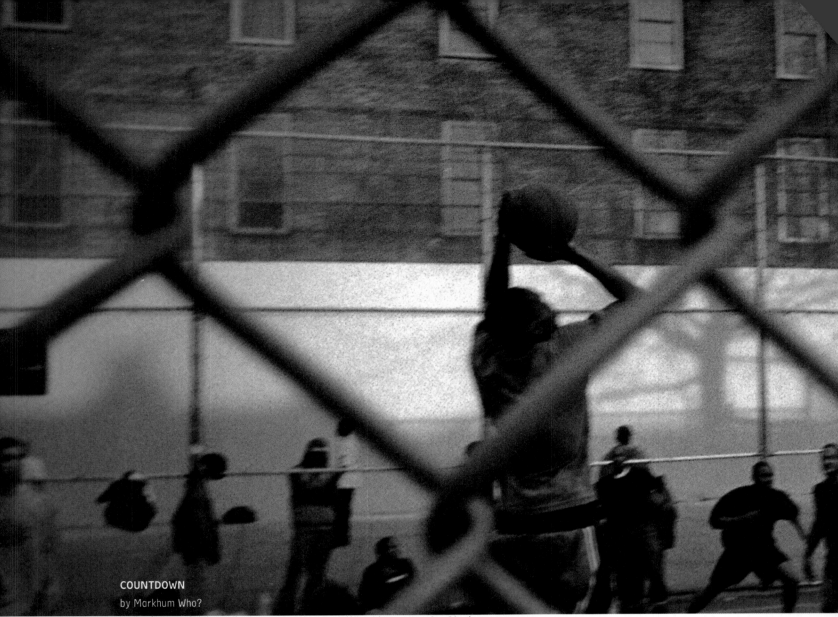

COUNTDOWN
by Markhum Who?

two down and ten to go ... 10 ... Magic races the ball up the court ... 9 ... Magic
looks at Jordan ... 8 ... passes to a wide-open Bird ... 7... Bird fumbles the
ball ... 6 ... a desperation feed to Dream in the post ... 5 ... nightmare they
collapse on Hakeem ... 4 ... Dream dishes to Jordan ... 3 ... Air is
suffocated ... 2 ... Jordan swings it to ME waaaaay behind the three-point
line ... 1 ... it's up ... it's going ... 0 ... it's gooood!!!!!

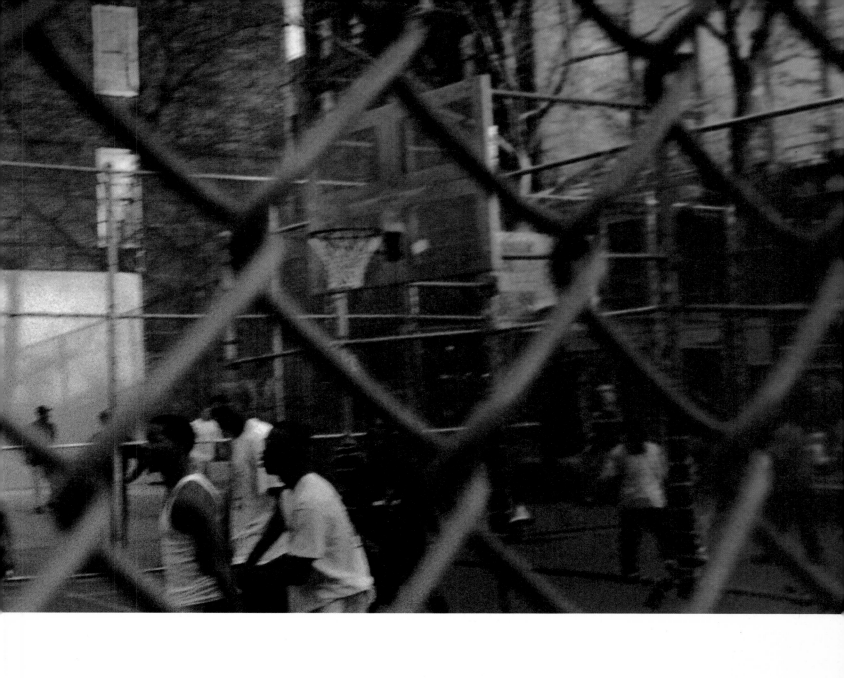

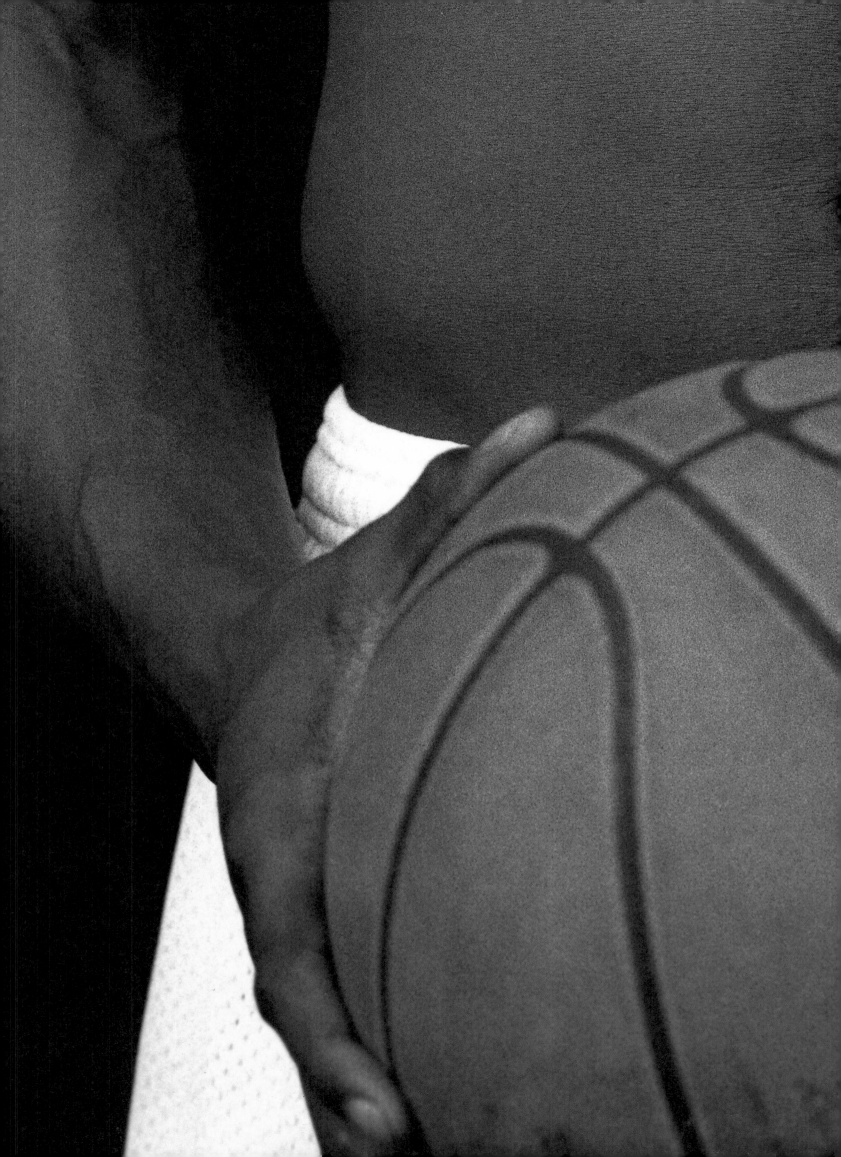

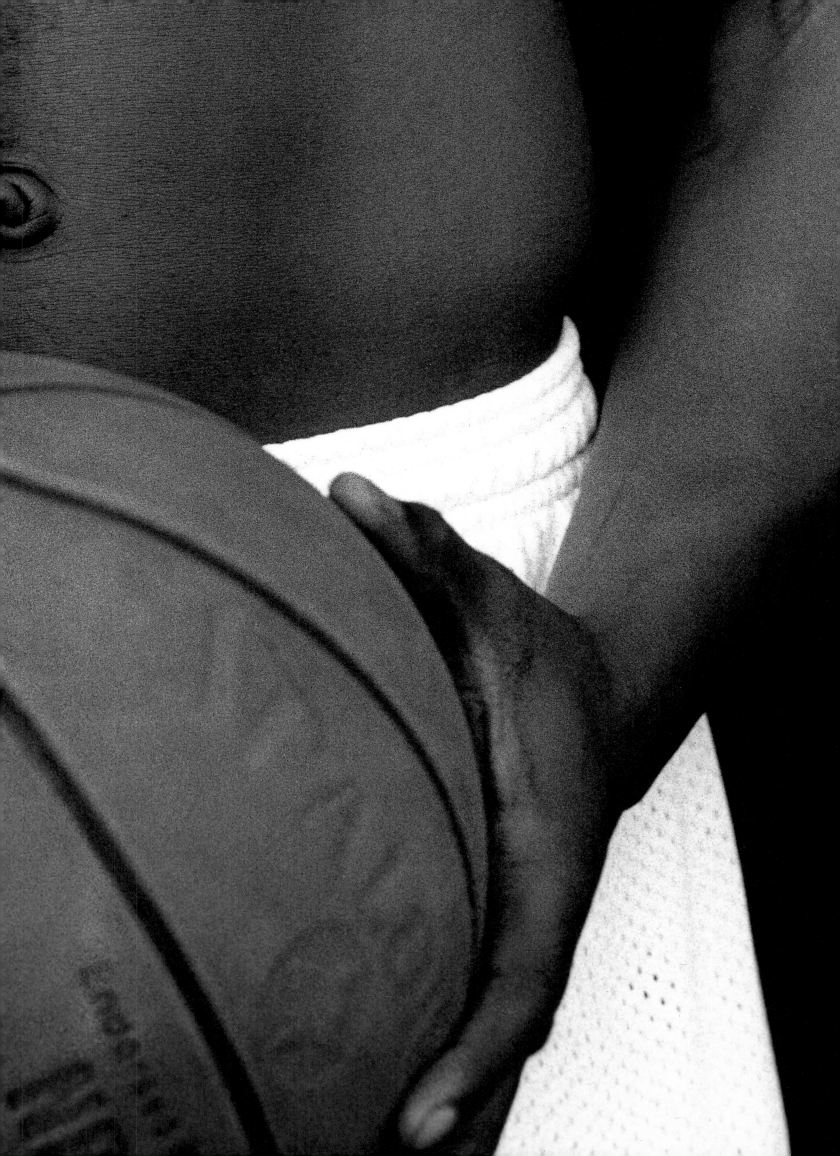

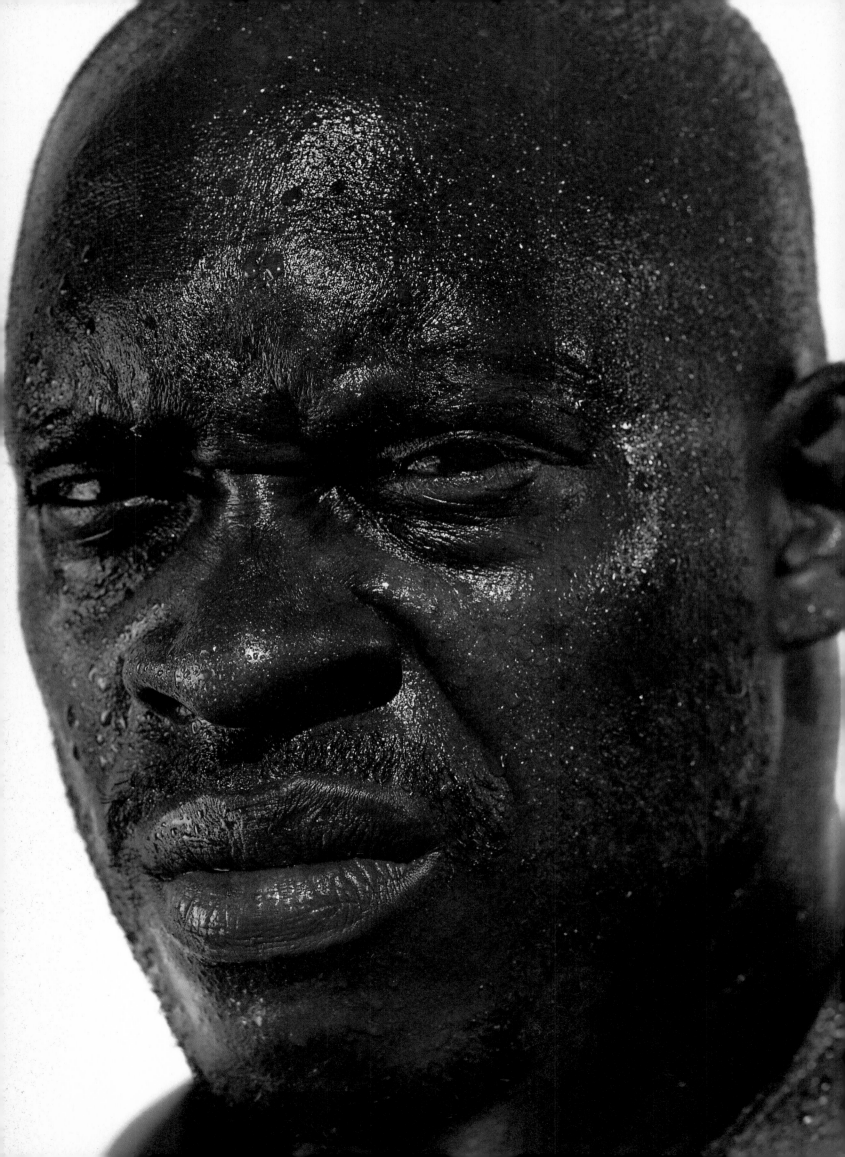

Archibald is the only player ever to have
led the NBA in both scoring and assists
in the same season (34 points and 11.4
assists per game in 1972–1973). He is an
NBA Hall of Famer and a player whose style
was cultivated on the streets of NYC. "As
far as I'm concerned, Tiny was the smartest
guard who ever played point," says Pee Wee
Kirkland. "His game was so sophisticated
that it took the rest of the league six or
seven years to understand what he was
doing." Drafted in the second round by the
Cincinnati Royals in 1970, Archibald played
14 seasons in the NBA, for five different
teams, including the Kansas City–Omaha
Kings and the Boston Celtics.

Nate Archibald, aka Tiny, aka Nate the Skate, point guard, NYC.

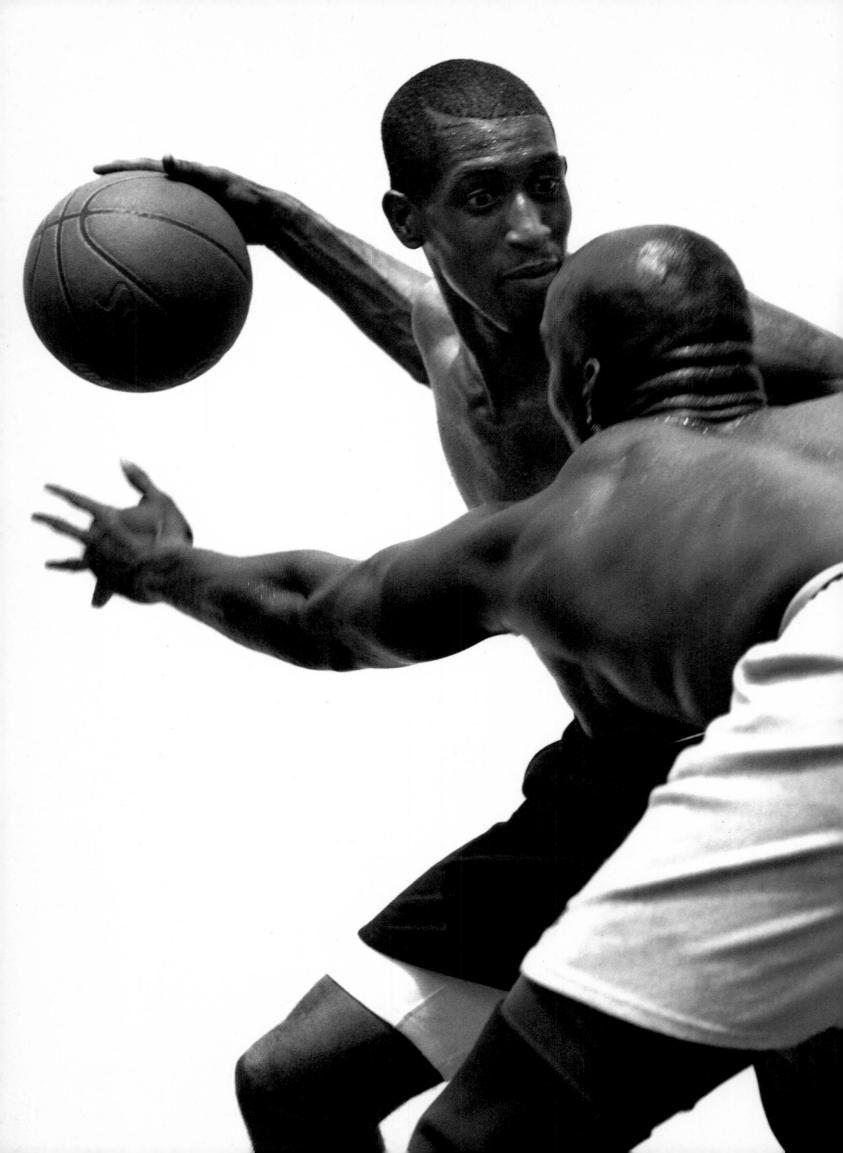

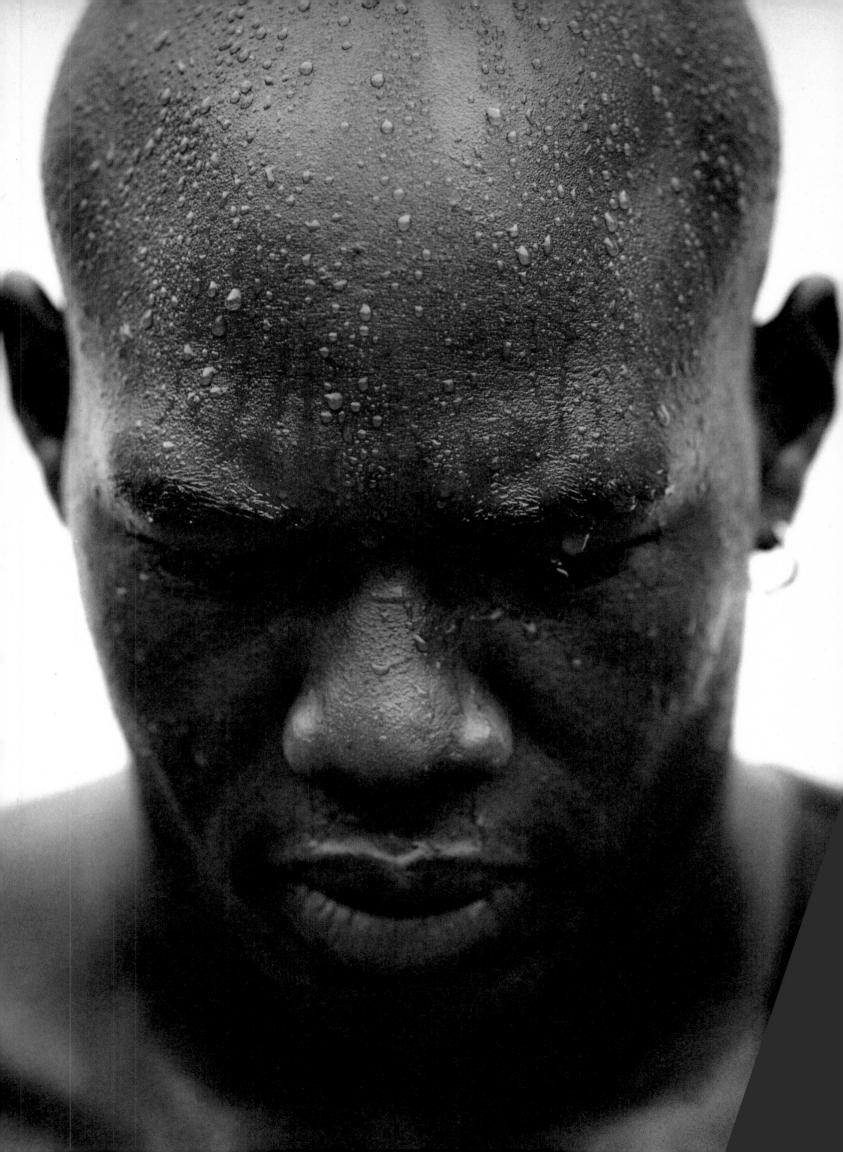

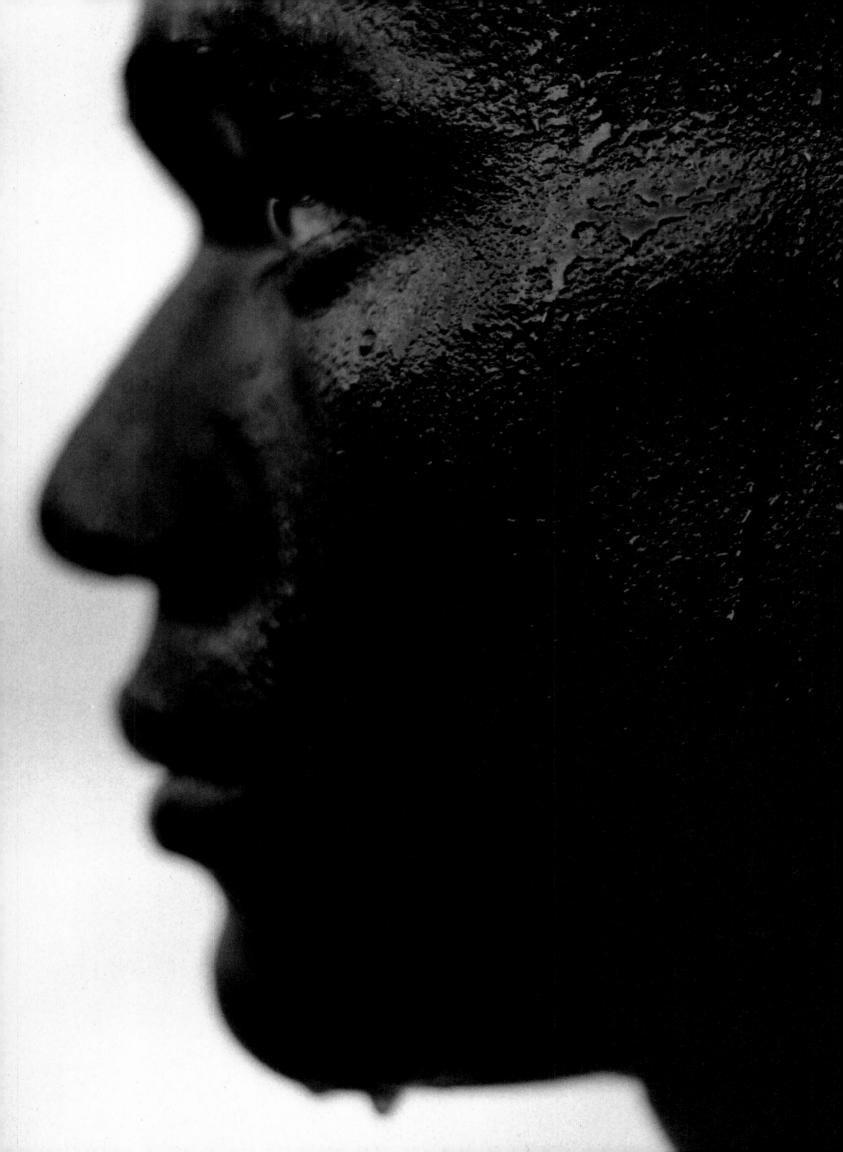

PASS THE BALL
by Markhum Who?

Yo! man I'm wide open on the block
All you gotta do is look.
Get me the rock
And let me throw my sky hook.

Your time will come baby.
You just gotta be cool.
Be patient, learn the game,
And watch me serve this fool.

I've told you once.
Get me the ball in the post!
Look who's checking me
It's a mismatch—he's toast!

Who you yellin' at?
Don't you know I run this show?
Do your job so I can do mine.
Gimme the rebound then get up and go.

Hey, fellas sorry, but da' game is over—
Nothing against y'all,
But this hawk on my squad
Just won't pass me the ball.

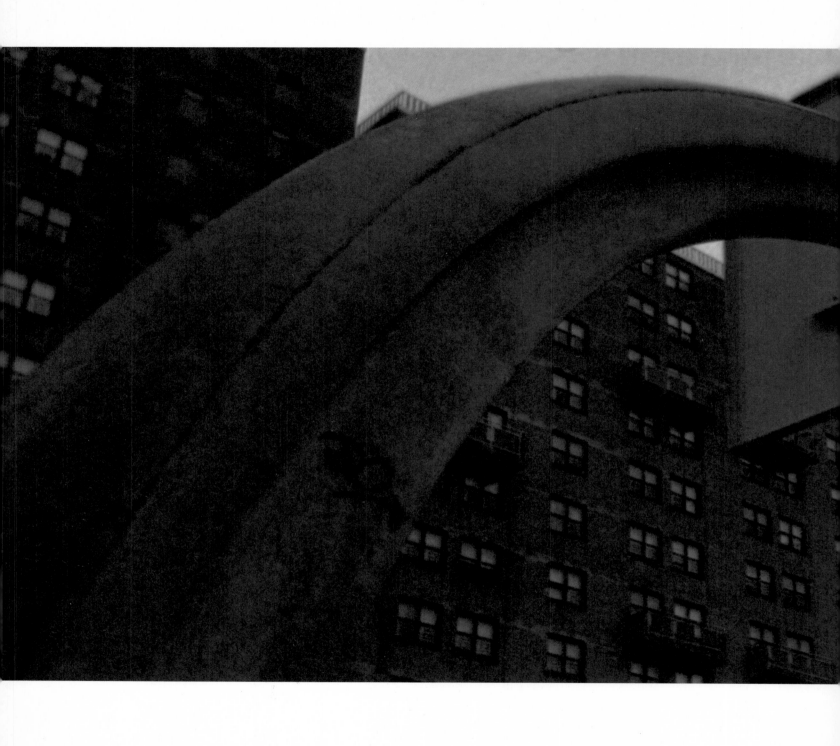

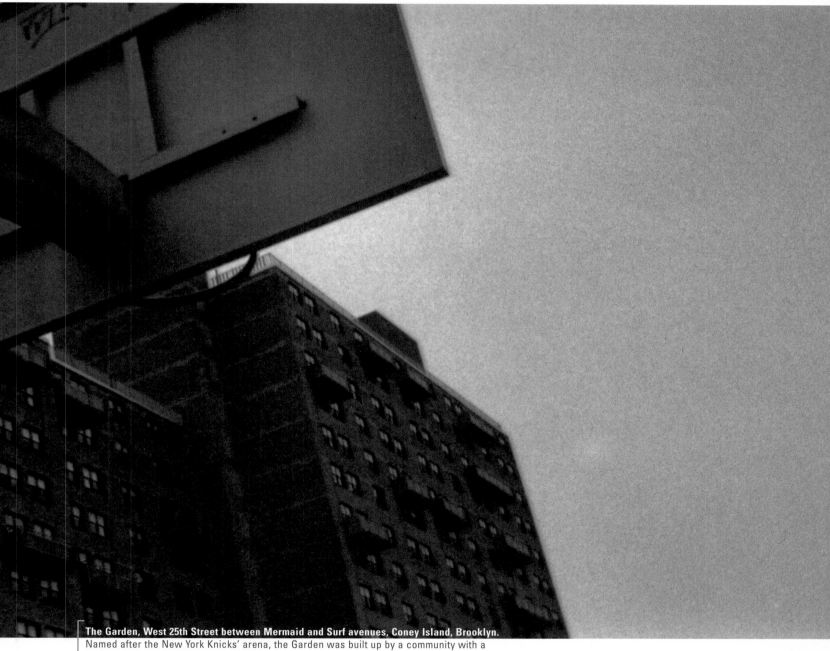

The Garden, West 25th Street between Mermaid and Surf avenues, Coney Island, Brooklyn.
Named after the New York Knicks' arena, the Garden was built up by a community with a
profound respect for basketball, and has served as a sanctuary in a neighborhood ravaged
by drug commerce. Court renovations during the '90s—everything from a new paint job to
the construction of concrete bleachers—may be directly attributed to community support.
The Garden has its own freelance coach, Robert Williams, a Coney Island resident known
by the players as "Mr. Lou." Every summer, huge crowds congregate to watch tournaments,
hoping to spot the players who will follow in the footsteps of Garden legends past: David
"Chocolate" Harris, brothers Eric "Spoon" Marbury, Norman "Jou-Jou" Marbury and
Stephon Marbury, Bernard "T" Mitchell, Dwayne "Tiny" Morton and Carlton "Silk" Owens.

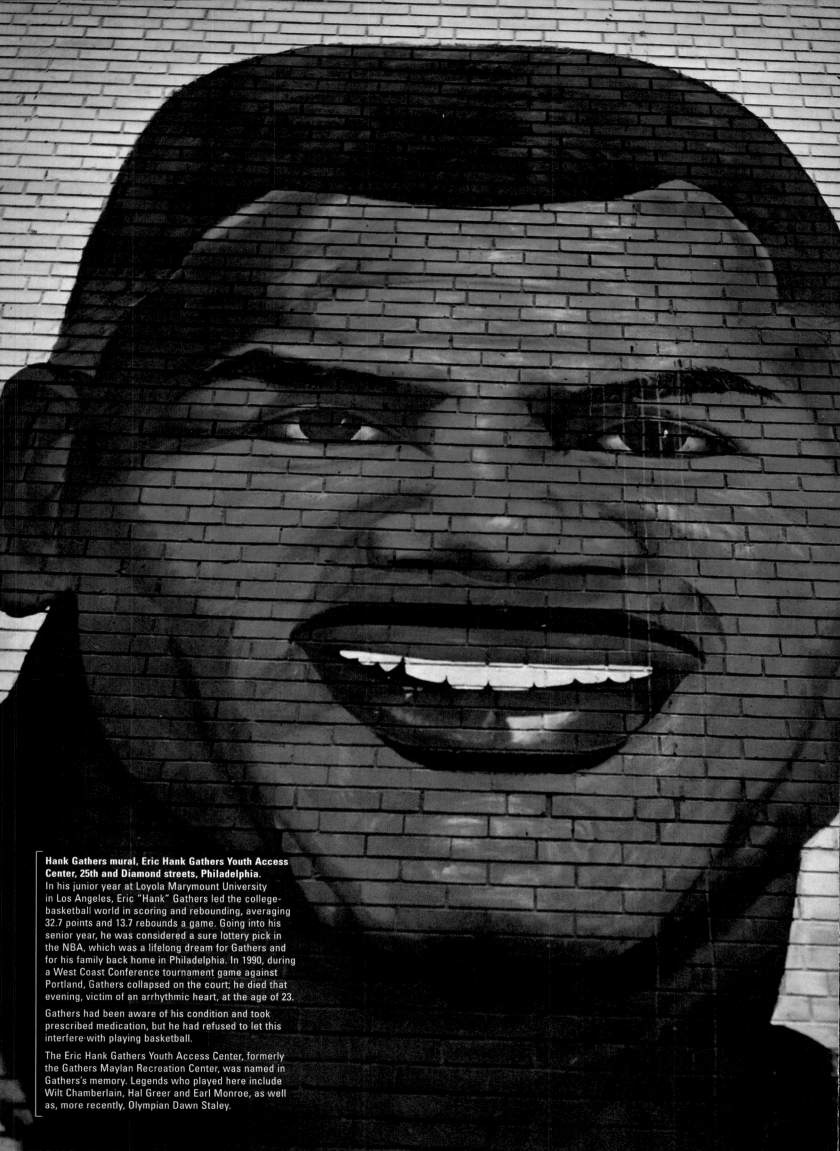

Hank Gathers mural, Eric Hank Gathers Youth Access Center, 25th and Diamond streets, Philadelphia.
In his junior year at Loyola Marymount University in Los Angeles, Eric "Hank" Gathers led the college-basketball world in scoring and rebounding, averaging 32.7 points and 13.7 rebounds a game. Going into his senior year, he was considered a sure lottery pick in the NBA, which was a lifelong dream for Gathers and for his family back home in Philadelphia. In 1990, during a West Coast Conference tournament game against Portland, Gathers collapsed on the court; he died that evening, victim of an arrhythmic heart, at the age of 23.

Gathers had been aware of his condition and took prescribed medication, but he had refused to let this interfere with playing basketball.

The Eric Hank Gathers Youth Access Center, formerly the Gathers Maylan Recreation Center, was named in Gathers's memory. Legends who played here include Wilt Chamberlain, Hal Greer and Earl Monroe, as well as, more recently, Olympian Dawn Staley.

G

by muMs the schemer

WHAT LEGENDS IS MADE OF

Legends be made up of how your toes succumb to my crossover,
and how I leave you looking left
while I be going right.
How my handle defies the laws of physics,
and how this jumper quiets my critics.

The no-look pass etched on minds
and remembered for years to come.
How I could never be played one-on-one.

the fadeaway
the finger roll
the hook
the behind-the-back
the alley-oop
the stutter step
the teardrop

And most of all
the way I whispered it all in my opponent's ear
before it all got started.
That's what legends is made of.

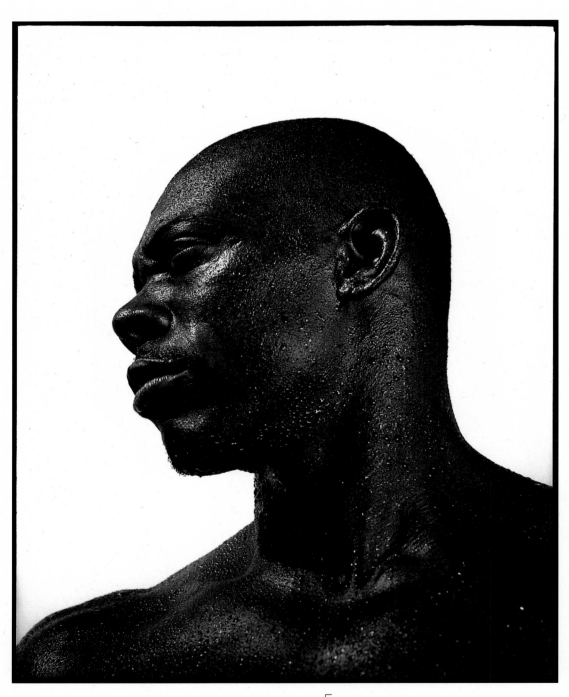

Lenzell Vaughn, aka Predator, power forward, NYC.

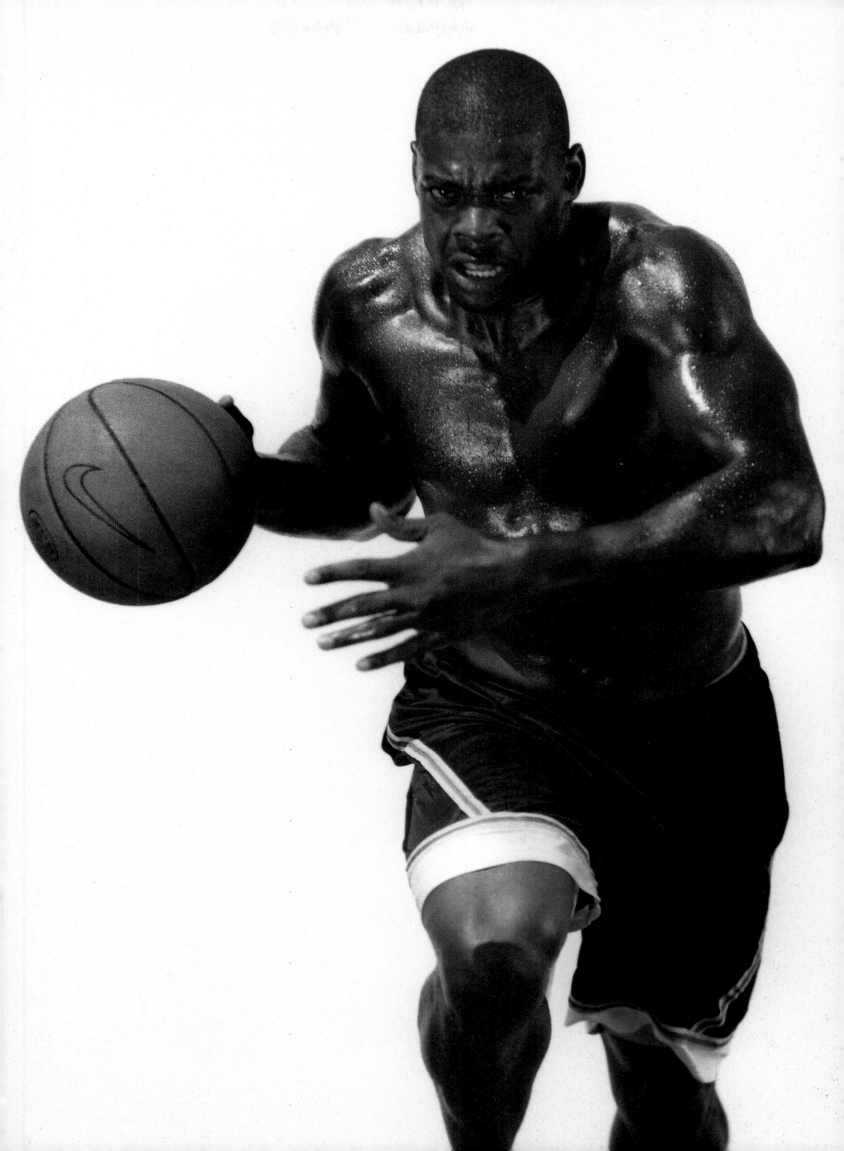

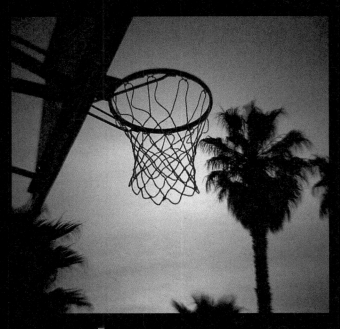

Venice Beach Recreation Center, Venice Boardwalk, Los Angeles.
Adjacent to Muscle Beach, this is the most prestigious streetball court
in all of California. And don't let the sunny skies and beautiful sandy
beaches fool you: Those who play here come to play. Just ask the
Los Angeles Lakers' child prodigy, Kobe Bryant. He broke his wrist here
trying to brace himself after a hard foul. Come strong or don't come at all.

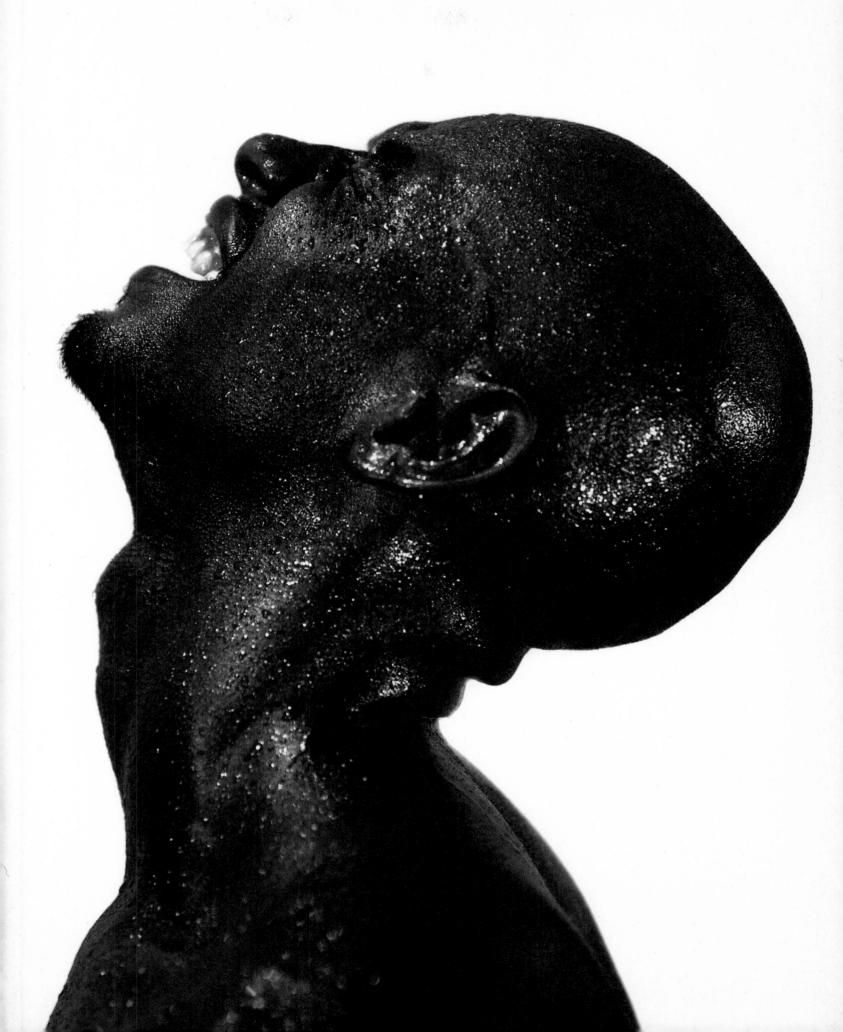

CAREFULLY

Fades, dreads and bald heads
run back and forth across the court
performing carefully choreographed ballets
 they call plays
 as the sun's rays
 melt away the different shades of skin
 color lines begin to dissolve
 and everyone unites in a simple common goal:

 get the ball in the hole.

 A simplistic ideal at best
but street ballers test their ability daily
to perform these street ballets
 and they don't need to get paid to play
 cause you can't put a price tag
or a thirty-second infomercial bag on what they do.

They play to win the respect of the other nine players on the court
and even though they may like wearing a certain brand of shoe
 if shoes could play basketball
 don't you think they would have by now.
 Fades, dreads and bald heads
run back and forth across the court

CHOREOGRAPHED

by Gregorio Deshawn McDonald

sporting high-top shoes
 low-hanging shorts
 and the competitive nature of all sports:

 color never matters.

Set all differences aside to achieve a common dream.
 Dr. King died for that message
 but his ideal lives and breathes
as simply as street ballers performing carefully choreographed ballets
 called plays
 all across this nation.

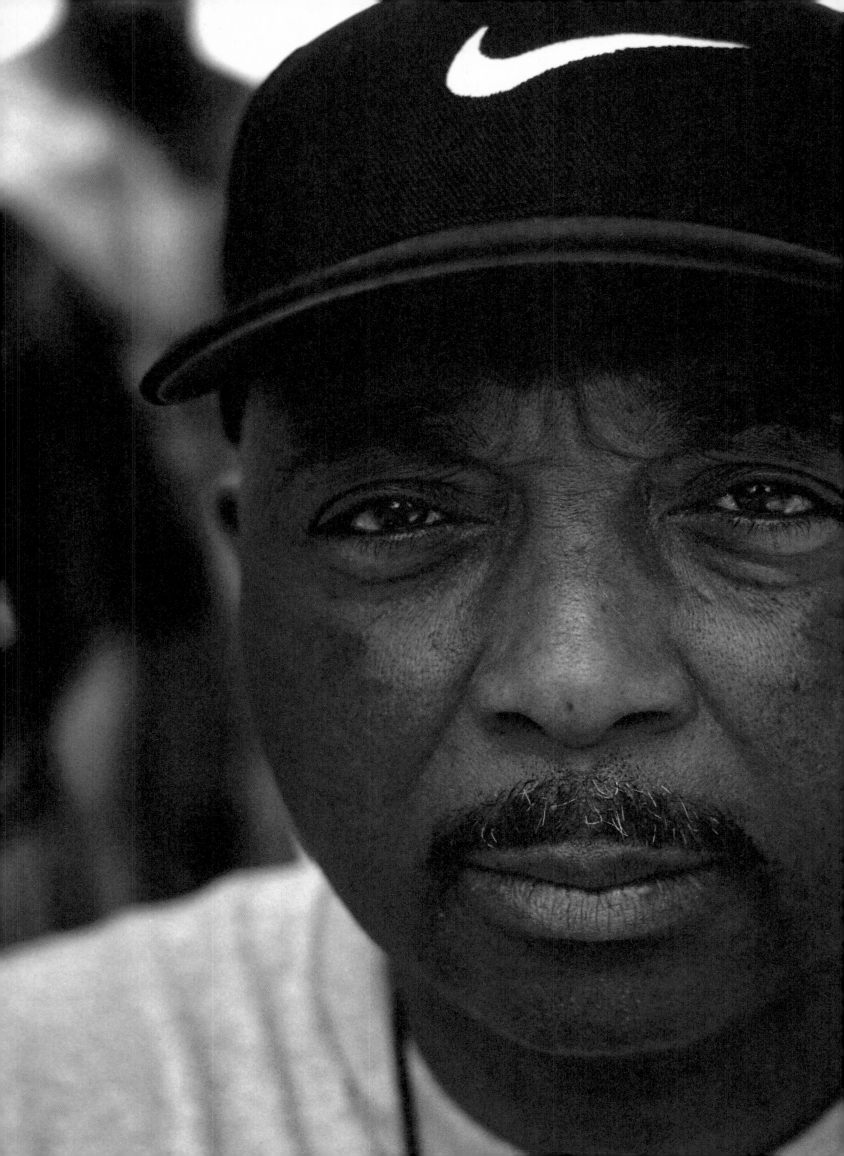

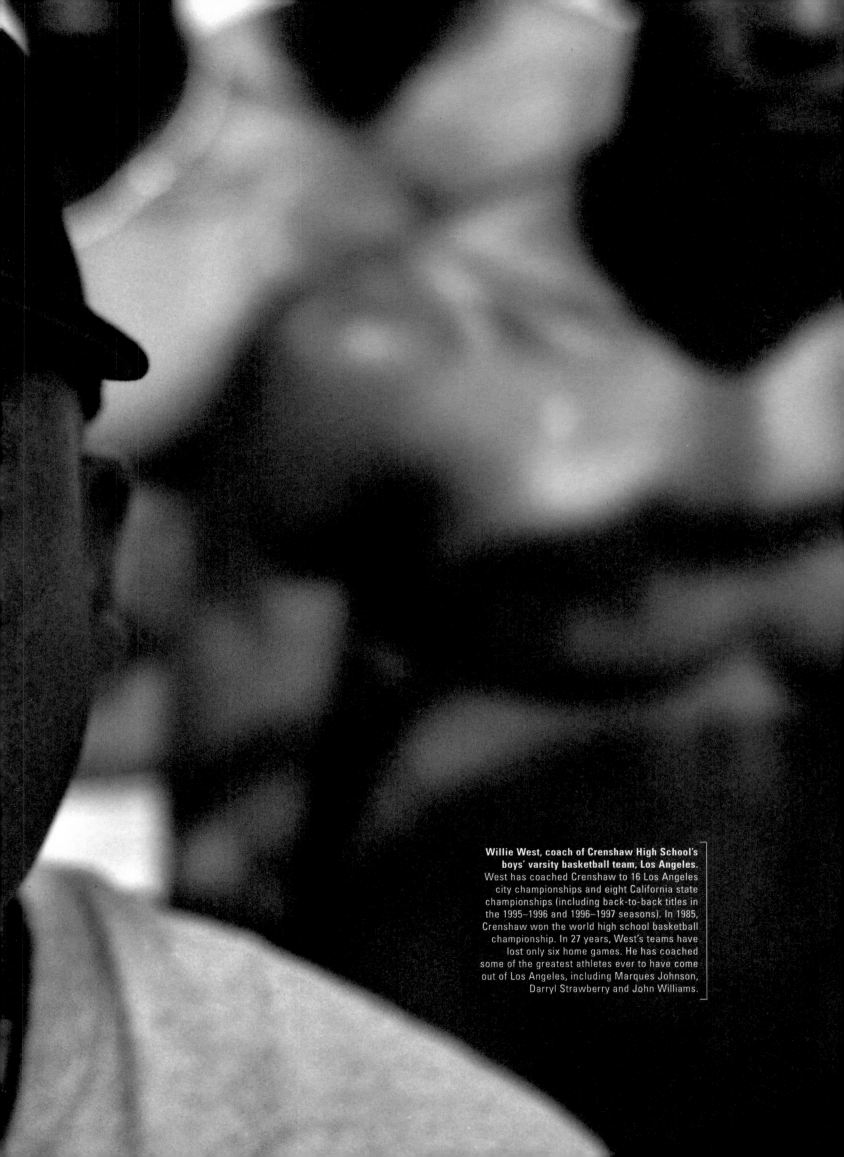

Willie West, coach of Crenshaw High School's boys' varsity basketball team, Los Angeles. West has coached Crenshaw to 16 Los Angeles city championships and eight California state championships (including back-to-back titles in the 1995–1996 and 1996–1997 seasons). In 1985, Crenshaw won the world high school basketball championship. In 27 years, West's teams have lost only six home games. He has coached some of the greatest athletes ever to have come out of Los Angeles, including Marques Johnson, Darryl Strawberry and John Williams.

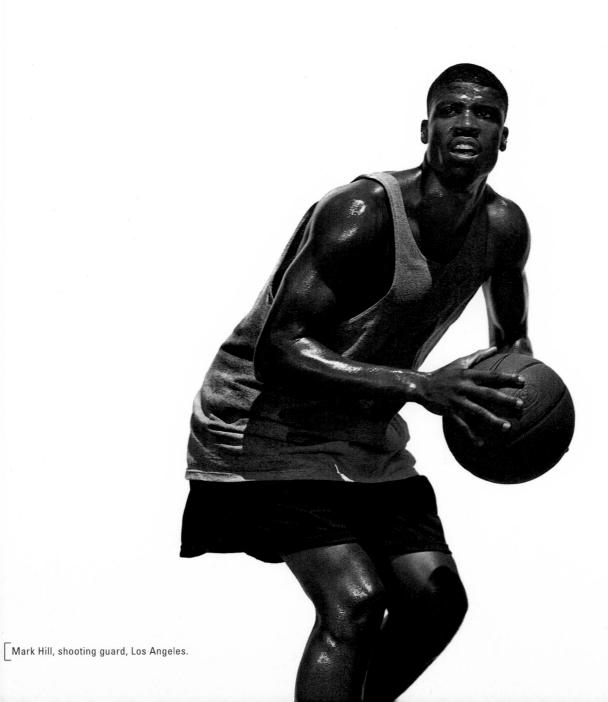

Mark Hill, shooting guard, Los Angeles.

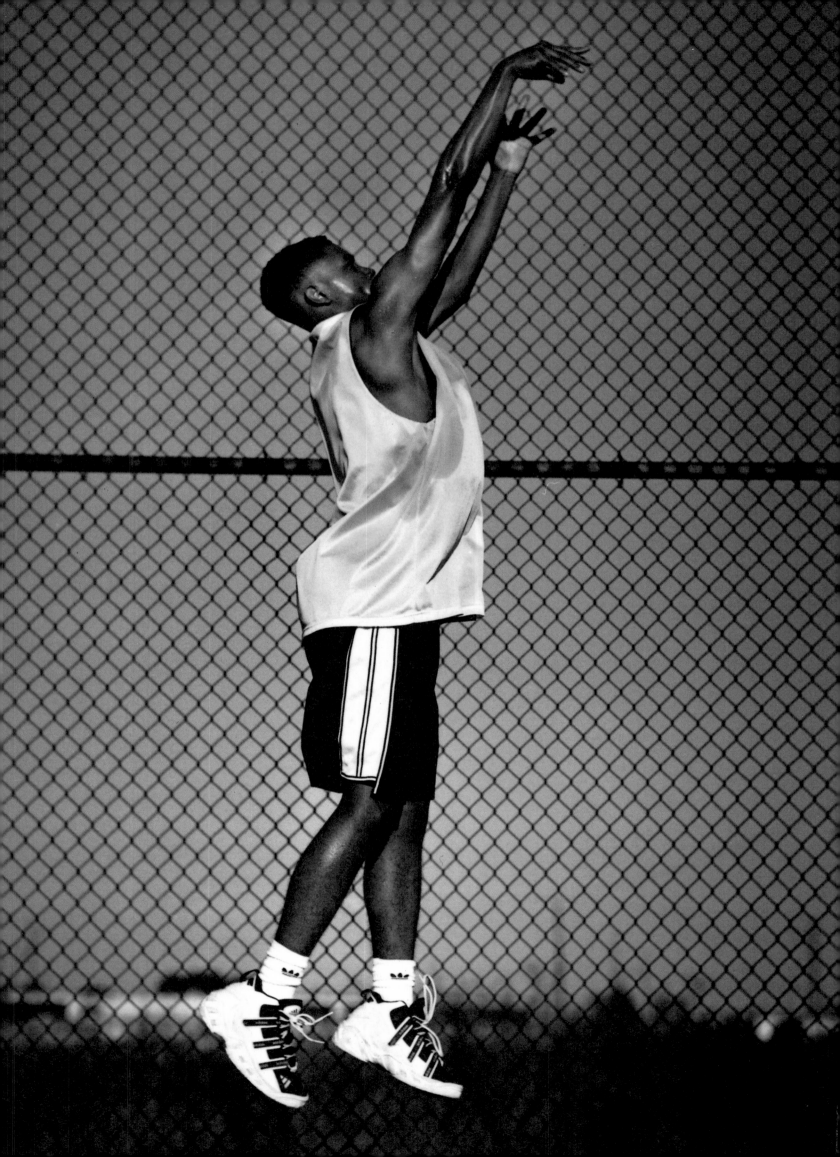

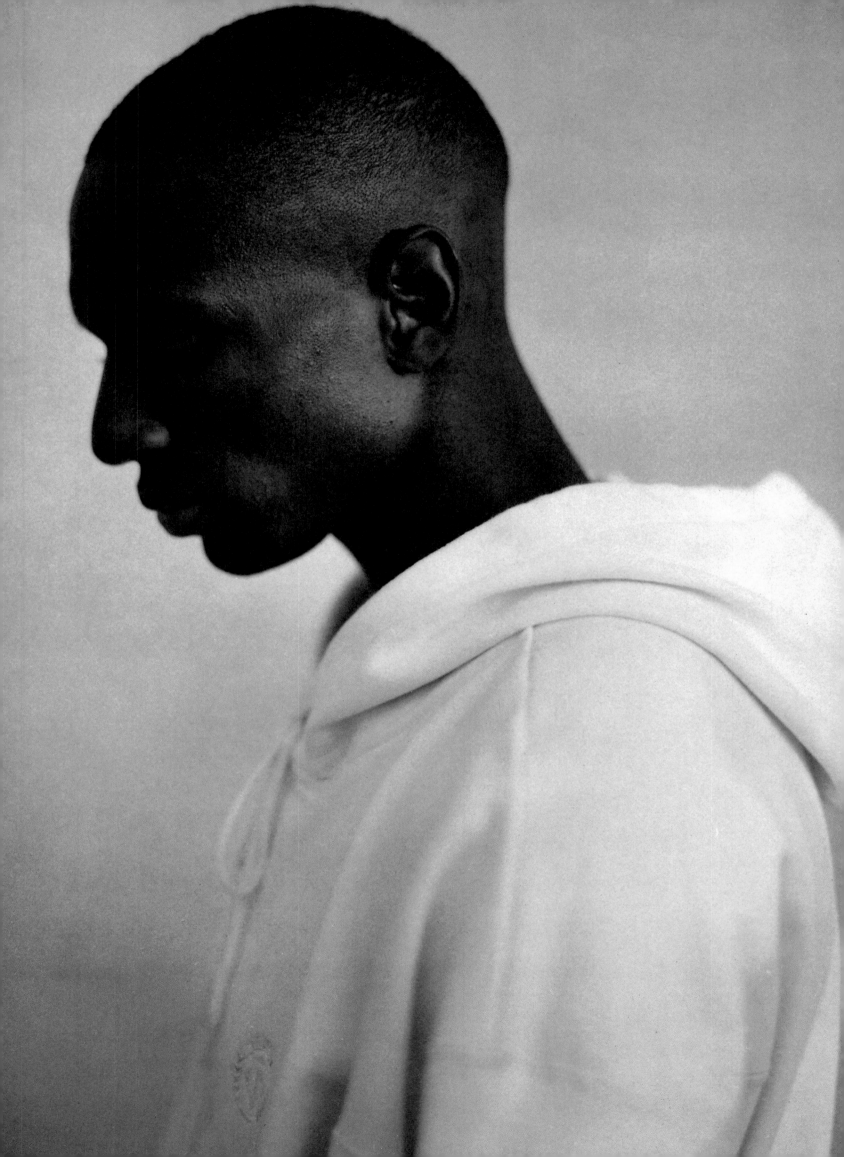

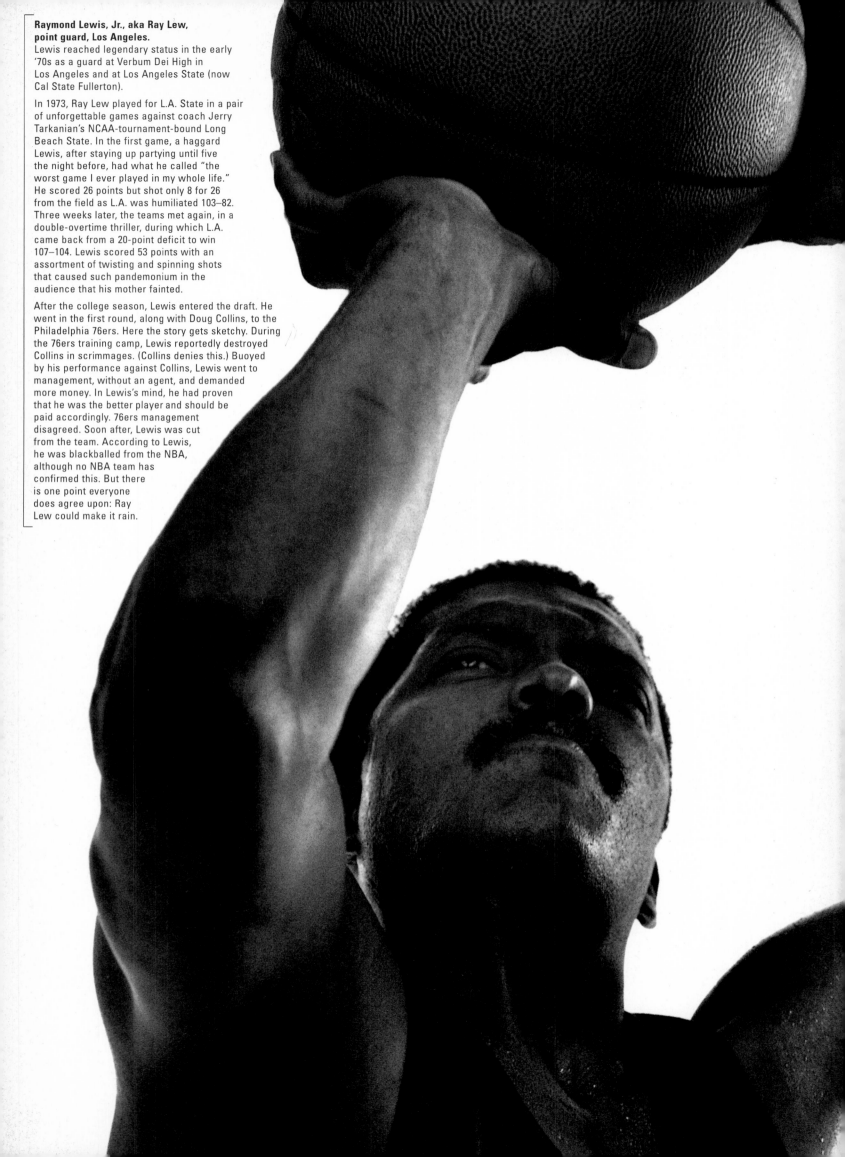

Raymond Lewis, Jr., aka Ray Lew, point guard, Los Angeles.
Lewis reached legendary status in the early '70s as a guard at Verbum Dei High in Los Angeles and at Los Angeles State (now Cal State Fullerton).

In 1973, Ray Lew played for L.A. State in a pair of unforgettable games against coach Jerry Tarkanian's NCAA-tournament-bound Long Beach State. In the first game, a haggard Lewis, after staying up partying until five the night before, had what he called "the worst game I ever played in my whole life." He scored 26 points but shot only 8 for 26 from the field as L.A. was humiliated 103–82. Three weeks later, the teams met again, in a double-overtime thriller, during which L.A. came back from a 20-point deficit to win 107–104. Lewis scored 53 points with an assortment of twisting and spinning shots that caused such pandemonium in the audience that his mother fainted.

After the college season, Lewis entered the draft. He went in the first round, along with Doug Collins, to the Philadelphia 76ers. Here the story gets sketchy. During the 76ers training camp, Lewis reportedly destroyed Collins in scrimmages. (Collins denies this.) Buoyed by his performance against Collins, Lewis went to management, without an agent, and demanded more money. In Lewis's mind, he had proven that he was the better player and should be paid accordingly. 76ers management disagreed. Soon after, Lewis was cut from the team. According to Lewis, he was blackballed from the NBA, although no NBA team has confirmed this. But there is one point everyone does agree upon: Ray Lew could make it rain.

Rain

by Poetri

Make it rain, Ray Lew
shoot, shoot, shoot, in the middle of the night
make it rain, Ray Lew, make it rain

At Verbum Dei
there was never a drought on game day
At L.A. College it was the same way, "What'cha say?"

Shoot, shoot, shoot, love the rock like a woman
if it's true love, when you let it go, it will come back to you
Make it rain, Ray Lew, make it rain, Ray Lew

Shot the smoothest 20-footer I've ever seen
Like a slingshot David, he shot down Goliath teams
Everybody scream, "Lay up! Lay up!"

And sho-nuff, the nets went swish, and begged for mercy
and other schools wished they had Ray Lew on their team list.

Shoot, shoot, shoot, make it rain, Ray Lew, make it rain.

No Mills
by muMs the schemer

I ain't never see no mills.
Ain't never see no sneaker deals.

Ain't never see no reason not to go in the game
in the last quarter.
It be always, "gimme the ball," in the last quarter.
Yeah, break my opponent at the key;
dish pass left;
got him looking right;
oops! back for the finish;
we slap hi-fives;
they got faces of dejection;

that be my only payment;
seems like all I needed.

I ain't never see no mills.
Ain't never see no sneaker deals.

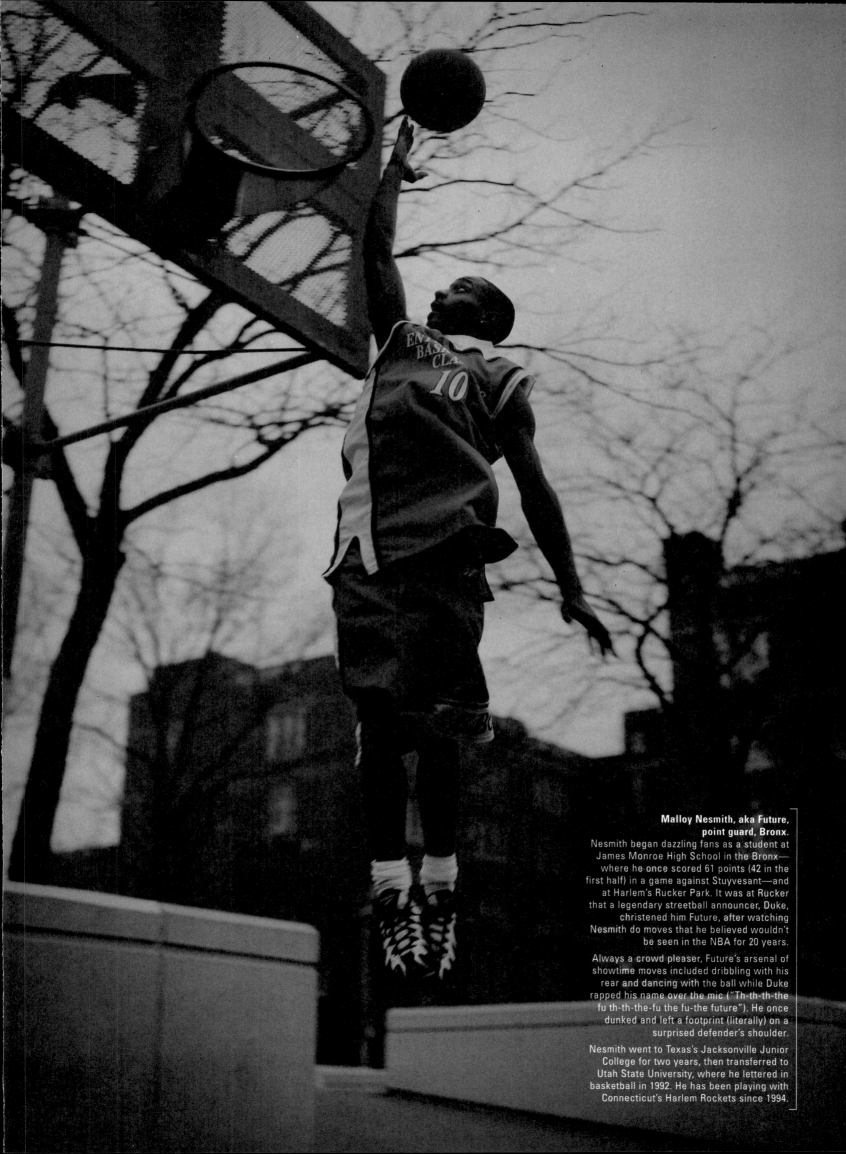

**Malloy Nesmith, aka Future,
point guard, Bronx.**
Nesmith began dazzling fans as a student at
James Monroe High School in the Bronx—
where he once scored 61 points (42 in the
first half) in a game against Stuyvesant—and
at Harlem's Rucker Park. It was at Rucker
that a legendary streetball announcer, Duke,
christened him Future, after watching
Nesmith do moves that he believed wouldn't
be seen in the NBA for 20 years.

Always a crowd pleaser, Future's arsenal of
showtime moves included dribbling with his
rear and dancing with the ball while Duke
rapped his name over the mic ("Th-th-th-the
fu th-th-the-fu the fu-the future"). He once
dunked and left a footprint (literally) on a
surprised defender's shoulder.

Nesmith went to Texas's Jacksonville Junior
College for two years, then transferred to
Utah State University, where he lettered in
basketball in 1992. He has been playing with
Connecticut's Harlem Rockets since 1994.

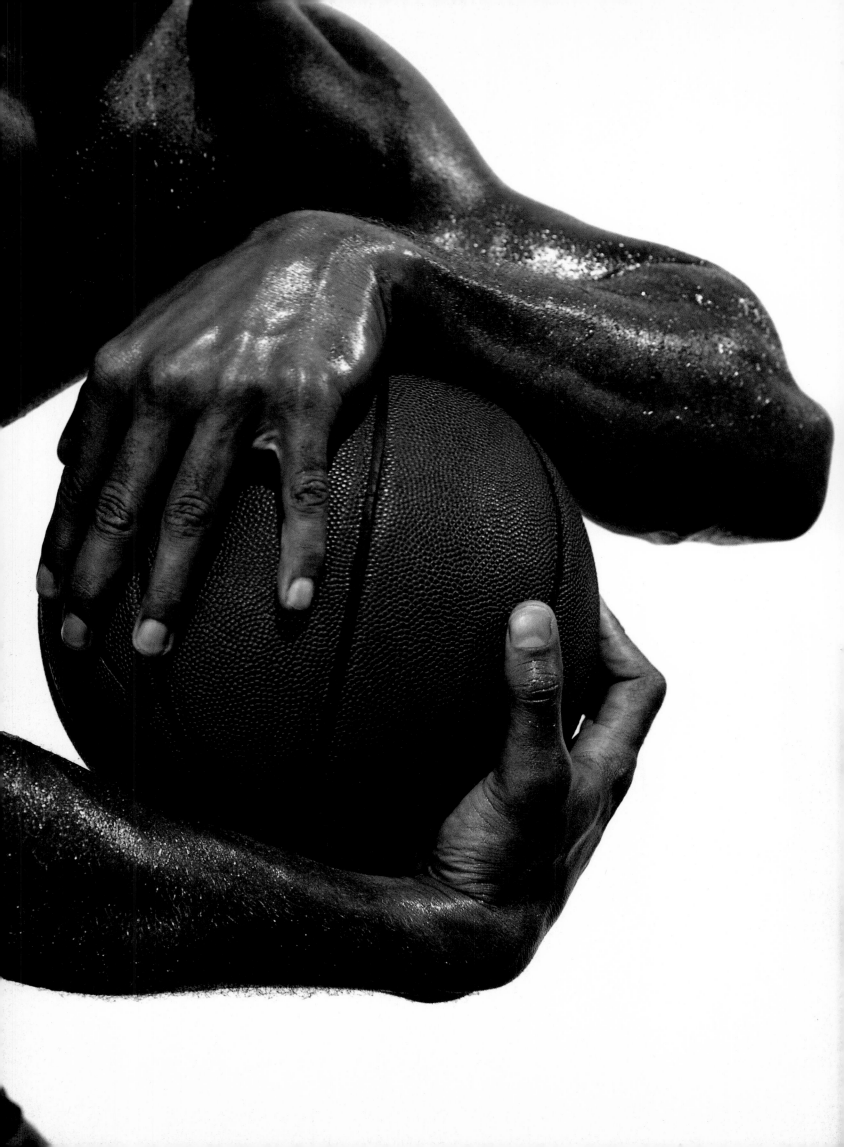

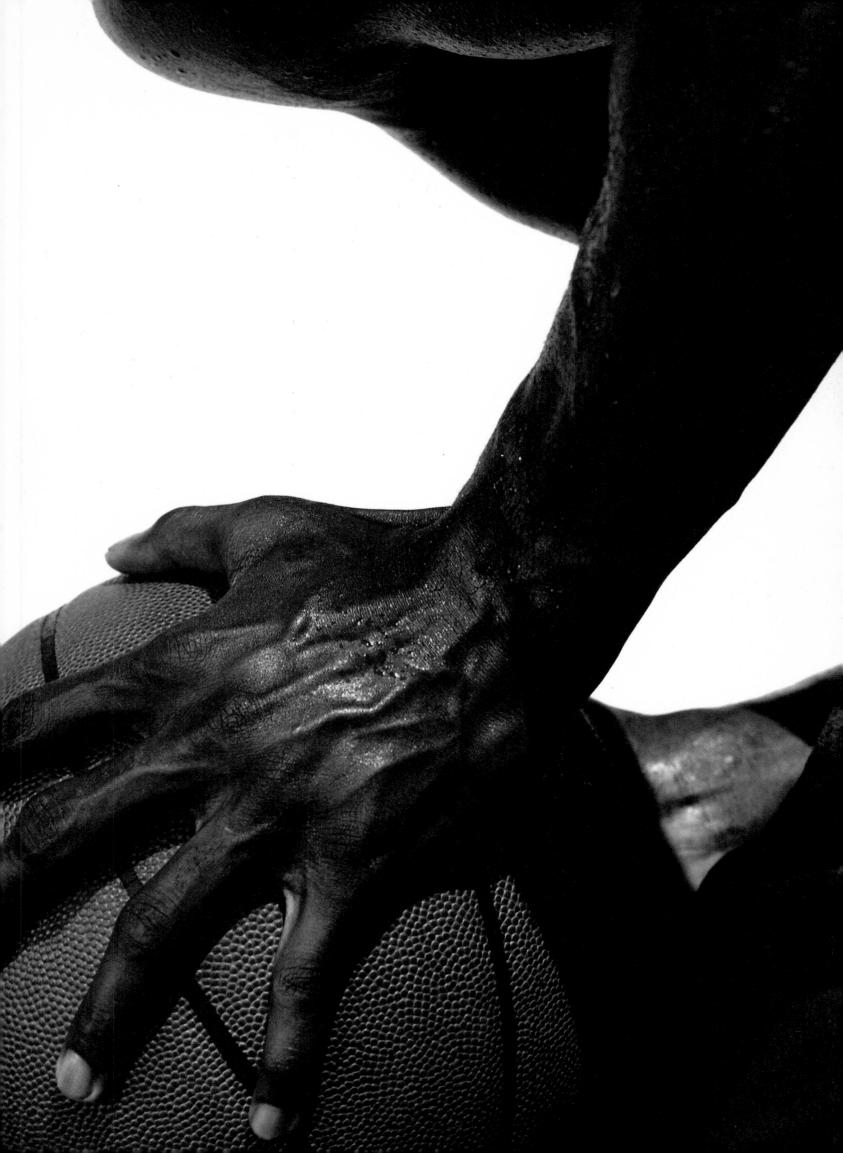

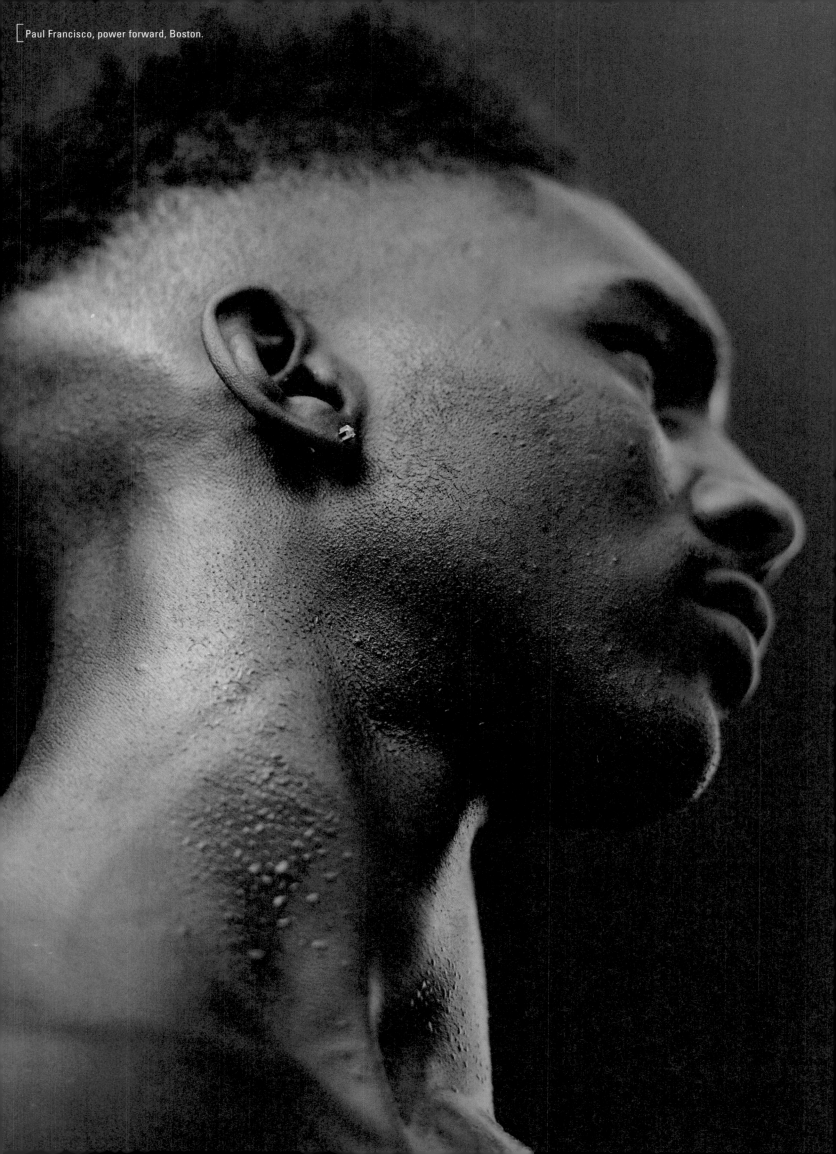

Paul Francisco, power forward, Boston.

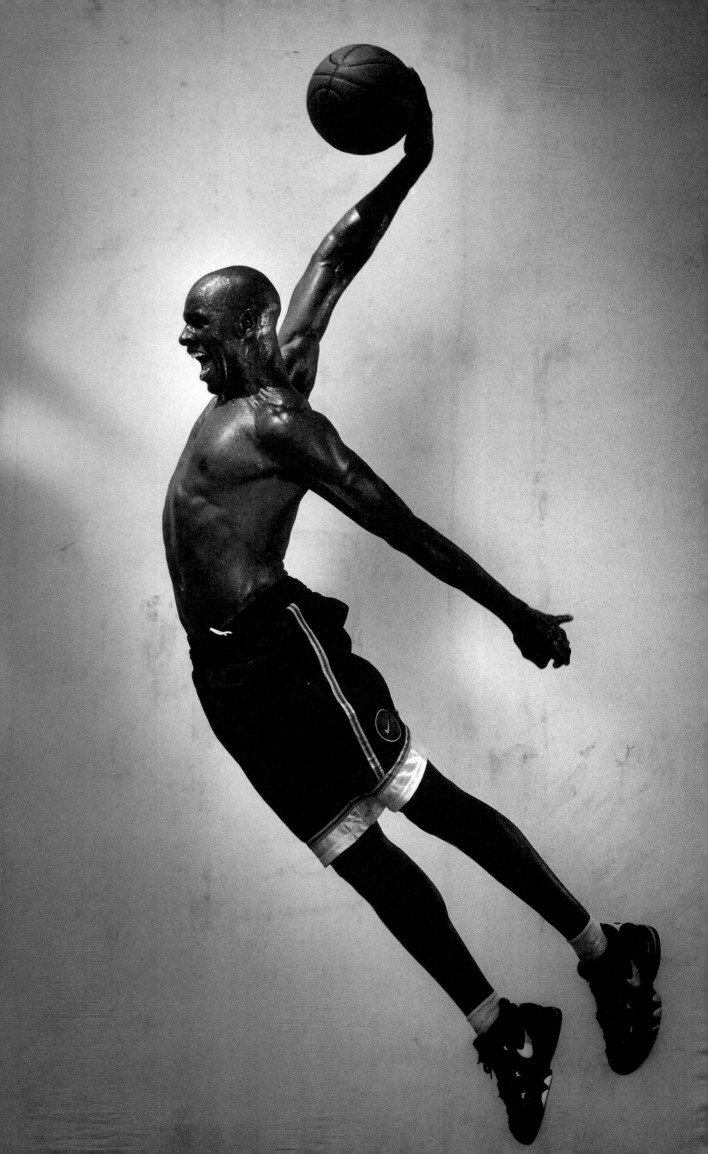

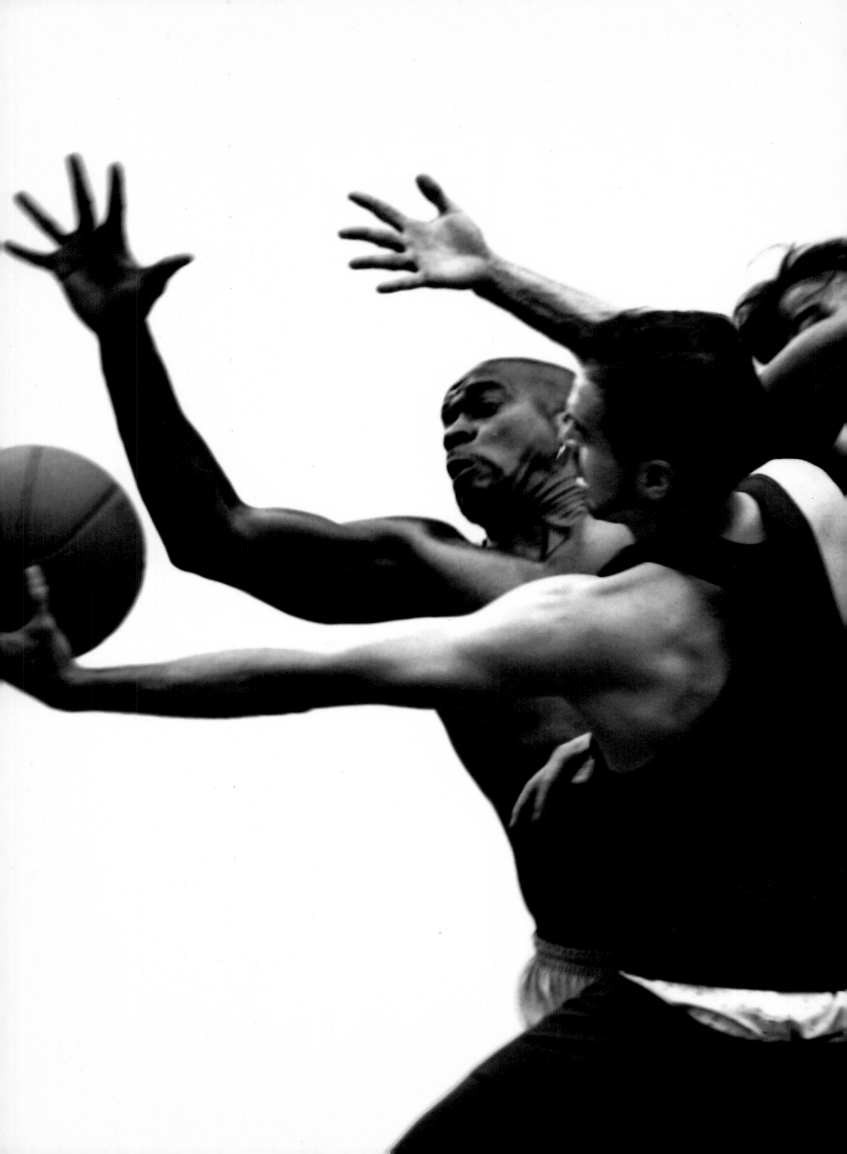

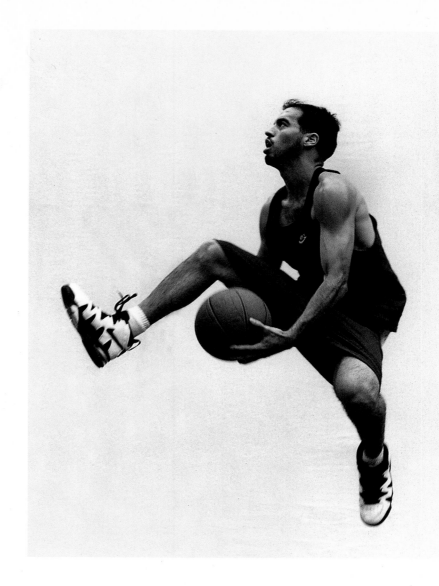

Robert Garcia, aka Bobbito, point guard, shooting guard, NYC.
After he bumped heads with his college coach at Connecticut's
Wesleyan University, Garcia landed a summer job playing pro
ball in Puerto Rico on a team called the Arecibo Capitanes. Later,
Garcia became a record producer and DJ, and started a talk
show devoted strictly to NYC street basketball, featuring on-air
discussions of topics like how City players wear their shorts. At
his East Village store, Bobbito's Footwork, you can find rarities
like a vintage pair of Converse Dr. J's. As a streetball historian,
Bobbito has a particular bias toward the way the game is
played in the Big Apple.

"A New York guard is the ultimate. He is not the type of guard
who needs a pick or to spot up. A New York guard can create his
own shot off the dribble. Whether you are a big man or a little
man, you have to have the ability to create," Bobbito says. "Just
like anything else in New York, you want to have a whole game.
Walter Berry, when he played at Ben Franklin High and St.
John's, was a legend in the playground because Walter had a
handle, and he was 6-foot-8. Magic is a legend in the NBA, but
Walter had boogie. Magic had boogie, but it was country boogie.
Walter would cross over, and a crossover is a dangerous move,
because you got the ball right in front of you. You're showin' it
to the defender, saying, 'Here, take it from me.' If you're a big
man and you can successfully cross over on somebody, it's
disgusting. It's like slapping somebody in their face. Walter Berry
had a crossover. He could spin and he had double pumps. In
New York, every big man wants to be a guard."

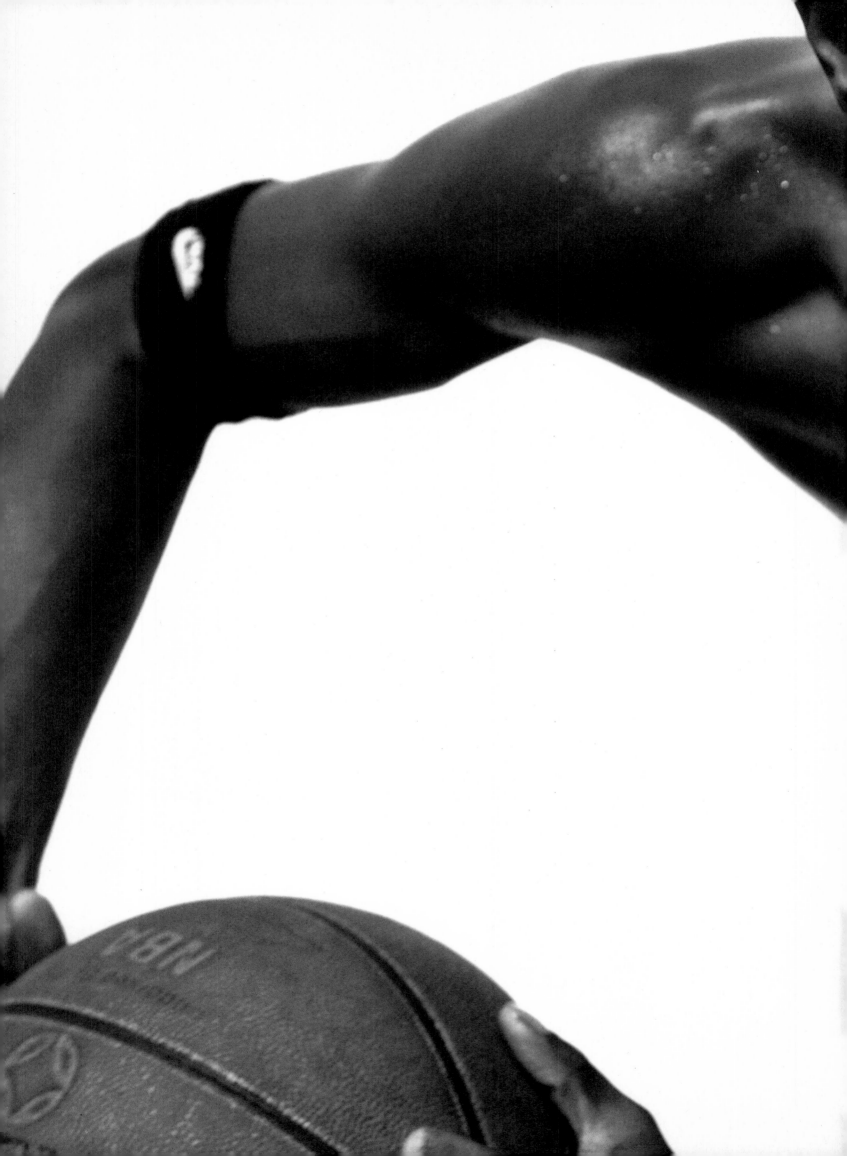

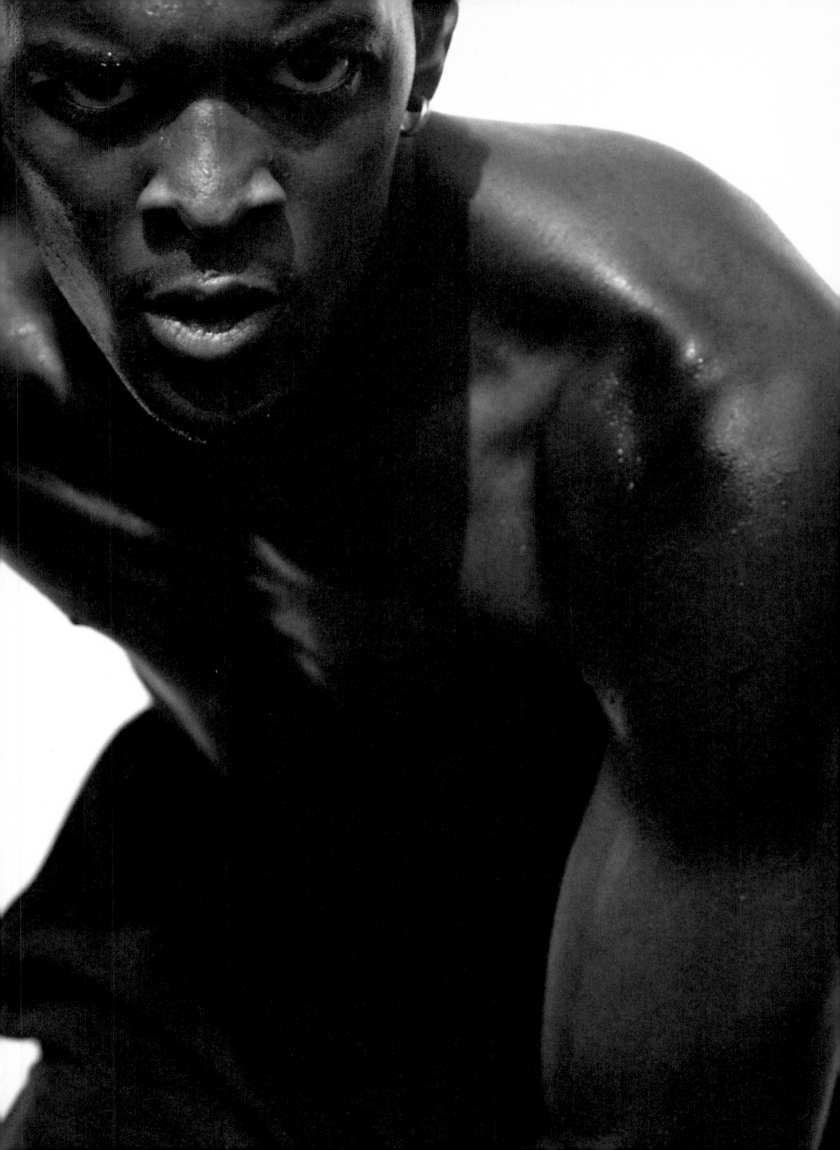

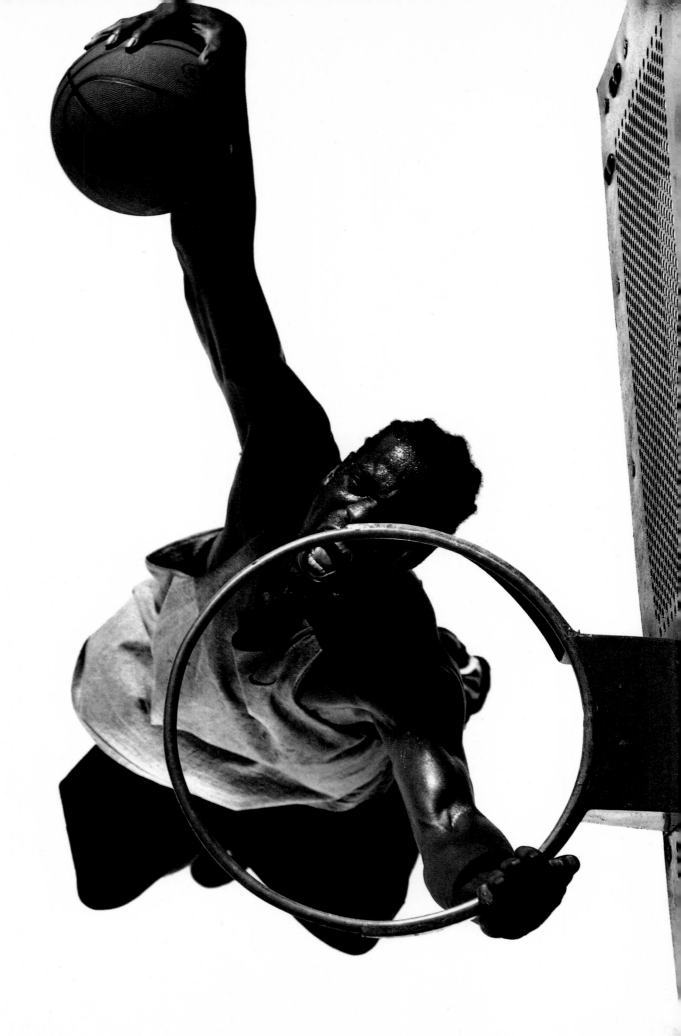

Seth Marshall, aka Up North (because he can jump
extremely high), aka Chairman of the Boards (because
he's a rebounding machine), small forward, NYC.

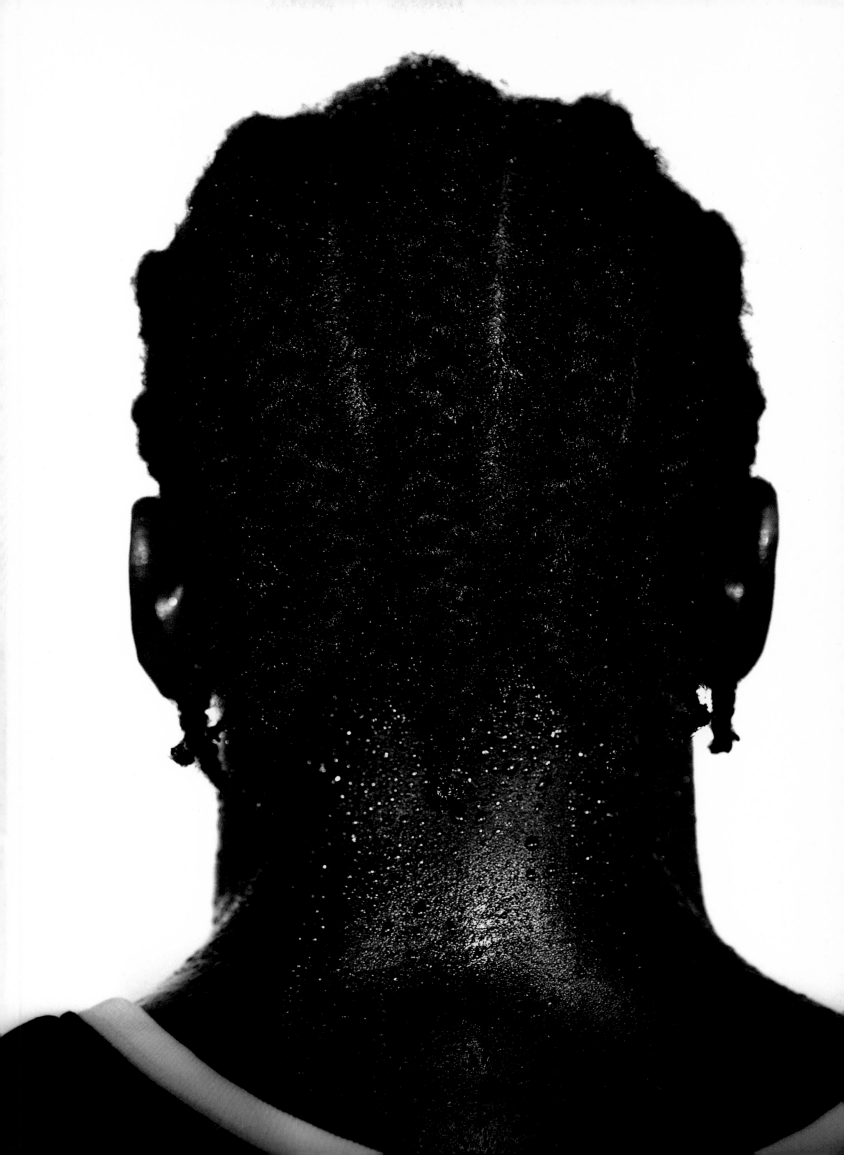

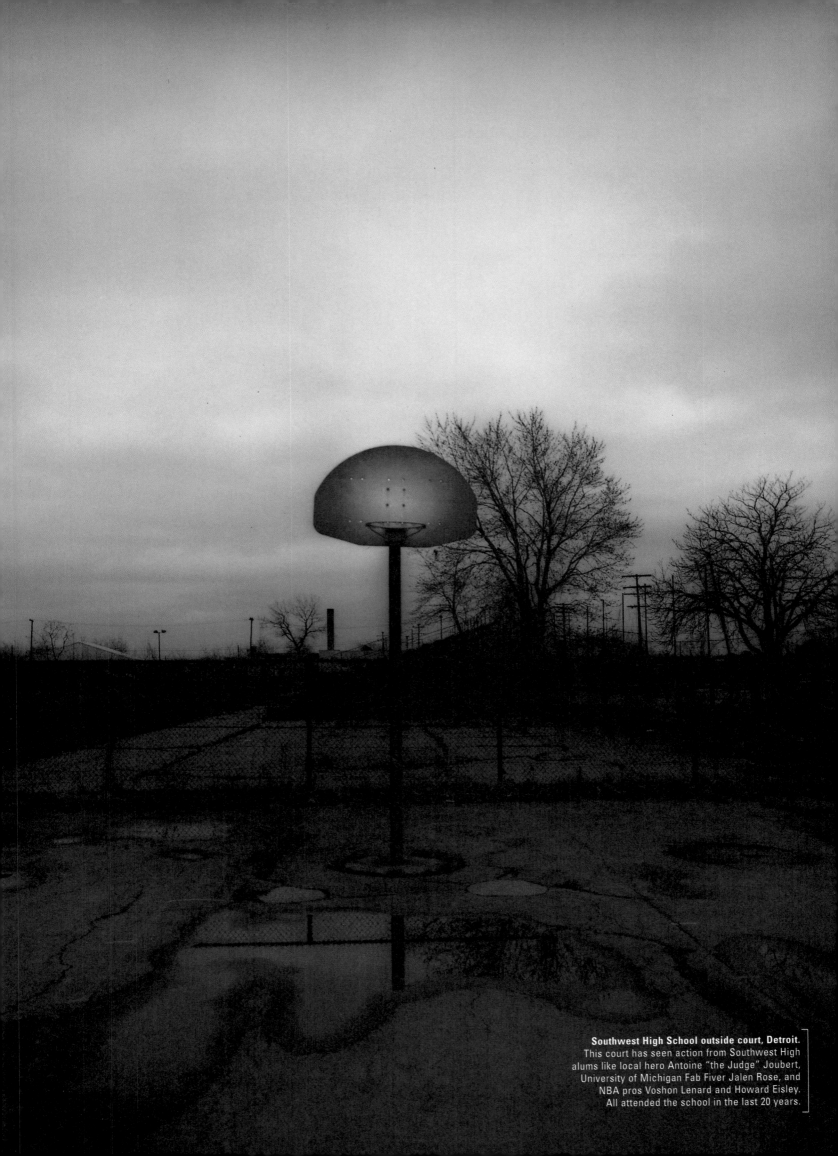

Southwest High School outside court, Detroit.
This court has seen action from Southwest High alums like local hero Antoine "the Judge" Joubert, University of Michigan Fab Fiver Jalen Rose, and NBA pros Voshon Lenard and Howard Eisley. All attended the school in the last 20 years.

CREATIVE TEAM

For 15 years, **John Huet** has been photographing the world's greatest athletes for sports companies including Adidas, Asics, Champion, Fila, Gatorade, Nike, Puma and Reebok, as well as many leading advertising agencies and design firms. Huet's photography has consistently earned awards from numerous publications, including *Graphis*, *American Photo* and the *Communication Arts Photography*, *Design* and *Advertising* Annuals. In addition to winning a One Show Award and a Clio nomination for his work with Nike and the NBA, Huet was nominated this year for the International Center of Photography's Infinity Award for Applied Photography.

John C Jay is a partner and creative director of Wieden & Kennedy, an international advertising and design agency based in Portland, Oregon. Jay has received numerous international awards honoring him for creativity in print and TV advertising, graphic and editorial design, documentary film and interior design. Jay's work has been exhibited at the Cooper-Hewitt Museum in New York, the Centre Georges Pompidou in Paris, and the Victoria and Albert Museum in London. In 1984, *American Photographer* magazine listed Jay as one of the country's 60 most important people in photography. He was named in 1995 by *I.D.* magazine as one of America's 40 most influential designers.

Jimmy Smith is an 11-year advertising veteran who is currently a senior copywriter for the Nike account at Wieden & Kennedy. Smith's work has been recognized by some of the most prestigious advertising-award shows, including ANDY, Cannes, Clio, New York Art Directors and One Show.

Pee Wee Kirkland is a championship-winning basketball coach at Manhattan's Dwight School, and teaches the philosophy of basketball coaching at Long Island University. He has appeared in commercials for Nike and in the 1994 film *Above the Rim*; he was also technical adviser on the film's playground-basketball sequences. Kirkland currently directs School of Skillz, a basketball program for inner-city kids.

Joshua Berger is founder and one of three principals of Plazm Media, a graphic-design firm, digital-type foundry and publisher of *Plazm Magazine*. Berger, who also works in Wieden & Kennedy's creative department, has been recognized by numerous design publications and award shows. With Plazm, he was listed in 1997 in *I.D.* magazine's "I.D. 40" as one of America's 40 most influential designers.

Founded in 1994, **Melcher Media** produces illustrated books on subjects including art, film, music, photography, popular culture and sports. Collaborating with leading international artists and media companies, Melcher Media has created a diverse, cutting-edge list, including a best-selling, award-winning publishing imprint for MTV. Most recently, the company released *Rent*, the companion book to the hit Broadway musical, and *Fast Forward: Growing Up in the Shadow of Hollywood*, by photographer Lauren Greenfield.

POETS

Markhum Who? is a poet and actor born and raised in Memphis, Tennessee. Markhum earned a B.A. in English, fine arts and theology from Georgetown University, where he also won the Kreeger Award for performance art. Currently a resident of Los Angeles, Markhum has published a collection of poems entitled *Strugglin' 2B Free* (Veracity Press).

Gregorio Deshawn McDonald was born in Torrejón de Ardoz, Spain, and presently lives in Orange County, California. He has been writing poetry for the past seven years and reads in numerous spoken word venues throughout Southern California. He has been featured at the World Stage of Los Angeles and performed in the 1996 L.A. Spoken poetry festival. His work has appeared in the literary magazine *The Drumming Between Us* and *The Thunderbird Society*, a Native American newspaper.

muMs the schemer is an MC and poet from the Bronx. He has performed at New York's Nuyorican Poets Cafe, the Sounds of Brazil and the Brooklyn Moon Cafe, and he represented New York State at the National Poetry Slam Championship in Oregon. He has acted in the Home Box Office series *Oz* and Black Entertainment Television's music-video program *Planet Groove*. He is currently at work on a book titled *Movements of the Cockroach*. muMs and his work have been featured in *The Quarterly Black Review* and *The Source*.

Poetri is a Los Angeles–based rapper, actor, poet and comedian, and is co-owner of RAZZOP Productions. He has performed his poems at several competitions in Los Angeles, including the World Stage, the Inner City Games and the Inner City Cultural Fest Poetry competition, where he won a first-place award in 1997. Poetri's work has been featured in *Billboard*, *Alternative*, *Cash Box* and *YSB*.

Gerald Quickley is a 32-year-old writer from New York City who has lived in Los Angeles for the past two years. As Playwright in Residence at the Tiki Ti Theatre Company in Manhattan, from 1992 to 1993, he directed a series of one-acts and short films. A member of the 1996 and 1997 Los Angeles Slam teams, Quickley has performed his poetry on the LifeTime Cable Network series *The Men's Room* and at venues across the United States and abroad. His poetry has been published in several anthologies and magazines, including *Beyond the Valley of Contemporary Poets* and *Alphabet City*.

ACKNOWLEDGMENTS

I am grateful to the individuals below for their time, dedication and hard work on behalf of this project.

My printer, Amy C. Hahn, was responsible for making all of the black-and-white prints for *Soul of the Game*.

My production team played many important roles in making this book possible: Stacey Barlow, K.B. Buckbee-Suarez, Marilyn Cadenbach, Carol Cohen, Robin Dictenberg, Kitty Ford, Paula Gren, Jonathan Knight, Nancy Kozak, Marie-Claire Lamarre, Ian Logan, Michael Lohr, Ray Meeks, Gayle Saunders Monahan, Tibor Nemeth, Kari Peyton, Brenda Ranes, Gregg Roth, Dana Stephenson, Sam Walsh, Loni Weholt and Cindy Whitehead.

The following group must be thanked for sharing their knowledge of the local streetball scenes in the cities featured in this book, and for their generosity in serving as our guides: Patrick Ford (Detroit), Bobbito Garcia (New York), Don Johnson (Los Angeles), Nigel Miguel (Los Angeles), Darrin Snulligan (Chicago) and Littel Vaughn (Philadelphia).

I would also like to extend my appreciation to John Jay, Jimmy Smith, Joshua Berger and Melcher Media for working with me to bring this book to life.

Finally, I owe a special thanks to my wife, Donna, whose enduring love and support mean more than she could possibly know.

—J.H.

This book was produced by Melcher Media, Inc.
170 Fifth Avenue, New York, NY 10010
under the editorial direction of
Charles Melcher, Publisher
Duncan Bock, Editor
Erin Bohensky, Associate Editor
Karin Rinderknecht, Editorial Assistant
Pam Smith, Director of Production
Joshua Berger, Designer

Special thanks to:
David Ball, Stacey Barlow, Marilyn Cadenbach,
Andrea Glickson, Amy Hahn, Janet Harris,
Wayne Kirn, Sally Kovalchick, Marie-Claire Lamarre,
Arlene Lee, Ellen Morgenstern, Jennifer Moyse,
David Pryor, Suzanne Rafer, Mallory Samson, David
Schiller, John Shostrom, Gillian Sowell, Richard
Thomas, Janet Vicario, Peter Workman and
Megan Worman.

Library of Congress Cataloging-in-Publication Data

Huet, John.
Soul of the game: images & voices of street basket-
ball/photographs by John Huet; art direction by John
C. Jay; poetry compiled by Jimmy Smith.

p. cm.
ISBN: 0-7611-1028-3 (hc)
ISBN: 0-7611-1123-9 (pb)
1. Basketball—United States. 2. Basketball—United
States—Pictorial works. 3. Urban youth—Recreation—
United States. 4. Hip-hop—United States.
5. American Poetry—Afro-American authors. I. Jay,
John C. II. Smith, Jimmy, 1961– . III. Title.
GV885.4.H84 1997
97-24966 796.323'0973–dc21 CIP

Workman Publishing Company, Inc.
708 Broadway
New York, NY 10003

Printed in Japan.
First printing October 1997
10 9 8 7 6 5 4 3 2 1

The images selected for *Soul of the Game* were
reproduced from John Huet's original toned silver
prints and digital-image files.

The type was set in Interface One, Interface Two,
Retrospecta Roman, Retrospecta Italic, Universe 57
Condensed and Universe 67 Condensed.

The tritone plates were printed in 175-line screen
from film made by Toppan Printing Company.

The book was printed and bound in Tokyo by Toppan
Printing Company on Oji OK Bright Rough Text.

Front cover: Todd Whitehead, aka Boogie,
point guard, NYC.

A 3702497 3

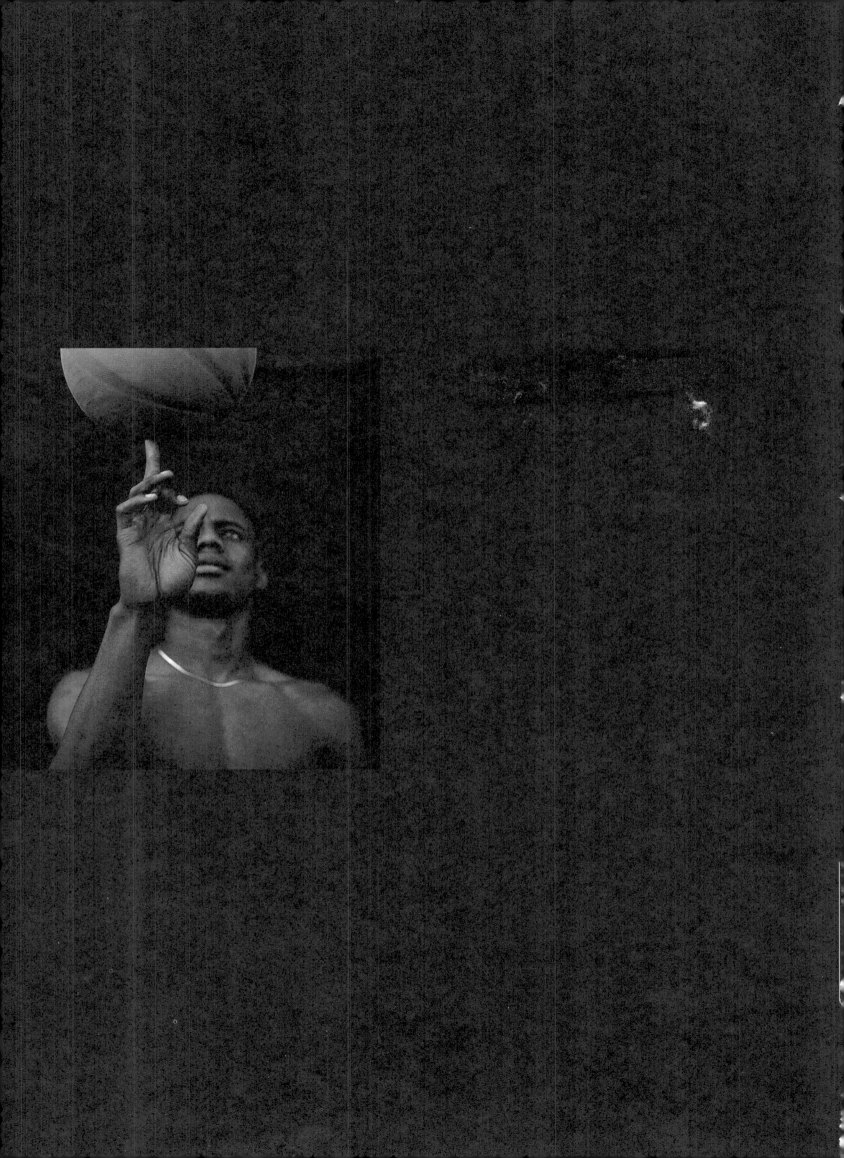

DATE DUE